Dedalus Original Fiction in Paperback

ZAIRE

Harry Smart was born in 1956 in the North of England. He lives in Montrose, in Scotland. He is married, with one son.

Harry Smart has published three collections of poetry with Faber: *Pierrot* (1991), *Shoah* (1993), *Fool's Pardon* (1995). His other publications include *Criticism and Public Rationality* (1991).

Zaire is his first novel.

Harry Smart

Zaire

Dedalus

Eastern Arts
Board **Funded**

Published in the UK by Dedalus Ltd, Langford Lodge, St Judith's Lane, Sawtry, Cambs, PE17 5XE

ISBN 1 873982 92 5

Distributed in the USA by Subterranean, P.O. Box 160, 265 5th Street, Monroe, Oregon 97456

Distributed in Australia & New Zealand by Peribo Pty Ltd, 58 Beaumont Road, Mount Kuring-gai N.S.W. 2080

Distributed in Canada by Marginal Distribution, Unit 102, 277 George Street North, Peterborough, Ontario, KJ9 3G9

First published by Dedalus in 1997
Copyright © 1997 Harry Smart

The right of Harry Smart to be identified as the author of this work has been asserted by him in accordance with the Copyright, Designs and Patents Act, 1988.

Typeset by RefineCatch Limited, Bungay, Suffolk
Printed in Finland by Wsoy

A C.I.P listing for this book is available on request.

1

Thomas Manza stood at his bedroom window and looked out over the lights of Zürich as they sparkled in the darkness. A city at night; lights in offices and homes, streetlights, head-lights, tail-lights. A universal. Manza looked and saw, it could be any city in the world, saw London and New York, saw the lights of Africa shining out like stars against the darkness, saw Brazzaville, Nairobi, saw Cairo and Kinshasa.

He turned away from the window and left the room.

He was sixty-three years old. When he left his country he'd been just over thirty, young for a cabinet minister, but every-one in that first government had been young. At thirty he'd been the oldest graduate in the Congo, one of only a handful of black men granted the privilege of studying in Europe.

The broad wooden stairway creaked beneath his feet as he made his way down into the hall. His wife, hearing his foot-steps, emerged from the sitting room. Beyond her, through the open doorway, Manza saw the TV. The sound was turned down low, subtitles spelling out a French translation of the German dialogue. After all these years, whispers, and the daily burden of translation.

'I have to finish my report for Etienne', he said. 'I promised I'd have it to him by tomorrow.'

'I'll bring you coffee, then?' asked his wife.

'Thank you', said Manza.

There was a sudden whirring in the hallway. The long-case clock was preparing to strike the hour. The whirring stopped and the first low chime shivered out through the house. Annette Manza shuffled off towards the kitchen. On the sev-enth stroke Thomas heard the door close softly behind her. He turned towards the study door. As the clock struck eleven he paused in the doorway, and stood for a moment. Stillness fell in the hallway, sudden after the striking hours, and the study too lay silent. He strode into the room, closing the door firmly behind him, and walked over to the desk. He flipped

the power switch at the back of the PC and heard the fan and the hard disk whine up to their working speeds. The monitor bristled with high-tension charge. The clicks and whirrs of the boot sequence, of memory counts and initialisation, had become familiar and comforting. He switched on the laser printer, which added its own humming note. He walked round the desk and, with a sigh, settled himself into his chair. Behind him was the large uncurtained window, and beyond its thick, double-glazed pane, the lights of Zürich.

The young African sitting in the passenger seat looked at his watch. The sea-green digital display changed silently to 11.00. Philippe Lukoji tapped lightly on the dashboard and the dark blue Renault moved forward. As it approached the high, metal gates they swung open and the car moved out into the dark street. It travelled quickly out of the city centre, onto Rämistrasse. No-one spoke.

They turned off to the right just before the Hospital, and soon the car was climbing up into Dolder, past big, solid houses which stood in generous grounds behind high walls and tall railings. The tree-lined streets were empty, the cars all settled down in off-road garages. Philippe spoke quietly to the driver, Alain, who pulled the car over to the kerb and stopped.

Alain was carrying a P-sieben while Robert, the gun-freak, had an early Colt automatic, a 1911 he'd lovingly rebuilt. Philippe carried a Glock Model 17; Austrian-made, frame of hi-tech plastic, seventeen subsonic 9mm rounds in the magazine. Philippe held his pistol up and let them see him fixing the suppressor into place; they did the same. There was the sound of metal sliding on metal as Robert pulled back the slide on his Colt, then the chunking sound as the spring threw it forward again, stripping a round from the top of the clip and loading it into the breech.

Philippe opened the door and stepped out into the street, looking for any sign of movement. Satisfied that there was no-one around, he ducked briefly back into the car.

'*Los geht's*', he said, and the two Swiss climbed out. They

6

closed the car doors quietly and neither of them noticed that Philippe had left his pistol on the floor of the car.

Still without speaking, they strolled along the street. They might have been residents, their clothes were casual but expensive, beautifully cut blazers, fine shoes, everything dark and understated.

Just ahead of them, old Doctor Weissmann came round the corner, leading Rolf, his dachshund. Weissmann saw the three men and stopped, staring at them with obvious anxiety. Robert, the taller of the two Swiss, strode towards the Doctor. Robert reached into his jacket and the Doctor stepped back in alarm. Robert put his finger to his lips and shushed the old man, showing him his ID card. Weissmann relaxed and smiled broadly. Alain, too, put his finger to his lips. The Doctor nodded vigorously, then hurried on his way, head bowed, tugging a reluctant Rolf behind him. The three men walked on a few yards, stopping in front of a white wooden gate, and then turned to see Doctor Weissmann still scuttling along the pavement. They stood and watched him until he turned out of sight at the far end of the street. Philippe checked his watch; it was fourteen minutes past eleven.

In the kitchen, Annette prepared her husband's tray with cup and saucer, milk in a jug, and a small plate of almond biscuits. The porcelain gleamed in the kitchen's soft light. The last of the water boiled up through the percolator with a sucking noise, and then dripped down into the wet mass of coffee grounds. Annette lit a small candle, like a night-light, and placed it beneath a little hotplate on the tray. The last of the coffee dripped through into the percolator's glass jug. She lifted the jug across and set it on the hotplate. She glanced at the kitchen clock and saw the minute hand tick down to the quarter hour. She picked up the tray.

Thomas scarcely looked up as she entered the study. Already he was absorbed in the report, frowning at the screen, at the list of delegates' names. It was thirty years since he'd stood in the UN building; precious few of those with whom he'd spoken were still alive. Hammarskjöld was long dead,

almost all the Congolese who'd been there were dead, so too were more US presidents and Soviet leaders than Manza could immediately remember. And of the African leaders who'd seemed so secure, none remained, not even Nkrumah, who had seemed invincible. Nkrumah had flown to Cairo, visiting Nasser on his way to Vietnam, a statesman on the world stage. Nasser met him at the airport and Nkrumah assured him that all was well back home in Ghana. Nasser grinned and said, 'I should just telephone to check that, if I were you.'

Thomas glanced up at Annette as she waited patiently by his desk. The frown left his face. He moved a folder aside to make room for the tray. She set it down and came to stand beside him. He took her hand and she leant towards him, her cheek brushing softly against his.

'Don't work too late', she said.

'I won't', he said.

Annette smiled as she straightened up again, and shook her head gently.

'Do you think Etienne has any chance?' she asked.

Thomas leaned back in the chair and scowled at the screen.

While all the world changed, Mobutu remained. He'd ridden out the Cold War, he'd ridden out the end of the Cold War. The New World Order had come and gone in a handful of years since the wall came down in 89, and Mobutu stood unmoved.

'He won't live for ever, Thomas', said Annette, and as she spoke his name the room exploded in a flash of light. A huge, blue-white light that burned its way in an instant into every corner of the room, yet there was no more noise than a door slamming. There was light, then the silence of complete shock.

Robert was first through the door. His first round shattered the lamp on Manza's desk, then he knocked out the standard lamp by the window. Two dull slaps, like books dropped onto a desk, and the sound, in the same two moments, of breaking glass.

The glow from Manza's PC monitor illuminated the desk-

top and the stunned faces of Thomas and Annette. The muzzle of Robert's gun emerged into the faint light but his face stayed back in the darkness.

Blinded, the Manzas struggled to make sense of the sounds. Annette was suddenly thrown aside and she crashed heavily to the floor, knocking her head against the wall. At the same moment Manza found himself hauled from his chair and thrown forward across his desk. His arms were wrenched round behind him and his hands drawn up towards his neck. Handcuffs were clamped onto him, cutting painfully into his wrists. He called Annette's name. He was struck hard across the face and a hand covered his mouth. A moment later a broad band of thick tape replaced the hand. He began to struggle, bucking and kicking, and felt his foot strike hard against someone's leg. The PC monitor was in his face. He pushed and the monitor fell off the desk. There was a loud bang as it hit the floor, and another blow across his face.

The two Swiss bundled Manza out of the house. Philippe checked Annette. She was unconscious, but still breathing.

Philippe left the house, carefully closing the door behind him and hearing the lock, undamaged when Alain had opened it, click shut. From the street he looked back at the front of the house; it seemed unchanged. Only the momentary flash of light like a flashgun blitz could have given the game away. That and two white men hustling a black man into a car, but some things you have to take a chance on.

When Philippe reached the Renault he paused again, but the street was as silent as ever. Robert and Alain had got Manza into the back seat and were holding a chloroform pad to his nose. Then Manza, too, was quiet, Alain was back in the driver's seat and the car was hurrying across Zürichberg. Philippe checked his watch, it was seventeen minutes past eleven.

They were due at the airport in thirteen minutes. They took Winterthurerstrasse at speed, then down onto the dual carriageway. Oerlikon on the left, five minutes to go; Glattbrugg, runway lights, Zürich-Kloten. The Renault pulled off the highway well short of the main entrance, took an

unmarked slip-road and entered by a gate in the perimeter fence so insignificant that few of the thousands of people who passed it daily were aware it existed. The gate swung open as the Renault appeared; the car barely slowed, driving through onto an unlit service road. Two minutes. Alain switched off the lights and they did the next half-mile in twenty seconds in the darkness, parallel with the main runway at first, then turned, crossed the runway and pulled up near an unlit hangar. A twin-engined jet aircraft stood ready.

Ten minutes later the two Swiss policemen drove Philippe back across the airport and dropped him off beside the terminal. Philippe knocked at a doorway and waited. When the door opened, he showed his passport with its diplomatic accreditation, and walked through into the terminal. He went to an Air France desk and checked in for the next flight to Paris. Alain and Robert drove back into Zürich; Robert was delighted with the Glock that Philippe had given him. Compliments, Philippe had said, of Joseph Desiré Mobutu, otherwise known as Mobutu Sese Seko, Kuku Ngbendo wa za Banga, All-conquering warrior who goes from triumph to triumph, Guide of the Zairean Revolution, the Helmsman, the Father of the Nation.

As for Thomas Manza, who had been absent from the Congo while Joseph Desiré was steering it to greatness, his years of exile were almost at an end.

2

Back in Paris in the early hours, the city was quiet. In his apartment on the Rue des Eaux, Philippe closed the door behind him and stood for a moment in the darkness, listening. The room was exactly as he'd left it fifteen hours earlier.

There was a message on the answering machine. In the darkness he could see its indicator blinking at him from the far side of the room. He switched on the lighting circuit. Around the room, from the one switch, all the lamps came on. The answerphone's winking red bead was almost drowned in the flood of soft lamplight.

He walked across the honey-coloured hardwood floor and took a bottle of Jameson from the cabinet. He took a heavy cut-glass tumbler and poured himself a drink. He carried it over to the answerphone and replayed the single message.

He smiled when he heard Marie's voice. She spoke quietly, as if she were embarrassed to be heard, one word of Lingala, '*Boni*'. She paused, and in the pause Philippe replied, '*Malaamu*', as if she could hear him. How are you? I'm fine. He stopped the tape and rewound it to just to listen to her voice again.

She'd called just to say that everything was fine, and to let him hear a few words from Eric. Eric told him all about the painting of a spaceship that he'd done that afternoon in school. Then, '*Je t'embrasse, Papa*', in the child's bright, confident voice, and the message ended. Kinshasa. Philippe sipped at the whiskey and he smiled, but the smile didn't last.

He went across to the stereo system. He pressed the power switches one by one. The stack of hi-fi separates came to life with a scatter of LEDs and LCDs, an overload of cryptic messages in shades of grey-blue, green and amber. From the chromed rack beside the stereo he picked a CD and, holding the flimsy plastic case delicately in his slim fingers, he took out the glistening disk. He pressed a button and the disk tray slid out towards him. He set the CD in place and pressed the

11

button again, smiling at the smooth whir of the returning tray. The CD spun and the track count was illuminated on the player's fascia. He pressed the repeat button, then play.

As Philippe walked through to the bathroom, Sam Cooke's voice followed him, big and gentle, no trace of strain, singing 'Danny Boy'.

Sam Cooke: born in 1931, died on the eleventh of December, 1964, shot down in a motel room. Just another black man killed for the sake of a nameless girl. 'You send me' was his first number 1, in 1957, and he recorded 'Wonderful World' in 1960. Dono much about hiss-taree, dono much biology. Philippe sat on the edge of the bath and spun the heavy chrome taps.

He undressed and climbed into the bath, keeping the whiskey beside him. He sipped at the drink and let the warm water and the soft music soak into him, but he kept hearing the sudden *whoof* of the flash grenade and seeing, through closed eyelids, the burst of blue-white light. The water cooled and the record kept on going, stepping from one gentle swinging track to another.

> Maybe I'm old-fashioned,
> feeling as I do.
> Maybe I am living in the past.
> But when I meet the right one,
> I know that I'll be true.
> My first love will be my last.

He pulled the plug and sat there while the water drained away from him.

> When I give my heart,
> it will be completely,
> or I'll never, never never give my heart.
> And the moment I can feel that
> you feel that way too,
> is when I give my heart to you.

Philippe sighed. It had gone well. It could hardly have gone better; no mess, no noise, no fuss. Kawena would be pleased. The Swiss would be pleased. Philippe had come through unscathed. He hadn't needed the gun.

He finished the drink, climbed out of the bath and dried himself with a thick white towel. He padded across the living room and picked up the stereo's remote control. In a restless world like this is, love is ended before it's begun. He killed the song and went to bed.

A scheduled flight, Zürich to Kinshasa, takes about eight hours. Thomas Manza's very own personal service took barely seven. Down across the wine-dark Mediterranean, on across North Africa. Dawn lifted as they flew clear of the Sahara, although Manza didn't start to come round until they'd crossed the forests of Cameroon and were over Congo-Brazzaville. The first thing he knew was the pain in his arms and shoulders, and he began to groan. The tall Zairois in charge of the flight leaned across to him and slapped his face.

'No trouble', he said. Manza indicated his agreement. The handcuffs were unlocked. The pain in his wrists as the cuffs came free seemed worse than before, but gradually it eased and Manza could start to take notice of the landscape below.

Just after six-thirty they began their descent. Brazzaville rolled by beneath them, then a fat, bulbous expanse of reddish-grey, shining water as they crossed the Zaire at Malebo Pool; finally Kinshasa, patches of bright green, tall office blocks downtown, the wide grey, smoke-grey sprawl.

'You'll see the city soon enough', said the Zairois beside him.

They landed at Ndjili and Manza paused for a moment at the aircraft door to look out across the airport, pale tarmac bright in the early sunshine and the shimmer of aircraft fuel in the air. It was the dry season, and there was a smell of burning scrub from the farmland round about the airport. Then he was hurried down the steps to a waiting black Mercedes. Beside the car stood two huge men in Mobutu suits, abacosts. The suits, of dark cloth, were closely cut, with jackets that

buttoned tightly up the front from the waist almost to the neck. There were little vestigial lapels, almost no collar. Even in the relative cool of morning they looked uncomfortable. Mobutu had introduced them as part of his grand scheme for undoing the colonial inheritance; '*à bas costume*' was the slogan. Down with Western dress, up with a bizarre kind of *authenticité*. Another element in the grand design was to drop European names in favour of the authentic African. The cities were renamed, Kinshasa replaced Leopoldville, the river Congo became the Zaire; everyone had to be reborn, French and Belgian first names disappearing just as Joseph Desiré rose in glory, Mobutu Sese Seko.

The two men squashed Manza between them in the back seat of the Mercedes. The cool, air-conditioned atmosphere was rich with cologne. The car left the airport and followed the wide road into the city, a broad pale track between acres of low, shanty houses.

Twenty minutes later the first concrete buildings appeared. The car turned right off the main road and into the rectilinear grid of the city proper. Manza peered out, hoping to recognise the streets, but they were unfamiliar.

'Where are we?', he asked.

The man on his left replied, a surprising note of deference in his voice. 'Just crossing Avenue Bokassa', he said. A few moments later the car swung to the right again.

Manza was beginning to find his bearings. He inclined his head towards the window. '*La Cité?*' he asked.

The two big men laughed.

The car had slowed in the traffic, and ahead of them was a broad boulevard. As they waited to turn onto it Manza looked out at the crowds pushing along the pavements. He saw that their faces turned away from the car. The two men on either side of him simply stared ahead.

They turned left onto the boulevard and followed it west. Manza saw the Utexco building on his right, just as it had been in the sixties, but across the road from it was a new Mercedes dealership. They drove on, out past Gombé, until they reached a wide, dusty roundabout busy with traffic. On

the left there was an automatic carwash with a Jaguar just emerging, bottle green and still slick with wetness. The stream of traffic paused before filtering onto the roundabout and a group of raggedy children rushed out to wash windscreens, while others approached the drivers with newspapers and fruit. Once again, they left the Mercedes alone.

At Kitambo Magasin they turned towards the river. There was a glimpse of the water then they turned off to the left and began to climb Ngaliema. Manza kept looking out to the right, looking for a sight of the river again, but it was hidden by a belt of trees and parkland with, now and then, glimpses of houses set amongst the trees. The whole park was surrounded by a black-painted steel fence. The tips of the fenceposts were shaped like arrowheads; no fine cast-iron fleur-de-lys, just functional plain steel.

The car pulled over to a gateway. A barrier was raised ahead of them and they drove through into the park.

'*Attention*', said the other man. He pointed to a lion stand-ing in a patch of open ground about fifty metres from the driveway. The two men laughed.

The car pulled up in front of a large, old, white-painted colonial mansion that backed onto the river. The two men climbed out of the car and stood still, patiently waiting for Manza to emerge, which, after a moment, he did. He straightened himself and looked around him. The scene was calm, there was birdsong, and the sound of the water rushing over Kinsuka Falls was carried to them on the breeze. There was a sudden shriek from a peacock somewhere close at hand, then quietness again. Overhead the sky was clear, a soft, pale blue.

Once again, a charade of deference from the two big men. They walked up a flight of stone steps to the building's front door then turned and waited for Manza to follow them. As he approached, one of the men reached across and opened the door for him. He entered the building and found himself in an elegant lobby. He was led along a white-painted corridor into a plain, windowless rectangle of a room. Behind a desk stood another man in a Mobutu suit, a man perhaps fifty-five, sixty

years of age. As Manza entered the room the man rose from his chair. He reached across the desk and shook Manza's hand. 'Good to see you, Thomas', he said, 'Welcome to *la deuxième Cité*'.

Kinshasa is an hour ahead of Paris. The phone woke Philippe at six-thirty, and even through the fog of half-sleep Kawena's harsh voice was unmistakable.

'*Bonjour Philippe*', he said, and laughed as Philippe's blurred voice replied.

'Your package arrived a short time ago', he said. 'It was in excellent condition.'

'Good', said Philippe.

'I'm very pleased with it, Philippe.'

'Good.'

'So is someone else, my friend.'

Philippe was suddenly wide awake.

'He is very pleased with the package, and he is very pleased with you. That should be good news, eh?'

'Of course'.

'He would like to speak with you, to show his appreciation.'

'When?' asked Philippe.

'He didn't say. But, if I were you . . . You can get a flight from Brussels this evening', said Kawena, and the line went dead.

It would give him chance to see Marie and Eric. He hadn't seen his family for three months. He glanced across at the picture on his bedside table.

His brother André had taken it when Eric was barely a year old. Philippe and Marie stood in the shallows of Lake Kivu, each holding one of Eric's hands while the boy kicked his feet in the water. Beside Marie stood Mireille, André's wife, looking down at Eric's smiling face.

It was the last time the family had been together in Bukavu. At the end of that summer Philippe had joined the civil service. Since then there'd been little enough time for Eric and Marie, let alone for the rest of the family. He'd been back to Bukavu once in the last six years, and only managed to get

together with André on a couple of occasions when business had taken them both to Kinshasa at the same time.

Bukavu, a thousand miles east of Kinshasa, and almost five thousand feet above sea level. Kinshasa was rank and sweltering, but Bukavu's air was sweet and temperate. Lake Kivu, with Bukavu on its southern edge, was fed by mountain streams. By day the water of the lake shone blue and the jagged shoreline was dressed in rich green. To the north were volcanoes, their incandescent craters casting a dull pink glow onto the underside of the evening clouds. And the ash from the volcanoes, when it fell into the lake, purified the water. Kivu was the only lake in Central Africa where you could swim without fear of bilharzia.

They'd driven out of the town in the morning, heading north on the metalled road to Goma, past coffee plantations and the lakeside villas that Belgian planters had built back in the thirties. The road ran away from the lake at first, but after Miti it swung back to the east and soon the lake was in sight again. Often, though, the water was far below them, at the foot of sheer cliffs. The road zig-zagged left and right as it worked its way round the steep-sided, fjord-like inlets, and sharp, jutting promontories. From the heights they could look across Ijwi, the island in the centre of the lake, and see through the haze the far shore, the Rwandan side of the lake, twenty miles away.

As Ijwi fell away behind them the road descended towards the lakeside and Philippe turned the car along a rough track that led to the water's edge. It was one of the few places where you could park on level ground and make your way easily into the shallows. It was a place he'd discovered years before, when he first had a car of his own, and he'd often driven out alone just to swim and to be at peace.

André's car pulled to a halt behind them.

They paddled together for a while and André took photographs. Then, as his brother set up the barbecue, Philippe struck out on his own. He swam along the lake shore with smooth, fluent strokes that took him quickly out of sight of the others. He swam until he reckoned that the flames would be leaping up from André's fire. When he finally set foot on

the lakeside again the fire had died down to a bed of glowing embers and there were steaks cooking.

They drove back in the late afternoon, warm and happy, with Eric asleep in Marie's arms and the smell of woodsmoke on their clothes.

The phone rang again. Philippe had packed a change of clothes and an abacost in dark grey silk, and had called a taxi to take him to Charles de Gaulle airport. It was his sister-in-law, Mireille. He hadn't spoken to her for months.

'Philippe, can I talk?' Her voice was abrupt. No pleasantries.

'If you're quick. I'm leaving for the airport any minute. Can it wait? I'm on my way back to Kinshasa. Can we ..'

'It can't wait.'

'OK'.

'My mother rang me. I've just put the phone down. I don't know what to do. I told her I'd talk to you.'

'So talk to me'.

'Do you know a Professor Manza? He's lived in Europe since the sixties. His wife knew my mother, they kept in touch ..'

'I've heard of him'.

'His wife's in a state. They were attacked last night. A gang. They kidnapped her husband.'

'A gang?'

'Well, not a gang. She thinks it was ..'

'She thinks it was Mobutu's men.'

'You're Mobutu's men', Mireille shouted. 'Have you heard anything? I told my mother I'd ask you ..'

'If Security have got him I can't do . . .'

'I know, I know. But you'd know, I don't know. You'd know who could help him.'

'Where did he live?'

'Zürich.'

'And he was picked up last night? Do you know when?'

'I don't know. Late. His wife's beside herself. It's all jumbled.'

Philippe saw the flash of blue-white light and heard Annette Manza's scream.

'So he could be back in Zaire already?', he said.

'I suppose so. Philippe, is there anything she can do?'

He said nothing.

'Philippe!'

His lips were pressed together and pulled back hard against his teeth.

'Please, Philippe'.

'Does she know Vungbo?' he asked.

'Who?'

'Vungbo. He was in the government in . . . I'm not sure, the seventies. He has a nephew in the Ministry of Justice . . . He might be able to call someone.'

'How could she reach him?'

'No way. I can't give you his number. If Vungbo asks about Manza, someone'll want to know who put Madame Manza in touch with him.'

'Philippe! I'm family, but I'm not stupid.'

'OK. OK.'

He took a notebook out of his jacket pocket, flipped through the pages, and read Vungbo's number out to his sister-in-law. He heard the relief in her voice as she thanked him. He put down the phone. A moment later he heard the intercom buzz, and the taxi driver announced his arrival. As the taxi driver spoke, Philippe heard the passing traffic over the intercom, muffled, in the background. It sounded, the noise of traffic, as if the intercom had brought it from a thousand miles away.

Vungbo dialled the number and, on Mont Ngaliema, in an office overlooking the river, Kawena's phone rang. He reached out and picked up the receiver.

'Monsieur Kawena? This is Auguste Vungbo. You remember me?'

'Of course, Monsieur Vungbo. What can I do for you?'

'I've just had a call from a Madame Manza. You may know of her husband. He once ..'

'Of course I remember. We have long memories here. You should know that.'

Vungbo hesitated. He took a deep breath then spoke again.

'Madame Manza is most distressed. It seems her husband has been kidnapped, from their home in Zürich. I wonder if you could ..'

'I'm sorry . . .'

'Do you know where he is?'

'I'm afraid I can't say where the man is.'

'Kawena, please. I'm asking . . . please. If he *is* with you, could you ..?'

Kawena waited, smiling, while Vungbo's silence stretched.

'I'll ask my men if they know what's happened', said Kawena. He pressed a button on the telephone console, putting Vungbo on hold, and then punched in his assistant's extension number.

'Whereabouts is the Professor?' he asked.

'He's just gone to the *abattoir*, patron.'

'Ah', said Kawena, and broke off the call. He reconnected Vungbo.

'I'm afraid, my friend, there's nothing we can do to help.'

'You mean it's too late?' asked Vungbo.

'I'm sorry. Please, though, if there's anything else, at any time, please call.'

Kawena put down the phone. Vungbo, standing in his spacious living room, looked out across the city and towards the river.

3

The sun was overhead and Mbuji-Mayi was hot. In the quiet streets around the college, when a car went by, it left pale orange dust hanging in the lazy air like a vapour. Bertrand Kotosa, wearing cream cotton slacks and a yellow t-shirt, sat on a low, cinderblock wall beside the few steps that led up from the street towards the college building. There were palm trees dotted along the street, and he'd found a patch of shade.

Bertrand was in his mid-twenties. He was neither tall nor short. He was neither skinny nor fat. His body was well-muscled. At a pinch he might have passed for a student, but on closer inspection – no; Rolex, Ray-Bans, labels on the t-shirt and the slacks.

Back in the college building a bell sounded. Several hundred students poured out of the classrooms and into the corridors. Moments later they began to spill out into the street, laughing and shouting, in twos and threes and larger groups that drifted past Bertrand with barely a glance, but a glance nonetheless. There was a little jealousy, perhaps, when they saw the sunglasses and the watch; a little admiration, even, for the firm, athletic body; there was curiosity, since he must be someone's elder brother, someone's boyfriend; someone must know him, and know how he got his money.

Fee Nkama – Fee was short for Philomène – came down the steps with a group of her friends and gave Bertrand a discreet glance. As she passed him he looked straight up at her. He smiled, she grinned and turned away. As she walked on he saw that she limped, though she seemed unperturbed by it, talking confidently to the tall youth who walked alongside her. As the group of students moved down the street, Bertrand stood up. He swatted the dust from the seat of his pants and began to follow them. They entered a student hostel, still laughing and joking together.

Bertrand stopped and leaned against the curving trunk of a palm. He took in the frontage of the building. It was a low,

three-storey structure, built of concrete, unpainted, unfinished. The two upper floors had balconies which jutted out a yard or so from the frontage of the building, giving it a clumsy, top-heavy appearance. There was a central stairwell, with an apartment off to either side on each floor. Six apartments, three or four rooms to each, plus a kitchen, a bathroom.

The hostel sat in the street like a vagabond dog or a broken-down settee, as if it belonged there. Everything shared the same tired, sagging character, the same pocked, pitted, matted surfaces, and over it all the same pale orange dust. There were three roughly-shaped letters set in the wall, standing in relief over the main doorway. They had once been painted scarlet but now they were so chipped and faded and clothed in dust that they were hardly legible. But when you looked you saw that they said 'MPR'. *Mouvement Populaire de la Révolution*: Mobutu's revolution.

Bertrand walked slowly away down the street. A youth stepped out towards him from between two buildings. The two of them paused, then walked on for a few yards. They paused again, and Bertrand handed over a small bundle of notes. They parted, and moments later neither of them was to be seen.

Fee and her friends were in their apartment on the top floor of the hostel. They were in the kitchen. All around the room were wooden poles and rough-cut sheets of cardboard. The tall youth, Kitenge, reached into his bag and took out a tin of blackboard blacking. The top unscrewed to reveal a brush fixed to its underside.

Fee went to the big, battered refrigerator and took out a plastic carton that had once contained palm oil. There was only water in it now, but they'd been fortunate with the electricity, so it was cool water. She gathered up glasses and cups and began to pour water for her friends to drink. Kitenge got busy with the cardboard and the black paint. Gradually, like islands coalescing, the little brushstrokes merged to cover the surface.

Leaning back against the refrigerator, Fee watched Kitenge work. '*Le Gouvernement Tchisekedi doit être*', she proclaimed.

Kitenge chuckled and carried on painting; '*à bas Mobutu*', he muttered, half beneath his breath.

There was silence in the room, then Fee took up the refrain; '*à bas Mobutu*', she called, and everyone laughed.

Kitenge had finished the first placard, but his paint was running out. He poured a little into what remained of his glass of water and watched as the dark cloud billowed out beneath the surface. He gave a brisk stir with the little brush, and immediately the whole glass of water was black.

Jean Mukulu, standing by the door, called across to Fee. 'Have you put the chicken on to cook yet?'

'Have you got yourself a girlfriend yet?' she called back. The room filled with laughter.

'Starvation all round', said Mukulu.

'Mobutu eats well', said Kitenge. There was a murmur of approval for the observation.

'Tchisekedi eats well too', said Mukulu.

They all turned to look at him.

'Well?' he asked. 'Can anyone deny it?'

Fee shook her head. 'Who else is there?'

Pierre Mayele had slipped into the room unnoticed. In the silence which followed Fee's question he asked quietly, 'Who else is still alive?'

When Bertrand reached his office there was a message for him. Kawena had telephoned and wanted Bertrand to call back as soon as possible.

Bertrand switched on the electric fan and stood for a moment beside it, enjoying the cool air. Then he sat at his desk. There was a box of paper tissues. Bertrand took one and wiped the palms of his hands. He threw the crumpled tissue into the basket, picked up the phone, and dialled Kawena's number in Kinshasa. The answer came at the first ring.

'Patron?' said Bertrand.

'Oui!' said Kawena. He sounded impatient, but hadn't recognised Bertrand's voice.

'It's Kotosa. You wanted me to call?'

Kawena's voice softened. 'Bertrand! Thank you, yes, I wanted to talk to you about . . . a mutual friend', he said.

'That would be Etienne?'

'Exactly', said Kawena. 'I gather he's going to pay you a visit, sometime in the next day or two.'

'I think he'll be with us tonight', said Bertrand. 'The students are planning a meeting.'

'It's good that the students take an interest in their country, Bertrand', said Kawena.

'Of course, patron.'

'They are the future of Zaire', said Kawena.

'Of course', said Bertrand.

'To encourage the students, that too is to build the new Zaire', said Kawena.

'Yes', said Bertrand.

'I always used to say to Philippe', Kawena paused, 'that nothing was more important than the healthy development of student minds.'

'Aha', said Bertrand.

'Bertrand?'

'Yes, patron?'

'Nothing is more dangerous, Bertrand, than a student who is led . . . whose enthusiasm is channelled into . . . unproductive . . .'

'Disputes?' said Bertrand.

'Exactly, Bertrand', said Kawena. 'Well done.'

'Thank you', said Bertrand, and dabbed at his brow with a tissue.

'Oh, and about Etienne', said Kawena.

'Aha?' said Bertrand.

'We wouldn't want Etienne to be caught up in . . . local difficulties, would we?'

'No', said Bertrand.

'So you'll look after Etienne. And the students?'

'I went to look at the college this morning.'

'Good', said Kawena.

Bertrand took a deep breath.

'Bertrand?' said Kawena.

'It's good to know that you're . . . doing such a good job', said Kawena. 'It's been good to talk to you. You must keep in touch. Tell me how things go, eh?'

'Thank you, patron', said Bertrand. 'I'll call you again tomorrow?'

'I'll look forward to it, my friend', said Kawena.

Bertrand heard the connection break. He reached out and took a tissue from the box. He wiped his forehead and his neck and threw the damp tissue into the basket. He reached for another. It was when he went to wipe the palms of his hands that he realised the telephone receiver was still in his left hand, that his fingers were locked around the hard white plastic like a dog's teeth bearing down on the bone.

Early evening. On the top floor of the hostel Fee and her friends were eating. One after another they dipped their hands in the bowl of sticky white cassava and took out a mouthful. Tonight they were lucky, since Paul Kitenge's brother had visited in the afternoon and brought them round a crate of Coke. Only Pierre had missed out. He'd had to make an early start, he'd said; he had an evening job at a restaurant. 'Mayele', said Fee, and laughed. Mayele, his name, meant 'wisdom', and once again Pierre's rather serious, sensible attitude had cost him good fortune.

The placards, half a dozen, stood against the wall. The students had argued for a long time over the slogans. Some called for Mobutu to set a date for free elections, some called for Tchisekedi to be Prime Minister. Some bore the initials of Tchisekedi's party, the UDPS, though none of the students in the hostel were members.

There were no ethnic slogans. Like many of the students in Mbuji-Mayi — like many of the people of Kasai — Fee and her friends were Luba. For years there'd been a call for a Luba state in the south-east of the country. In the last century the Luba kingdom had rivalled the great Kongo confederacy which stretched through the coastal regions of Angola, Zaire, and Congo-Brazzaville. No-one seriously expected to see the ancient kingdoms rise again across the borders of the nations,

but to break away from the rest of Zaire was possible. The Luba in Kasai would claim the region's huge diamond deposits, and their brothers in the neighbouring province of Shaba, as Katanga had been renamed, would claim the copper and the cobalt. With support from neighbouring Zambia, itself with a big Luba population and with its own diamond fields, an independent Kasai was a real hope for many Luba; for people who, in the Triumphant Warrior-Guide's Great Nation, had little other cause for hope.

Fee and her friends were quiet as they ate. Beyond the kitchen's unglazed window the street was still bright, but the harsh brilliance of midday had passed. The Coke bottles, straight from the fridge, were misty with coolness.

The men arrived in four unmarked cars that drove slowly along the street, turning the quietness of early evening into taut silence. The cars stopped in front of the hostel and the men climbed out. They were dressed head to foot in black, with brightly coloured ski-masks concealing their faces. Two men stood below the balconies in case anyone should jump. Two more men went through the building and out into the bare concrete yard to its rear. The rest of them spread out inside the building, going two at a time into each apartment. Some carried bayonets, all of them wore at their waists a casual looking arrangement, a cordelette made out of climbing rope, with a mousqueton in place of a buckle, a karabiner, a light, snap-lock steel loop.

Bertrand, barging into Fee's apartment, saw the Coke bottles. He picked up an empty bottle and smashed it against the edge of the table. He grabbed Jean Mukulu by his shirt and slammed him back against the wall. He set the jagged edge of the bottle at the side of Mukulu's throat and pushed hard. The blood spurted out in an arc over the table, spattering into the last of the white cassava which sat there, dumb in the pot, while Mukulu tried to pull away from the jagged glass.

Paul Kitenge had leapt towards the window as soon as Bertrand entered the room. He'd understood what was going on as soon as he heard the first screams coming from apartments lower down the building. He landed badly on the hard-

packed ground below and felt a searing pain in his right leg. He struggled to stand, but was caught before he could drag himself to his feet. The man aimed a powerful kick at Paul's head and the student's neck cracked. To make sure, the man knelt and drove his bayonet into Paul's back, tearing into the flesh and ripping it open, the blade grating on bone. Paul's blood flooded out as if someone had turned on a tap. His legs twitched but he was already dead. The man stepped away from the widening pool of blood. He stooped and wiped the blade of his bayonet on the seat of Paul's pants. Someone else had jumped in the time he'd been dealing with Paul. It was a girl, and she too had fallen badly.

Fee was the only one left alive in the kitchen. She was on the floor, pushing herself back into the corner of the room as if she thought she could escape into the wall itself, as if she could lose herself in the wall's inanimate bulk. Bertrand's colleague caught her ankles and dragged her out, kicking and skidding on the slick of blood, into the middle of the room. The man crouched over her and slapped her hard across the face. He took his knife and ripped open the front of her shirt, then hacked through the waistband of her skirt. He ripped the skirt open and cut down through the waistband of her pants, cutting through the thin cotton and slicing into her flesh. She threw back her head and cried 'No-o, No-oooooo!', so he hit her again across the face, but then he felt Bertrand's boot prodding him.

'Just kill her', said Bertrand. Fee looked up at him, her eyes wide.

'Please', she cried. 'Please!'

Bertrand remembered the smile he'd seen on her face earlier that day. He glanced at the slick of blood across her thighs.

'Hurry up', he said.

Bertrand crossed to the other apartment on the upper floor. Everything was in order. He looked out of one of the bedroom windows into the yard at the rear of the building. There were three students lying there in awkward, twisted positions.

He went down the stairs to the next floor. The men were finished there too. All in all it had been a very noisy business,

and messy. Bertrand looked down at his clothes, the black of his shirt glistening. The men were gathering round him, looking for instructions.

'Get the shovels', he said, and walked out to the rear of the building. Beyond the concrete was a piece of dry ground with weeds and low scrub growing, and with patches of bare earth showing through. Bertrand directed the digging, a shallow pit seven or eight feet wide and about twice as long. It took them half an hour to dig it, and all that time the street was silent.

When the pit was dug, Bertrand gave the order for his men to collect the bodies. He went out to his car as they worked.

The street was still silent. Even beyond the street, the sounds of the city seemed to have vanished, as if the shock and fear were travelling outward from the hostel like the shock waves of an explosion.

There was a muffled bang. Bertrand turned. His men had thrown one of the bodies down into the street; it was easier than dragging them along the corridors and down the stairs. Having cottoned on to the trick, the others were doing the same. Bertrand watched as one body after another thumped down into the street. Then the men came out of the apartments, and he heard them laughing and shouting to each other as they clattered down the stairs and spilled out into the street. They began to drag the bodies through the ground floor of the hostel and out to the back.

Bertrand opened the car boot where there were two large cans of kerosene. He shouted to one of the men to help him and, each of them struggling with one heavy can, they made their way to the pit.

Minutes later, as the lighted match met the kerosene, there came a thump of flame that leapt the length of the pit. But news of the events, leaking silently from the street, had already reached Tchisekedi's hotel. The flames had barely begun to die down when his plane lifted off from the city's airstrip.

4

Brussels is one of the biggest airports in the world. Big and ugly; acres, hectares, square kilometres of a spewed mess of raw building site and half-cannibalised industrial park. It seems permanently to be dismantling and reconstructing itself, like a huge ocean liner refitting from the keel up on a rough day in mid-Atlantic; all around it trails an archipelago of barren, floating landlocked dockland, overhead a heavy overcast.

The bus from the aircraft into the terminal buildings was crowded as usual, and Philippe had to stand for the long ride in. Once off the bus, he walked slowly through the bustle of travellers and up to the shopping mall. He spent an age strolling among the glazed caravanserai of shops and finally bought a bracelet for Marie, a light gold hoop set all around its circumference with small diamonds. For Eric he tracked down a handheld computer game, and played it himself to while away an hour or so of the time before the flight to Kinshasa. As the aircraft lifted up into the evening sky he slipped his hand into his jacket pocket. He felt the box in which the bracelet lay and saw in his mind's eye the circle of diamonds, hidden in the darkness like blind stars.

The flight landed at Ndjili just before four in the morning. Philippe had changed into his abacost on the plane. He sat back in the rear of the Mercedes and tried to relax as the car left the airport and turned away from the city, heading east on the broad highway.

It was half an hour to the turn-off for Nsele and a two-mile drive into the thousand-acre site before the white-stuccoed palace emerged from the darkness. Low-set security lights splashed their beams upwards onto the walls, leaving a low swathe of darkness at the foot of each wall so that the palace and its retinue of villas seemed to float above the ground. The black Mercedes drove on through the complex, past the house where Ali had stayed for the Foreman fight in 1975, close to the river bank. They drove up beside the President's yacht, the

29

Kamanyola. It was a tall, three-storey boat, a rebuilt colonial steamer with a broad deck at the rear where a military helicopter sat. The whole spectacle, boat, quayside, helicopter, was doused in multi-coloured light. Philippe, who had been dozing in the car as they drove out from the airport, woke up as the car came to a halt.

'*Awa?*' asked Philippe. Have we arrived?

The driver nodded. '*Boye, Patron.*'

Philippe got out of the car and walked across to the quay. The boat looked deserted. He could hear the river slapping against the quayside, against the boat, and he could sense, by the absence of sound beyond, the vast expanse of Malebo pool stretching out into the distance.

He walked across the gangway and onto the boat. There was still no sign of life. He looked back at the Mercedes. The driver had switched on the interior light and settled down to read a newspaper. Philippe turned and entered the reception room on the lower deck. The lights were on, but the chairs, gilt-framed and over-upholstered in red brocade, were carelessly stacked back against the walls. He walked through to a suite of smaller rooms and there, sitting in a generous armchair and with a drink in his hand, was Kawena.

'How was your flight?' asked Kawena.

'Fine', said Philippe, looking around the room.

'The president can't be with us, I'm afraid', said Kawena. Philippe didn't reply.

The president could be with us, or the president couldn't. The president had never had the slightest intention of meeting Philippe. Or the president had meant to meet Philippe, but then he'd seen a film clip on his satellite TV and decided to fly through to Europe to watch the film the same evening. Right now he was asleep in his residence on the Avenue Foch, ten minutes' walk from Philippe's Paris apartment and Kawena was trying on the president's clothes with no-one around to see. Or maybe Mobutu was watching from the next room through a two-way mirror.

Kawena stood and went over to a side table where coffee

and sandwiches were ready. He took a plate and filled it, handing the food to Philippe. Then he poured coffee.

'Two sugars, milk rather than cream', he said, and passed the cup to Philippe. He returned to his chair and gestured to Philippe to sit beside him.

'I have another . . . favour to ask of you', said Kawena.

Philippe's face was expressionless.

'A small problem. Not unlike the last one you ..'

Kawena unbuttoned the jacket of his Mobutu suit and took from an inner pocket a small photograph. He held out the photograph to Philippe, who took it delicately by its edge. It was a portrait, a graduation photograph; a young man wearing an academic gown with a scarlet hood, a mortar board perched on his head.

'It's a fairly recent photograph', said Kawena. 'The young man's in England at the moment. We understand that he . . . has been acting unwisely.'

'What's his name?'

'His name's part of the problem. It's Lumumba.'

Philippe glanced at Kawena, eyebrows raised. He looked down at the photograph again.

'A relative?' asked Philippe.

'It's not an especially common name.'

'You said that was part of the problem?' said Philippe.

'The other part is the British authorities', said Kawena. 'They aren't willing to extend us the same . . . courtesies as our Swiss colleagues. It's not that they object to our point of view. They say they can't guarantee the . . . discretion, that we'd require. The whole process will have to be completed within Britain. It will call for a degree of improvisation.'

'The president asked me to do this?'

Kawena smiled.

'Asked particularly for me?'

'Think of it as an honour, Philippe.'

'For the glorious revolution.'

Kawena laughed. 'Every revolution needs its martyrs.'

Philippe managed to smile. At the college in Cairo they talked all the time about Mickey Mouse; kept drawing the

diagram, big round face, two enormous ears, eyes like huge saucers. Listen and look. But they drew the mouth small as a full stop; shrink it, shrink it almost to nothing, close it down like the pupil of the eye in bright, bright light, quick, instinct-ive, shut. Philippe smiled, but his lips were closed and Kawena saw it. Philippe handed the photograph back to Kawena and took a drink of coffee. He set the cup down.

'I'll need a new ID', said Philippe.

'No problem', said Kawena.

'Give me a couple of days', said Philippe. 'I'll spend a couple of days with Marie and Eric, then I'll fly to London. I'll find somewhere; the less contact with the embassy the better. When I have an address, I'll let you know, you can send me the ID.'

Kawena shook his head.

'I'm sorry, my friend', he said. 'The president wants you to fly out in the morning. You can fly to Paris first, there's a flight at eight. But, fly on to London as soon as you can, OK?'

It might be the president's wish.

'Here', said Kawena, and passed Philippe a slip of plastic like a credit card. Philippe nodded and dropped it into his pocket.

'The driver will take you back to the airport. You can phone Marie from there.'

'I have presents for them.'

'The driver will take them.'

'Yes. Exactly. The driver will take them.'

'Philippe, trust me. The driver will deliver them. He's a good man.'

Philippe gazed for a moment at Kawena's face. Kawena smiled.

'You haven't eaten your food. Come on, eat up. It beats airport food', and Kawena laughed again, but the laugh didn't reach his eyes.

As they cruised down the highway in the black Mercedes, Philippe flipped through the file Kawena had given him. Then he closed the folder and looked out at the dawn. The airport buildings came into view on their right and the

driver slowed for the turn. Philippe leaned forward and saw the man's shoulders stiffen. He spoke quietly, almost into the man's ear.

'Drive on', he said.

The driver pulled over to the side of the road. He looked in his mirror.

'Kawena said take you to the airport', he said.

'And here we are. Now I'm telling you to drive on.'

'If Kawena finds out I didn't leave you at the airport . . .'

'Kawena will find out. You should think instead what will happen if you don't drive me into the city.'

'Please', said the man. 'Please. No, don't make me. Kawena will kill me.'

'Don't be foolish', said Philippe. 'Kawena wouldn't kill you for that', and he laughed. 'Besides, I'll speak to Kawena and tell him how well you obeyed me. It's all right. Trust me.'

The man drove on. They entered the city and drove along the Boulevard du 30. Juin. They passed the Avenue Kasavubu on the left, and on the right, Avenue Bandundu. Avenue Bandundu leads to the ONATRA offices where you can book a place on one of the big river boats, the infamous floating townships that plough upriver to Kisangani; huge river boats with half a dozen flat steel barges strapped to their bows and, tethered to the barges, reaching out into the river like so many slim fingers, as many as thirty long pirogues.

The car passed on down the wide, wide boulevard, on to Kitambo Magasin. The driver glanced off to the right, towards the river, but Philippe told him to go straight ahead. The car turned off, eventually, into the leafy suburb of Binza Ma Campagne where Marie and Eric lay sleeping peacefully.

Philippe had the car draw up some fifty yards short of the house. He let himself in through the gate. He climbed the wooden stairway that led from the garden up to the verandah and he paused at the top to listen. Everything was quiet. He walked to the bedroom door and he laid the bracelet on the boards just outside it. Next door was Eric's room. The door was ajar. Philippe eased it open without a sound and stepped into the room. Eric lay peacefully on the bed, a single sheet

over him. Philippe knelt beside his son. He listened to the child's soft breathing and saw the rise and fall of his chest beneath the sheet. He stretched out his hand and, ever so gently, he brushed the child's dark curls. Then he laid the present on the bedside table and as silently as he'd entered, he left.

'Just a couple more stops', he said to the driver, back in the black Mercedes, 'then you can take me to Ndjili.'

5

It was July 1960, and the TV pictures were in black and white. Eisenhower was President but the election was only four months away. July 1960, and people called the city Leopoldville, not Kinshasa.

Saturday, July 9th
As Manza strolled towards the Hotel Memling he saw a fat red cadillac, roof down, draw up at the kerb. At the same moment Moise Tshombe strode out of the hotel. Tshombe shouted at the driver of the car, who rapidly got out and opened the rear door. Tshombe climbed awkwardly into the rear seat of the cadillac.

Manza called out, 'Moise!'

Tshombe turned towards him. 'Thomas', he called. 'My dear Thomas, where have you been?'

'I didn't know you were still in Leo', said Manza. 'I thought you'd have flown down to Katanga by now.'

'I did', said Tshombe. 'And then I flew back to Leo to see Patrice. But he won't see me. Listen, I spent the whole of yesterday at his residence, and no-one in his office would let me in to see him. Why?'

'Moise, Patrice was ..'

'I'll tell you, Thomas. There are two possibilities. Either he was refusing to see me, or his staff didn't want him to hear what I had to say.'

Manza laid his hand on the car door. 'Listen, Moise', he said. But Tshombe wouldn't.

'Thomas. I came specially to see him. What I have to say is vital for the unity of the Congo. I'm the president of my province, for heaven's sake ..'

'Moise, Moise. Patrice wasn't even in his residence yesterday. The Council met at Camp Leopold. How could he see you when he wasn't there?'

Tshombe stared at Manza with contempt.

'He could have made time to see me. His staff could have told me where he was. I would have gone to him.'

Manza smiled at the improbable thought of Tshombe trailing meekly after Lumumba.

'Why is it so urgent, Moise?' he asked.

'I'm going back to Katanga', said Tshombe. 'You can tell Lumumba for me. He'll be sorry he ignored me.' Tshombe patted the driver's shoulder and the car pulled away. Manza stood and watched the cadillac into the distance.

It took Tshombe's aircraft four hours for the thousand-mile flight from Leo down to Elizabethville, Katanga's provincial capital. Luluabourg, the capital of Kasai province, was almost exactly half-way.

In Luluabourg, Monique Ryckmans was feeding her two-month old son when the Congolese soldiers, four of them, kicked down her front door.

'We are in charge now!', shouted their leader. Monique stared at him. The baby pulled away from her breast. The leader, a tall, thin man, laughed.

'Get out! Get out!' she screamed, and the baby started to cry. She grabbed at her dress, covering herself.

The soldiers slowly levelled their rifles at her, each with a bayonet. The blades gleamed silvery-grey.

'Please! Please, no', she said. Her voice was lowered. She held the baby close. The child stopped crying.

'We won't hurt the child', said the tall Congolese. 'Put him in his crib.'

Monique stood. She backed out of the sitting room and along the corridor to their bedroom. The bayonets followed. Feeling behind her, she found the door handle and turned it. The four soldiers followed her into the room and watched as she laid the child in the cot.

'Now strip', said the soldier.

She turned towards the bed and, with her back to the Congolese, she let her hands fall to her sides. Her dress, unbuttoned at the top where she'd been feeding the child, fell open.

'Strip!', shouted the soldier. She glanced across at the cot,

then began to undo the rest of the buttons that ran down the front of her dress. She slipped the dress off and stood with it puddled around her ankles. Once again, she stood still, her hands by her sides, her head bowed. Behind her she heard the four soldiers quietly laying down their weapons. She looked back at them over her shoulder.

'Please', she said. 'Isn't that enough?'

There was a peculiar stillness in the room. The Congolese soldiers smiled at the woman and shook their heads. She unhooked her bra and heard the soldiers laugh as she dropped it on the floor beside her. She peeled down her pants and stepped carefully out of them.

'Now, please, will you leave me?', she asked.

Once, a couple of years ago, a group of drunken soldiers had broken into a European's house. They'd made the woman strip. Then they'd just stood and looked at her. Then they'd gone.

The stillness in the room was broken. They grabbed her and threw her onto the bed.

When her husband found her she was sitting naked on the floor, holding the child, rocking backwards and forwards. She wouldn't let go of the child, nor would she answer her husband's questions. Eventually he wrapped blankets round both Monique and the child and led them out to the car.

The Immokasai building in the centre of Luluabourg was packed with Europeans. There were officials of the mining companies and their families, there were the families of Belgian officers, together with assorted freelance professionals. Among them was a doctor, with two white nurses and three African nursing assistants who had decided they were safer with the Europeans. The medics cleared two of the larger offices and turned them into a hospital area, one for the women, the other for the men. There were both men and women who had been badly beaten, and some had been cut with bayonets and machetes, but no-one had been killed.

Most of the men had brought hunting rifles with them. Ryckmans had taken a stack of rifles with him from the camp,

and several cases of ammunition. Hendricks, a *Force Publique* captain, took charge. He set up positions on the upper floor of the building, on all four corners, with separate guards at the main and side doors. There was still power, and as evening fell they darkened the building but flooded the compound with light, trying to maintain a lit perimeter. Already, on the open ground surrounding the building, a handful of Africans lay dead.

Hendricks made Ryckmans his second in command.

'I want you to go round the building every hour', said Hendricks, 'and bring me any news from the firing positions.'

Ryckmans gave a quick salute.

'And tell the radio operator I want a report every hour, too', said Hendricks. 'But for God's sake, make sure he doesn't tell anyone else what he hears.'

Ryckmans set off on his tour of the building. In every room there were people crouching on the floor, below the level of the windows. Every few minutes a burst of rifle fire would ring out, glass splashing down into the rooms, and from somewhere on the upper floor there would be a volley in reply.

Every hour Ryckmans knocked on the hospital door and asked the nurse about his wife and child. Every hour he heard the same, the child was fine, but Monique wouldn't say a word. Every time, the nurse closed the door gently on Ryckman's staring face.

He was with Hendricks when the telephone rang. They were on the ground floor, sitting in half-light behind the reception desk where the telephone switchboard was situated. Ryckmans picked up the receiver.

'It's Matté', he said. 'From Elizabethville!'

'The lines aren't down! Ye Gods', said Hendricks. 'Give me it here.' Ryckmans passed him the telephone.

'André, how are things with you?' he asked.

Ryckmans tried to make out what Matté was saying, but it was impossible. Suddenly a dozen rounds from an automatic weapon clattered into the office. As the first round came in, Hendricks held up the receiver, as if inviting the bullets to speak.

'You hear that?' he shouted down the line. 'It's being going on like that for the last three hours.'

Hendricks passed the telephone back to Ryckmans.

'It sounds as if they're in the same boat', said Hendricks. 'They can't get through to Kamina, either.'

'At least they'll have heard what the wogs are saying', said Ryckmans.

Weber, the radio operator, crawled into the room.

'They've rioted in Matadi and Thysville', he said.

'Shit', said Hendricks, 'The whole fucking country.'

'Lumumba', said Ryckmans.

'Janssens, more like', said Hendricks. 'Did you ever hear anything as stupid, "Before Independence equals After Independence", what the fuck did he expect?'

'Do you want me to go on air?' asked Weber.

'For heaven's sake, no', said Hendricks. 'Don't make a sound.'

An hour later the firing seemd to have died down. Ryckmans was back with Hendricks when they heard an African voice, over a loudhailer, addressing the building.

'Mukenge?' said Ryckmans. Barthélémy Mukenge was the provincial president.

'I am going to approach the main entrance', said the voice.

Ryckmans and Hendricks looked at each other, their eyebrows raised in surprise.

'I want to negotiate with you', said the voice. 'I am coming on my own. I am unarmed. Is Captain Hendricks with you?'

Ryckmans crawled across to the window. He raised his head and looked out.

'It is Mukenge', he whispered to Hendricks. 'He's on his own'.

The black man was standing alone in the glare from the compound lights.

'I'm in here', shouted Hendricks. 'What do you want?'

'I want to talk to you. I want all this to stop.'

'Tell the soldiers to go back to camp, then', shouted Hendricks.

'They say they won't go back unless the Belgian officers

give their places to Africans', called Mukenge. He was standing just yards away from the window. He held the loudhailer at his side and his voice sounded as clear as if he were in the room with them.

Hendricks stood and made his way to the main entrance. Mukenge moved hesitantly towards him, then paused, and saluted. Hendricks returned the salute. The two men shook hands.

'Can I come into the building?' asked Mukenge. Hendricks agreed. They went inside and joined Ryckmans.

'This is Lieutenant Ryckmans', said Hendricks. Mukenge bowed his head politely.

'Lieutenant Ryckmans has a wife', said Hendricks. 'This afternoon she was raped by your men'. Ryckmans glared at the black man.

'They are not my men', said Mukenge. 'They are your men. That is the problem. They believe you have no intention of letting the command pass over to Africans. They believe you have no intention of leaving our country.'

'*Our* country?' shouted Ryckmans. 'Who made this fucking place a country in the first place!'

'Lieutenant Ryckmans', said Hendricks. Ryckmans stamped out of the room, the broken glass crunching beneath his boots. He marched to the hospital area and knocked impatiently on the door to the women's room. A black nurse opened the door. Recognising him, she led him gently across the room to where his wife lay sleeping.

'I'm very sorry, Mr Ryckmans', said the nurse. Something in her voice made him turn to look at her. She was weeping. As Ryckmans watched, she began to sob. She was shaking. He laid his hand on her shoulder and they stood side by side.

When he got back to Hendricks, Mukenge was gone. Hendricks looked up as Ryckmans entered, and shook his head sadly from side to side.

Sunday, July 10th
At dawn the firing began again, and as the light strengthened, so the exchange of gunfire grew heavier. Then there was a

sudden lull, and Weber dashed along the corridor from the radio room.

'It's Elizabethville', he shouted. 'The paras went in at first light. They've got the airport, and the army camp, the whole place!'

Hendricks' face fell. 'Who did they use?' he asked.

'One para', said Weber. 'Why? What's the matter?'

'Why the hell aren't they here? That's what's the bloody matter!'

Hendricks looked up and saw Weber's crestfallen face.

'I'm sorry', said Hendricks. 'It's not your fault. Keep listening.'

A heavy machine gun opened up from outside and Weber hit the floor. The 20mm bullets tore through the cinderblock walls. On the upper floor the first Belgian died, his head burst open like a fruit. On the ground floor, Hendricks lay amid the debris wondering how much longer they could hold out. One para were based at Kamina; from there it was three hundred miles to Elizabethville, or, in the opposite direction, two hundred miles to Luluabourg. They had evidently made their choice. And if Hendricks realised what that meant, so did the Congolese outside.

Lumumba looked round his office. He'd asked his assistant the night before to see to the mess the soldiers had left behind. They'd stormed in, throwing papers and folders around and demanding that he sack Janssens. It was lucky for Lumumba that he hadn't been there himself; there'd been as many threats against Lumumba as against the Belgian general. Then the soldiers had apparently stormed across to the presidential building and terrified Kasavubu, demanding that he sack both Janssens and Lumumba.

Lumumba raised his voice. 'Why is my secretary never here when I need him', he called. He heard footsteps approaching.

'Patron?'

Lumumba turned and looked at the man.

'Damien, why has this place not been cleaned up?'

'Patron, I'm sorry. They promised me they would do it.'

'Who is "they"?' asked Lumumba, but Damien had hung his head in shame.

The telephone rang. It was Antoine Gizenga, Lumumba's deputy Prime Minister.

'Patrice, have you heard? The Belgians have landed at Elizabethville.'

Lumumba slammed the phone down. A moment later it rang again.

'Patrice? Patrice, listen ..'

'Why have they invaded?' asked Lumumba.

'Tshombe must have invited them.'

'He has no authority.'

'I know that', said Gizenga.

'Has he seceded, then?' asked Lumumba.

'I don't think so.'

'We can arrest him!'

'He's surrounded by Belgians. They won't let us near him.'

'Where's Kasavubu?' asked Lumumba.

'He's talking with his Abako people'.

'What for? Is he talking to the Belgians too? Is he taking the Bakongo out as well?'

'He says he's talked to Wigny and demanded that the Belgians withdraw their troops and apologise!' Wigny was the Belgian Foreign Minister, safe behind a desk in Brussels.

'Well thank God for that', said Lumumba. 'Where is Kasa exactly?'

'Presidential palace', said Gizenga.

'Meet me there', said Lumumba. He put the phone down and walked quickly out of the office.

That evening, as the light fell, two companies of Belgian paratroopers were dropped north-east of Luluabourg. They moved in to the airport and after a quarter of an hour they'd secured it. They moved on to the army camp, where a dozen Belgian officers had been held at gunpoint, and from there they moved into the town. An hour after they jumped, Luluabourg was secure and the siege of the Immokasai building had been lifted.

They were still celebrating when Weber picked up a broadcast from Leopoldville. It was on the public frequency. In offices throughout the building, Europeans gathered round to listen. After a few words of introduction, they heard Lumumba's voice.

'We have just learned', it said, 'that the Belgian government has sent troops to the Congo and that they have intervened.'

A huge cheer went up from the building; the rescued Europeans danced and hugged the paratroopers. Lumumba's next two sentences were drowned out.

'We appeal to all Congolese', he continued, 'to defend our Republic against those who threaten it.'

The building fell silent. Hendricks felt a hand on his shoulder, and turned to see Weber standing beside him. Weber whispered to him, 'Lumumba's coming tomorrow.'

Monday, July 11th

Lumumba and Kasavubu landed at midday. They were met by Mukenge, together with Hendricks and the paratroop commander. An honour guard of Congolese soldiers from the *Force Publique* stood to attention, and opposite them stood an equal number of Belgian paratroopers. Each detachment presented arms while the President and the Prime Minister of the Congo walked along the ranks. Only the Belgians' rifles, however, were loaded.

Lumumba and Kasavubu followed the red carpet towards the airport building. Inside the building a lounge had been laid out for lunch. Lumumba and Kasavubu, together with Mukenge, were seated at the top table, and at the same table were the heads of the major corporations which still held mineral concessions for the Kasai.

Lumumba stood to address the company. He looked around the room and on every side white faces stared back at him.

'We are no longer your *macaques!*' he shouted. The whole room froze.

'We have experienced contempt, insults and blows, morning noon and night, because we were "blacks". A black man

was always called *tu*, not because he was a friend, but because only the whites were given the honour of being called *vous*.'

Hendricks stared down at his hands, which were hidden from view below the level of the table top. His fists were clenched.

'But now', said Lumumba, his voice rising, 'Now the Republic of the Congo has been proclaimed, and our land is in the hands of her own children!' He turned to glare at the officials from Forminière, the huge forestry and mining company.

'We shall take care that the soil of our country really provides for the good of her children.'

He paused, and around the room whispering and muttering began.

'Silence!' he shouted.

'From now on your country and ours will meet as two equal and independent countries. If you stay to help us build the future, you will stay because we consent to it. You will exercise your responsibilities in accordance with *our* wishes.'

Then, as if he'd spat it out together with the words, the fury seemed to leave Lumumba.

'Belgium', he said, 'has signed a treaty of friendship with the new Congo. I ask you for your co-operation, and I ask it secure in the knowledge that such co-operation can only benefit both our countries. For our part, we shall respect the engagements into which we have freely entered. I ask you to do the same.'

He sat down, and handclapping, like sporadic gunfire, broke out around the room. After the first hesitant moments the applause gathered strength. As it died away the black waitresses moved into the room to serve the first course, and Mukenge touched Lumumba on the arm.

'Patrice?' he said. Lumumba turned to him.

'It was as well that the Belgians came, Patrice. The fighting brought us nothing but death. Hendricks means well. Go easy on him.'

That evening, obeying his Belgian supporters, Tshombe broadcast from Elizabethville. 'The government of Katanga',

he said, 'has determined to proclaim the independence of Katanga. That independence is total.' He called on the world to recognise the new state, and he begged the European residents to join Katanga 'in close economic community'.

The same evening Pierre Wigny, the Belgian Foreign Minister, sent a telex to his embassies around the world. 'Whatever you do', it said, 'make sure that no-one recognises Katanga.'

6

Philippe arrived back in Paris that evening. His apartment seemed undisturbed. The answerphone had nothing to say. He walked across to the stereo and picked up the remote. The power was still on, the CD was still in the player. Philippe hit the button for random track selection. The machine came up with 'Wonderful World'. He went through into the bedroom, changed out of his abacost and showered. Even the drenching spray of hot water seemed hardly able to wash him clean. When he was dry he stood in the bedroom and looked down at the silk suit, lying discarded on his bed. He picked it up; it smelled of Kinshasa. He threw the suit aside.

He spent the night in his apartment. He woke early. The morning was grey and cold. A gust of wind dashed rain against the window.

He washed and shaved. The blade stripped the last of the foam from his face. He rinsed the razor beneath the tap and towelled himself dry. Then he paused and studied his face in the mirror.

He packed a suitcase and called a taxi to take him to the airport. As the cab headed out through the traffic to Orly, a silver-grey Mercedes followed.

They drew in at the entrance to the terminal. Philippe paid the driver. The grey Mercedes stopped fifty yards short of the taxi and a black man in his mid-twenties emerged. He followed Philippe into the terminal and watched from a distance as Philippe approached the Air France check-in desks. Moments later, as Philippe headed for the departure lounge, the black man rejoined his colleague in the Mercedes. Using the carphone they called Kinshasa.

Kawena answered.

'He's checked in', said the man in the Mercedes.

'To Heathrow?' asked Kawena.

The young man smiled. 'Frankfurt.'

<div align="center">★</div>

The aircraft broke out into the clear sky above the cloud and the cabin was filled with warm, clear light. Philippe reached into his jacket and took out his wallet. Opening it, he gazed again at the snapshot of his family, at the figures paddling in the shallows and at the open water beyond them. André had been standing on the lakeside, looking offshore; he should have got closer so the people were bigger in the picture. As it was, much of the image was taken up with the lake itself, shining blue-grey water, stretching out into the hazy distance. The lake was so deep out there that no-one had ever been able to measure its depth.

They boasted, in Bukavu, how safe the lake was; no bil-harzia, the water a degree or so too cool for hippopotamus, but to venture out far from shore, they all knew, was unwise.

There were storms for one thing. The wind could rise in a matter of minutes, and a heavy rain could cut down visibility as effectively as thick fog. On a lake that size, fifty or sixty miles long, twenty wide, you could get waves as big as ocean waves. There were plenty of people who, caught out far from shore when a storm blew up, had never made it home. But there was another danger, less definite, that was spoken about only in whispers. It was as if something in the climate round about the lake gave rise to dreams; as if dreams were the means whereby, even as children, people learned what to fear. Then, when Philippe was still a child, he'd gone swimming in the lake with a friend and the friend had just disappeared. Stories had surfaced for a time, about something living in the deep water, something which would strike upwards to the surface and draw the swimmer down.

One morning, Philippe was about nineteen, he'd driven out on his own to the place where, several years later, the family would go for their barbecue. There was fine sunshine after a heavy, early shower. The twisting road led him along the lake which, with the sun still low, flashed like polished chrome whenever the road curved to the east. The forest by the road still glistened from the rain, leaves slicked wet, juicy greens punctuated now and then by the scarlet flowers of flame trees.

He stopped the car beside the water and sat for a moment, just listening. A sunbird flew out from the forest and perched on the side of the car, only a yard away from him. Its feathers were black except for a red breast with a sheen on it like a dark jewel. He looked at the bird and, fearlessly, the bird stared back at him. A moment later and without a sound the bird flew away out of sight.

Philippe undressed and walked to the lake's edge. The water, clear as he stepped into it, was suddenly cloudy with the fine silt that his feet disturbed. The darkness boiled up from the lake bed like a storm in miniature. He waded until the water reached his waist then he struck out with a smooth, relaxed stroke, away from the shore.

A couple of hundred yards out he turned and floated on his back. He kicked gently, treading water, and looked up at the clear blue sky. He could hear only the lapping of the water, and see only the bright heavens above. Every human encumbrance, family, possessions, the daily routine, had simply washed away; only the elemental things remained, water, clean sunlit air, his own skin, muscle and bone.

He turned again and began to swim back to the shore, to his clothes, to his car, and the drive home. He was still some distance out when the headache struck him like a huge wave risen from nowhere and breaking over him. His muscles tightened into spasm; he screwed his eyes tight shut, as if he could block the pain by shutting out the light, and the water opened out beneath him, as if a space had opened deep below and the surface water were rushing down, carrying him down like a leaf in the swirling flow.

He kicked out. He wanted to kick away from whatever it was that held him, that was drawing him down into the darkness. His head broke the surface of the water and, as his eyes opened, the light stabbed at him. He tried to draw breath and gulped down water. He cried out in pain and kicked again, kicking and kicking with legs that seemed to have doubled in weight, forcing them into some ragged semblance of a swimming stroke. He reached out with his arms and felt the water's resistance. He shouted at himself to swim, but seemed unable

to manage anything more than an uncoordinated thrashing about. His body seemed determined to curl up and fall like a stone into the deep, black water, but he fought against the blackness and the pain behind his eyes, and gradually he found himself swimming.

He opened his eyes and tried to find his bearings, but he couldn't see the shore and the pain from his eyes was terrible. Grimacing and blind, he forged on in what he thought was the right direction. After the first sharp pain, the headache had grown duller, as if the first moment had been the impact of a jagged stone crashing into his head and now he had only to cope with the burden of the stone's weight, dragging at him, rocking inside his skull. He shook his head, as if he could shake the stone loose, but every movement made the stubborn mass bang against the inside of his skull, and every time his face turned upwards to the sun he felt the sunlight burning in his eyes. He'd lost the sense of time or distance. Everything was concentrated on the struggle to keep swimming, simply to fight off, moment after moment, the temptation just to let the darkness underneath the water pull him down. Then, at last, as he kicked out he felt his foot brush the muddy bottom of the lake. He stumbled out onto the lakeside and lay face downwards on the grass.

He had fallen asleep. When he looked around him he saw that the aircraft cabin had lost its brightness. Beyond the window was cold grey cloud. The stewardess was explaining that it was time to fasten his seatbelt. They'd begun the descent towards Frankfurt.

Kawena looked out from the window of his office, on the third floor of the old colonial building that stood by the river Zaire. The air conditioning equipment was hidden away behind fine wood panelling, but there was a soft hum in the room like a distant aeroplane propellor.

He turned away from the window. He picked up the phone and made the call. It rang only once at the other end before the answer came.

'*Patron?*' he heard. A young man's voice, a note of insecurity.

'*Boni*', said Kawena. 'It's good to hear your voice, Bertrand.'

7

It's a myth that the trains are never late in Germany, as it's a myth that everything is clean. The schedule allowed just nine minutes for the connection, and the train down from Frankfurt was running nearly half an hour behind time. When Philippe arrived at Würzburg the train on to Steinach was long gone. He found a telephone booth in the grubby station foyer and made a call, then checked his watch. He still had an hour to wait.

He walked over to the station entrance, where he stood and looked out towards the town. A tramcar turned in a broad circle just in front of the station. In the centre of the circle was a small formal garden and a hose playing over it. The jet of water was chopped intermittently by a simple, swinging bar. Each time the bar swung into the jet it broke it for a moment and turned the nozzle so that the spray was gradually shifted round. Philippe stood and watched the jet of water, solid at first, spreading into a wide plume of spray which caught on the breeze and drifted into the street. It was a bright day and a rainbow formed in the falling mist at the water's furthest reach.

Another tram arrived and deposited its passengers. They strolled across to the station and spread out into the foyer. The station clock ticked laboriously through the minutes and there was nothing to do but wait. Philippe wandered round the foyer. He browsed in the bookshop and left without making a purchase, having been paid an unwelcome degree of attention by the shop assistant. He bought a coffee from the Imbiss and wandered round the foyer again.

In a gloomy corner he found a train set. It was a magnificent layout, ten feet by six, encased in glass. There were six different trains, passenger trains and goods trains, steam locomotives and modern diesel units. The hills were thick with dried sponge painted green and to the rear of the display they rose into a mountain with the track running, hidden, through

its heart. There was a town in the centre, high-stepped Renaissance gables turned to the street, genuine Romantische Strasse. A river ran through the landscape, bridged by the tracks at either end of their elliptical course. Glancing down, Philippe saw that there were slots for coins, a slot for each train. He dropped a coin to run the goods train and it ground around its loop. It came to a halt in the same position it had started from. Philippe glanced up at the station clock; it had hardly moved.

He sipped his coffee and wandered around the station again before returning to the model railway. He dropped a coin into the slot for the passenger train but nothing happened. He surveyed the layout and on the far side of it he saw, staring at him through the glass case, a child of eight or nine.

The connections from Würzburg to Steinach, and from Steinach on to Rothenburg were slow country trains through landscapes that seemed as far away from the bustle of Zürich and Frankfurt as Bukavu was from Kinshasa. The weather was warm and bright, and there were men and women working their fields. They passed an orchard, a small piece of ground some seventy or eighty yards across, and a sturdy old man in a dark serge suit was cutting long grass round the trees with a scythe. The hay fell in loose, irregular swathes and shone a pale, watery green. The train came to a stop, as if it had decided simply to take a short rest. Philippe stood and opened the window and he breathed in the fresh-mown scent.

Joseph Nsembe met him at the station in Rothenburg. Nsembe was a stoutly-built man, wearing the long black robes of a Catholic priest. A white dog-collar gleamed at his throat and a simple wooden cross on a leather thong hung against his paunch. The two men shook hands and smiled at each other. The flow of travellers passed on either side of the two black men like a river flowing round an island.

'*Wie geht's?*' asked Nsembe.

'*Geht's mir gut*', answered Philippe.

They took a taxi to Nsembe's home, which stood inside the mediaeval city walls. The housekeeper, an elderly German woman, showed Philippe to the guest room at the top of the

house. He laid his case on the bed, went over to the window and looked out at the rooftops beyond.

Not a single modern building broke the roofline, and not a single street ran straight. Even the Marktplatz was on a tilt, cobblestones slithering downhill. No two buildings were the same. The roofs were all tiled, but the colours wandered through every variation of russet and red earth; they were shades of terracotta, of pale brick and dark brick, of rusty iron and sun-dried fruit, figs and apricots and peaches. Some of the roofs were in shade and some still in the warm light of early evening. Some were so steep and tall that they had two separate rows of windows let into them, with tiles curving up from the pitch of the roof to cap the lights like drowsy eyelids. It seemed as if, centuries ago, the city had simply fallen asleep.

'It's all fake', said Nsembe, and Philippe turned to see him standing in the doorway.

Nsembe smiled. 'Well, not all fake', he said. 'Some of it's old. But the whole place was flattened in the war. They just built it up again the way it always was.'

'Ask me the news from home and I will tell you', says the poem by Nkuhlu. So, over breakfast the next morning, they talked about Kinshasa. They spoke about the city's landmarks, the streets renamed, the statues of colonial figures long ago torn down, just as, in more recent years, Stalin and Lenin had tumbled down to disgrace, revealing their hollow interiors. Stalin and Stanley, Lenin and Leopold, all overthrown; tall palms along the boulevards cut down. They talked about Kinshasa, about Kisangani and Bukavu. They talked about the river and about Lake Kivu. Philippe hadn't said anything to Nsembe when he called, only that he needed to talk.

After breakfast Nsembe suggested they go for a walk, and they strolled into the centre of town. Already the tourists were out in force, the Japanese and Americans pointing their camcorders into every Gothic corner. When the two black men reached the city wall they climbed up to the walkway that ran around the parapet.

'You can walk almost the whole way round', said Nsembe.

'One day', said the priest, 'I shall walk round seven times, and give a great shout.'

'And nothing will fall', said Philippe.

'Exactly', said Nsembe, and they laughed.

'Everything falls eventually, my friend', said the priest. They paused and looked out over the town.

'*La patience est amère*', said Philippe. Patience is a bitter thing.

'*Mais les fruits de la patience*', said the priest, '*sont très delicieuse*'.

They walked on and came to a place where, looking outward from one of the wall's many towers, they could see the valley tumbling away below them. The steep sides were clothed in trees and the river was hidden from view. Philippe looked downward and, for a moment, he swayed, then he clutched at the handrail and steadied himself.

'Come on', said the priest. 'There's something I want you to see.'

They made their way along a narrow street that ran just inside the wall. The houses were lower, with timbers that were unmistakably ancient set into their walls, and with the ochre rendering of the wall surfaces flaking and crumbling. After a short time the street curved away from the wall, back into the town, and they came to a large building in good repair, its entrance surrounded by clusters of tourists. Nsembe said nothing but led the way in.

Inside the door was a ticket booth. The priest paid for the tickets and ushered Philippe through the turnstile. They were in a large hallway, barely furnished. There were more tourists, there was a shop selling posters, trinkets, postcards. Philippe, still puzzled, looked around him. Once again the priest led the way, off to the left and down a flight of stone stairs into the basement.

The temperature dropped. To either side of the passageway there were iron bars, running from floor to ceiling, closing off primitive, stone-walled cells. Inside the cells was a collection of stout wooden benches and trestles. Fixed to several of them were heavy leather straps, so that someone might be firmly

held in place. Laid over benches or hanging from the walls were whips. In the low-vaulted ceilings were thick iron hooks, and below one of these was a pile of heavy iron weights.

On a stand inside one of the cells an old, leather-bound book lay open to view. The text, in an ancient, Germanic black-letter type, was barely readable, but facing it was an illustration, a beautifully executed engraving of a pair of hands, like Dürer's praying hands, with a detailed drawing of cords binding the wrists tight together. It was evidently a manual, showing just how to tie the knots, exactly where to place the binding. Another illustration showed the victim hanging from a hook in the ceiling, with weights just like the weights on display, hanging from his ankles.

They moved along. Behind another set of bars was a large wooden cartwheel. Set in an arc round part of its perimeter was a thick iron blade. In another ancient woodcut there was a man lying on his back on the ground. At his wrists and ankles were men holding him in a taut, spread-eagled position. Beneath one of his legs were two logs, and, holding the wheel high above him, another man prepared to let it fall on the leg.

They walked on through the museum, past the weapons and the woodcuts and the tableaux of wax figures. They passed the beheadings and the burnings at the stake, and the lesser punishments, the floggings with barbed whips, the brandings and the mutilations.

'Some of it is very crude', said Nsembe. 'And some of it is very ingenious.'

They moved into a room where the displays were all annotated in clearly legible modern type. Nsembe led them round from one exhibit to another.

'Look at these', he said, stopping in front of a small glass display case. Inside it were two small pear-shaped devices made out of steel, or, they shone so cleanly, it might even have been silver. The surfaces were beautifully decorated with swirls and curlicues, and at the tip of each device, where the stalk would be on a pear, was a small wheel.

'Each of the pears', he read, 'is designed for a particular orifice, for the anus, or for the vagina.'

Philippe stared at the two devices, at the swirls and curlicues on their silver-grey surfaces, at the soft gleam of light reflected from them.

'When the pear is inserted into the orifice', continued Nsembe, 'the wheel is turned, and the pear opens out'.

Philippe saw how each of the devices would open, the fruit splitting into knife-edged segments along its longer axis.

'The result, generally speaking, is death', read Nsembe.

They walked on, past the headsman's sword, past the block of wood with the hammer lying on it, and beside the hammer lay a thing like a broad chisel. In the woodcut a man's forearm was laid on the block and the chisel rested on his wrist, with the hammer raised high for the blow. They emerged into the entrance hall and they sat for a while on a bench in the middle of the room while the tourists with their aimless chatter and their camcorders milled around. Philippe held his head in his hands and stared at the wooden floor. When he raised his head he saw, just a few feet in front of him, a display case for the souvenir shop. In the display case were postcards and books. One of the books caught his eye, its bright scarlet cover with a reproduction woodcut, and the title in black letter, *Justiz in alter Zeit*; 'Justice in the olden days'.

Nsembe laid his hand gently on Philippe's shoulder.

'I always used to wonder', he said, 'how it was that white men treated Africans the way they did.'

They finished dinner, and the housekeeper took a tray with coffee through into Nsembe's study. Bookcases lined the walls, and more books sat in tall piles beside the chairs and the overflowing desk. Over the fireplace were three African masks, looking down on the room with a stern, ancestral stare. Just beneath them, in a frame sitting on the mantlepiece, was a photograph of Lumumba.

Nsembe poured the coffee and passed a cup across to his guest. Philippe sat the cup on the broad, leather-covered chair arm. The leather was stained and marked by cup rings, and worn to a high, dark polish. Nsembe settled back in his own

chair and lit the pipe. He blew a cloud of blue-grey smoke up towards the ceiling, and looked across to Philippe.

'You've made up your mind, I take it?' said Nsembe.

Philippe gave only the slightest nod of his head.

'You know there's not much I can do to help you?'

'I know', said Philippe.

'Where will you go?'

'Kawena wants me to go to London. I can do that.'

'Do you know anyone in London?'

Philippe shook his head. 'Not really. I know a few names, runaways. They won't be much help. One or two people in the embassy in Brussels, a couple in Paris, but it's too dangerous there.'

'There's a man in London', said Nsembe. 'I haven't seen him for .. ten or eleven years, but we keep in touch. He's English ..'

Philippe raised his eyebrows.

'I met him when I was a student. You knew I was at Oxford?'

Nsembe carried on.

'He's not at all political. I could ring him. He might be able to find somewhere for you. I don't know. It's a start. Would you like me to ring him? His name's Chris. Chris Davis.'

'That would be . . . yes, please', said Philippe.

Nsembe smiled, and pulled at his pipe. His expression turned to a frown as he realised that the pipe had gone out. He tore a strip from a newspaper and rolled it into a spill which he lit from the fire, but after a few moments, in which the flames from the spill of paper shot up threateningly, he gave up. He stood and, crouching by the fire, he knocked the pipe out into the grate.

As he stood, he came face to face with the portrait of Lumumba. He stared at it for a moment, then turned and looked carefully at Philippe's face. Philippe smiled but said nothing. Nsembe picked up the photograph and held it so that he could glance between the picture and Philippe.

'You do look very like him, you know', said Nsembe.

'So I have been told', said Philippe. He stood and took the

picture from Nsembe, then placed it carefully back on the mantelpiece.

'Man looks on the outward appearance', said Philippe, and smiled.

'But God looks on the heart', said the priest. 'I know. I'll make that telephone call'.

He walked over to his desk and picked up the receiver. Holding it, he hesitated and looked back at Philippe.

'How will you get Marie and Eric out?' he asked.

Bertrand sat in Kawena's office on Mont Ngaliema and squirmed uncomfortably in the reproduction Bauhaus chair. The leather of seat and back squeaked as he moved, slipping against the tubular chrome frame.

Kawena wasn't there. The secretary had shown Bertrand into the office and invited him to sit. She'd offered to bring him coffee, but he lacked the confidence to accept.

The minutes ticked on. Bertrand stood and went over to the window. He gazed out at the river and wished himself out in the open air, out on the river perhaps, in a small boat pushing steadily upstream and away from the city. The air-conditioning poured out a generous chilled breeze.

Half a mile out on the river he could see the ferry crossing towards Brazzaville. Although its destination lay straight across the river, the ferry's heading took it out to the right, upstream, working against the massive flow of water.

Bertrand opened the window and drew a deep breath.

Suddenly, from the distance, there came a loud blast of sound. He glanced out at the ferry and saw that it had begun to drift downstream. Its siren sounded again, and Bertrand could see that jostling had broken out among the passengers packed on the ferry's decks.

From the near shore, answering the signal, a powerful tug surged out into the river. The colours of the river water, the colours of lilac, of beer, of rust, were churned up in the tug's wake, the froth of pale coffee, the white of dirty snow.

At first the ferry had drifted hesitantly on the water, its forward momentum still not surrendering to the current. As

the tug drove towards it the ferry began to gather speed, turn-
ing slowly as it went, with the bow swinging round to point
downriver. The tug's course adjusted.

The siren meant that one of the ferry's two engines had
failed. If the tug did not reach it quickly the water would
carry it down into Kinsuka, the first step down the gigantic
series of cataracts through which the river fell towards sea
level. Once into Kinsuka the ferry would be lost. The boat
itself might reappear eventually, miles downstream, smashed
about by the falls as if it were a toy, but none of its passengers
would survive.

Bertrand watched the tug approach the ferry, saw the two
trajectories converge. He unfastened the top button of his
abacost and went back to the chair.

The door opened, catching Bertrand in the act of sitting
down, stranded between sitting and standing, trying to turn
back towards the doorway. His hand slipped on the chair arm
and he fell clumsily into the chair. He jumped to his feet again
and reached out to shake Kawena's outstretched hand.

'Bertrand', said Kawena, beaming from ear to ear. 'It's good
of you to have come so promptly.'

'I came as soon as I could, patron', said Bertrand. 'I'm sorry
I couldn't get here sooner. There was a flight last night, but
there was a fault with the plane, and they couldn't leave. I
went to see the pilot . . .'

'Sit down, Bertrand', said Kawena.

Kawena called for coffee, then seated himself behind his
desk.

'Where will you start?' he asked.

Bertrand hesitated.

'You said that he flew to Frankfurt?' said Bertrand. 'Do you
know who he knows in Germany?'

'He lived there for over a year. He speaks the language. He
could go anywhere . . .'

'But we have an address?'

Kawena called through to his secretary and she came in
with a grey manila folder. Kawena tapped the desk, and the
woman laid the folder neatly in front of him. He flipped the

cover open and began to leaf through the handful of documents within. Kawena withdrew a slip of paper and handed it across to Bertrand. There was an address in Frankfurt.

'He left there six months ago', said Kawena, and passed the rest of the folder over.

Bertrand began to look through the papers. He pulled out a personnel form and saw Philippe's address in Kinshasa, the details of his wife and child; there was an address in Bukavu, and the address of the apartment in Paris. There was Philippe's age and height. There was a photograph stapled to the form, not much like Philippe, a younger, smiling face wearing his graduation outfit.

'We could start with his wife', said Bertrand. Kawena was running the tip of his finger gently from side to side across his mouth, barely brushing his closed lips.

'Or with the apartment in Paris?' said Bertrand.

'I'll leave it up to you', said Kawena. He stood up and reached out his hand. Bertrand shook it.

'Let me know what you need', said Kawena. 'You can pick your own help. Just tell me who you want.'

'We'll get him, sir', said Bertrand. 'I'm sure of it.'

'I have every confidence in you, Bertrand', said Kawena. 'But just find out where he is and watch him.'

8

The president of the Republic of Ghana and the prime minister of the Republic of the Congo have given serious thought to the idea of African unity, and have decided to establish with the approval of the governments and peoples of their respective states among themselves a *Union of African States*. The Union would have a republican constitution within a federal framework. The federal government would be responsible for:

(a) Foreign affairs
(b) Defence
(c) The issue of a common currency
(d) Economic planning and development.

There would be no customs barriers between any parts of the federation. There would be a federal parliament and a federal head of state. The capital of the union should be Leopoldville. Any state or territory in Africa is free to join this Union. The above Union presupposes Ghana's abandonment of the Commonwealth.

Dated this 8th day of August 1960.

The declaration was signed in Accra, Ghana, by Kwame Nkrumah, the Ghanaian President, and by Patrice Lumumba, the Congolese Prime Minister. They agreed, at the same time, to call an all-Africa summit conference. It was to be held in Leopoldville later that month.

On that same August day, Albert Kalonji made his own announcement. Kalonji, leader of the Luba people in the Congo's Kasai province, declared himself emperor of the independent and sovereign state of South Kasai. He declared Bakwanga his capital, and he set about building close links with Moise Tshombe's breakaway Katanga, which lay next door. The Republic of the Congo was just 38 days old, and of the three regional leaders who had threatened secession, only Kasavubu had still to carry out his threat. For the time being,

'King Kasa' was happier with the pomp and circumstance which attended him as the Congo's President and Head of State.

Thursday, August 25th

Manza pushed into the crowd of people who were standing in the doorway of Lumumba's office. As he jostled his way through he could see the tall figure of Lumumba standing beside his desk, apparently arguing with Damien Kandolo, his *chef de cabinet*. Kandolo – the name is a Luba name – was excellent when wild opinion was called for, but hopeless at the practical business of running the Prime Minister's office. Hovering at Kandolo's shoulder was his assistant, a Belgian called Grootart.

'Patrice', called Manza, and heads turned to look at him. Patrice looked up and smiled in recognition.

'Thomas', said Lumumba. 'It's good to see you.'

'Patrice', said Manza, 'Get these people out of here. We can't talk like this. It's like a madhouse.'

Lumumba spoke briefly to Kandolo and Grootart, who started shooing the crowd of hangers-on out into the corridor. There were angry glances at Manza, and whispered complaints, but they complied. Kandolo and Grootart closed the door behind them, leaving Lumumba and Manza on their own in the room. The squabbling clamour of protest and complaint could still be heard from outside. The two men stood and listened until it died away.

'Thank you, Thomas', said Lumumba. He sat down behind his desk, leaned back in his chair, and stretched his arms and legs. Manza took a chair in front of the desk and leaned forward, studying Lumumba closely. He had lost weight, and his suit, though well pressed, hung loosely on him.

'When did you last get any sleep', asked Manza.

Lumumba grinned sheepishly.

'You can't go on like this', said Manza.

'It's just until we can ..'

'What, Patrice? You've enough on your plate to keep ten

men busy for the next year. You have to get proper rest. Can't you delegate?'

Lumumba shook his head. 'Who can I delegate to?'

'Your ministers, for heaven's sake! Surely there are some you can bring yourself to trust?'

'I thought I could trust Antoine', said Lumumba. 'But after that business at the UN, I don't know. Grootart says he has heard that he wants to set up a coup and ..'

'Patrice! Antoine Gizenga's the most loyal minister you've got.'

Lumumba shook his head again. 'Why are you here, Thomas?'

'The conference is due to start. People are already wondering where you are and why haven't you gone to greet them?'

'Who is wondering?'

'Andrew Djin is wondering, for one', said Manza. Djin was the Ghanaian ambassador in Leopoldville.

'What does he want?' asked Lumumba.

'He wants to talk to you about Katanga', said Manza.

'What is there to talk about with him?'

'Patrice, listen. Djin is your friend. You should listen to him.'

'I've noticed, Thomas', said Lumumba, 'that when people say they are my friend, it usually means they're about to disagree with me. It was you that told me Hammarskjöld would be my friend.'

Manza raised his head and stared at the ceiling for a moment. He closed his eyes. When he looked down again, Lumumba was staring at him with suspicion.

'Patrice', said Manza. 'I want the same things for the Congo that you want. I want to save the Congo in one piece. I want to save you. When will you believe me? You trust everyone who drifts in and out of here. You let them issue communiqués that give away every move you make ..'

'I'm sorry, Thomas', said Lumumba. His voice had softened. 'But you are going to disagree with me, aren't you?'

Manza smiled.

'And so is Djin, isn't he?'

'Yes.' Manza was trying to find a new way into the same business they had argued about for days, the problem with Hammarskjöld. Somehow Manza had to find a piece of common ground between Lumumba and the UN Secretary General, and maybe, if Lumumba could trust Djin, and if Djin could get through to him, maybe there was a way.

The door banged open and Grootart ran in.

'Patron! Patron!' he shouted.

'What is it?' asked Lumumba. Grootart stood and tried to catch his breath.

'Shooting. The delegates.'

'What?'

'There was a demonstration. At the conference hall. It was Kalonji's supporters, I think, and some Bakongo.'

'Against me, I suppose', said Lumumba.

Grootart was still out of breath. 'They had placards', he paused and took a deep breath, 'they were trying to get to the delegates . . .'

'Did you see this yourself?' asked Manza.

'I've just heard on the phone', said Grootart. 'There were some of our police there, and they stopped it, they fired, it was only over their heads.'

'Is anyone hurt?' asked Lumumba.

'No, I don't think so', said Grootart. 'But they're frightened.'

There were only formalities planned for the first day of the conference. Lumumba was to welcome the delegates, but he knew he'd be speaking, for the most part, to the ambassadors who would have been in Leopoldville anyway. The whole point was to get other African heads of state together, to get a joint African position worked out that could stand up in the UN against both the Americans and the Soviets. The ambassadors would sniff out each other's mood on the first day, and if things looked uncertain, the heads of state would stay at home. Scaring the ambassadors out of their wits was about the worst thing that could happen, though, God knows, they scared easily. Manza and Lumumba were still absorbing the news when there was a quiet knock on the open door. They

looked up to see Andrew Djin, a scowl on his face, standing in the doorway. Grootart took in the scene and scuttled out of the office, closing the door behind him.

'Is it true?' asked Djin.

'What?' said Lumumba. 'The shooting? I suppose it is, I . . .'

'Is it true you've accepted the Soviets' offer of aircraft and ..'

'I've accepted the Soviets' offer of a small number of *civil* aircraft and a small number of *civil* trucks, for the legitimate purposes of the legally constituted government of the Republic of the Congo!'

In Bakwanga, Pierre Chiluba crossed to the other side of the street but the gang of youths up ahead crossed over too. He dropped all pretence, turned on his heels, and ran.

He was fast. He heard them calling to each other to hurry, heard them shouting at him to stop, and he could tell from their voices that he was getting away from them. He darted down an alley between two buildings and out into the next street. He turned and ran to his right. The street was empty, he ran across to the other side and down another alley. It was a long way down the alley, a hundred yards or more, and as he emerged from it he looked behind him. There was no sign of his pursuers. Then he turned and saw the trucks closing in on him and heard the wild howls. He turned back into the alley and started to run back the way he'd come. A truck pulled to a halt behind him and he saw, up ahead, the first group of youths enter the alley. There was a tall wire fence beside him, and beyond that a patch of waste ground. He tried to climb the fence but they caught him and dragged him down.

At first they stood round him in a half-circle.

'What is your name, boy?', he heard.

'Pierre', he said. 'My name is Pierre'.

'Pierre what?'

He stared at the youths. They were armed with machetes and with pieces of wood. There was a strongly-built youth who seemed to have taken charge. He wore tattered shorts,

and a blue t–shirt heavily stained with oil was stretched tight over his stomach. He carried a heavy pipe–wrench.

'What is your name?' asked the youth.

Pierre felt his mouth running with saliva. He was trying to stand straight but his legs seemed paralysed.

'I know him', said a voice from the back of the huddle of youths. 'I know where he lives. His name is Chiluba, but his mother comes from the north, from Luluabourg.'

The half–circle tightened in on him and he saw the weapons raised. The youth in charge lifted his hand and everyone stood still.

'Is that true?' asked the youth.

'I'm from Bakwanga', said Pierre. 'I've always lived in Bakwanga.'

'But your mother, she is from North Kasai. True?' Pierre tried to swallow, but choked. Spittle dribbled from his mouth.

'So you are MNC-Lumumba,' said the youth. Pierre stared at him.

'You support Kalonji?', asked Pierre. There was no answer. 'You want a separate Kasai?' he asked, and a cheer went up from the crowd. The youth in charge raised his hand and they became quiet.

'Where is Lumumba now?' asked the youth. 'Where is he when you need him?' Pierre shook his head and looked down at the ground.

'Look at me!' shouted the leader. Pierre raised his head and the heavy wrench caught him in the throat, throwing him back against the fence. It was the signal that the others had wanted; they closed on him and struck, and even after he was dead the crowd continued to tear at him. They ripped the bloodstained clothes from him, and there wasn't one of the youths gathered round who didn't add his own mark, some cut or tear, to the naked body.

They dragged the remains out into the street where the trucks were parked. One of the youths climbed into the back of the first truck and threw down a length of rope. They lashed Pierre's ankles together and fastened the rope to the

truck's tow-bar. The trucks set off down the street with Pierre's body dragging and bouncing in the dust.

They drove to the street where he had lived, and trailed his body up and down the road, shouting and cheering as the people emerged from their homes. Chiluba's family and neighbours gathered at their doorways, afraid to venture out. His mother, seeing her son's disjointed body flapping and banging behind the truck, howled and screamed. All along the street her cry was taken up, and answered by the jeering of the youths in the trucks. Then they drove away and the only sound that remained was the sound of sobbing. Pierre Chiluba's mother, curled in the tracks her son's dead body had made in the dust, was rocking herself and crying while her husband tried to comfort her.

The trucks drove to the edge of town. Beside an abandoned building site the youths dug a shallow grave. They tumbled Pierre's broken body into it and threw a thin covering of soil over him. Then, subdued, they drove away.

Djin said nothing to Lumumba's outburst. He walked across the office and picked up a chair, then carried it over to Lumumba's desk and set it down beside Manza. He sat down and, carefully settling his suit so it wouldn't crease, he finally looked at Lumumba. When he spoke, his voice was quiet. 'Why', he said, 'did you take the Soviet planes?'

'Why won't Hammarskjöld throw the Belgians out of Katanga and Kasai', said Lumumba. Manza groaned.

'Because he can't', said Djin.

'Because he won't', said Lumumba.

Manza interrupted. 'Patrice', he said, 'Hammarskjöld doesn't believe the Belgians are the problem. You know that. *You* know . . .'

'They claimed they were there to protect life', said Lumumba. 'You tell me, then, why they mined every road and railway line between Katanga and the rest of the country!'

'Patrice', said Manza, 'I know, I know ..'

'And tell me', said Lumumba, 'why they've flown in weapons and armed every Belgian in the province. Tell me

why there are offices in Brussels and Johannesburg paying $1000 dollars a month to anyone who'll join Katanga's so-called *Gendarmes* . . .'

'I believe you', said Manza. 'The problem is that Hammarskjöld doesn't, and until the two of you can ..'

'Fascists', said Lumumba. 'I have proof. Men who fought for Hitler and for Mussolini ... criminals, anybody who can . . .'

'I know!' Manza shouted it, and for a moment there was silence. Djin turned his head and looked calmly at Manza. Lumumba went on.

'Hammarskjöld's given in to every one of Tshombe's demands. He has UN troops guarding anything and everything that doesn't need to be guarded, and it makes Tshombe look good because he's co-operating with the UN. It frees the mercenaries to train a Katangan army that's entirely under *Belgian* control, is paid with *Belgian* money, is armed with weapons flown in from Belgium and from South Africa on Belgian military aircraft, and Hammarskjöld says the Katanga problem "does not have its root in the Belgian attitude"! He says he can't intervene in an internal dispute! He says he must remain neutral! He's neutral between law and *dis*order!'

Lumumba sagged back in his chair, sweat trickling down his face. Djin glanced at the closed office door and, looking at Manza, he lifted his eyebrows in a silent question.

'There are no secrets in the Congo, Andrew', said Manza. 'If two men talk, a third one overhears.'

'All it needs', said Lumumba, his voice quiet and steady again, 'all it needs is to fire a few rounds. The Belgians can't fight back and all their loyal gendarmes will run away. Just a few rounds. No-one has to get hurt. All I have to do is get the army into Kasai and Katanga, and they can do the job in an hour.'

'If you use Russian planes, Patrice, the west will rage about the Communist Lumumba, and sooner or later, my friend, they will fire just a few rounds.'

'If they shoot me', said Lumumba, 'they're shooting the Congo. They're shooting Africa.'

Djin rose from his chair. Lumumba and Manza stood in response. Djin stepped round the desk and laid his hand on Lumumba's shoulder.

'I know that, my friend', he said. 'That is why it must not happen'.

Manza and Djin left together. They closed the door behind them and walked, without saying a word to each other, out into the street. The heat of the day struck them. The conference was due to open in less than half an hour.

That evening the first of the big Ilyushin transports lifted into the air, flying troops of the ANC, the Congolese National Army, from Leopoldville down to Kasai.

Saturday, August 27th

Serge Michel, Lumumba's French press secretary, rushed into the office. 'They've taken Bakwanga', he said, 'Kalonji surrendered.'

'Has anyone been hurt?' asked Lumumba. Michel shook his head.

'Thank God for that', said Lumumba. 'Serge. This is exactly what I said would happen. We only had to get our men into Kasai, and Kalonji's men would run away. Where's Kalonji? Have we got him? We have to get him. We have to bring him back to Leo for a trial. It must all be done according to the law, we must make him tell the world what's been going on . . .'

'We haven't got him', said Michel. Silence.

'He's escaped to Elizabethville', said Michel, 'Tshombe's looking after him. That's where he broadcast from, to say he'd surrendered.'

'Still', said Lumumba, 'this is good news. Now we can go into Katanga.'

Serge Michel hesitated for a moment before speaking.

'Patron?' he said, 'Why not stop for a while. Consolidate in Kasai.'

'It's too late. Sendwe's going into the north of Katanga now.'

Jason Sendwe was the leader of a Luba faction in Katanga. Sendwe's men were completely opposed to Kalonji's notion

of a separate Luba state. They'd been driven out of Katanga by Tshombe's Belgian-led *Gendarmes*, but they'd gathered their forces in Kivu province, ready to support Lumumba's attack on the two breakaway regimes.

There was a knock at the door and the two men turned to see Joseph Mobutu entering the room.

'Joseph', said Lumumba. 'Well done. I've just heard.'

Mobutu smiled and sat down.

'Has Sendwe gone in yet?', asked Lumumba.

'He wanted to wait until Kasai was settled', said Mobutu.

'So you can wait', said Michel.

'No', said Lumumba. 'I want to get Tshombe. I want them to go straight on into Katanga.' He looked at Mobutu. 'You understand, Joseph? Straight on. I don't want any . . .'

The telephone on Lumumba's desk rang. He picked it up.

'Thomas!' said Lumumba. 'Have you heard the news? Isn't it excellent'

Even Michel and Mobutu could hear Manza's bellowed denial. They looked at each other with puzzled expressions while Lumumba listened silently to Manza. Lumumba was frowning. He put his hand over the mouthpiece and looked at Mobutu.

'Do you know a place called Nyanguila?'

'It's near Bakwanga', he said. 'It's on the road to Katanga'.

Lumumba spoke into the telephone again. 'Thomas', he said, 'I promise you. I told them there was to be no shooting. I wouldn't tell them to do that.'

That Saturday afternoon Lumumba flew from Leo up to Stanleyville. When Lumumba's plane was already in touch with the control tower at Stanleyville, a big American Globemaster transport touched down. It taxied to a halt beside the small terminal building. Stanleyville was Lumumba's home base and the crowds were out to meet him. As the crew of the Globemaster emerged from the aircraft a rumour went round the crowd that they were Belgians, that they were out to arrest Lumumba as soon as he arrived. The crowd surged towards the aircrew and began to beat them. The

Americans were saved when a detachment of Ethiopian troops serving with the UN intervened. By the time the stories about anti-American Congolese mobs reached western capitals it was too late to catch the Sunday papers, so the news broke on the following Monday, the 29th of August.

At Nyanguila, the bodies of Luba women and children machine-gunned by ANC troops at the little mission station of St Jean de Bakwa lay untended in the sun for almost a week. Then those who had escaped the killings gathered the courage to emerge from hiding. The first eye-witness accounts of the shooting appeared in the western press on the 2nd of September; 'Massacre in Congo', said the headline in the *Daily Express*; 'Lumumba delays his advance on Katanga to hunt down and kill off spear-armed tribesmen'. And that was just London; the view from Brussels, like the view from Washington, was far less generous.

The independent Congo was two months old.

9

The intercept on Philippe's home line was easy to arrange. Bertrand had no further to go than the floor below Kawena's office. For the sake of appearances he began the paperwork he'd need for French co-operation on an intercept for the phone in Philippe's Paris apartment. But wherever Philippe was, he wasn't in Paris; the apartment was just a discarded shell.

The home in Kinshasa, on the other hand, still held Philippe's wife and child; he'd want to communicate, perhaps to arrange for them to leave Zaire, at the very least to reassure himself that they were still all right. Everything he did would set up ripples of movement. Bertrand's job was to watch, to observe each disturbance of the surface so that he could infer its origin.

Philippe took the Underground from Heathrow for the long ride in to town. It took almost an hour to reach Finsbury Park, and when he emerged from the station it was nine in the evening. The streetlights had a bitter, amber cast, half shadow, as if the shadow were somehow in the light itself. The cold wind swirled litter along the pavement, polystyrene cartons from greasy burgers, the drab confetti of bus tickets, tube tickets, betting slips, the trampled pages of tabloid newspapers. Looking at the dilapidated bustle of Seven Sisters Road, it was hard to tell how much of its appearance was due to the darkness of the evening, and how much was simple grime.

He heard a bell ring, and turned to see a black girl on a bicycle bearing down on him, head down over the handlebars, backside high above the saddle. He stepped aside and she was past him. He followed her with his eyes as she rode under a rail bridge and, up above, a commuter train rattled by, wheels drumming on the metal bridge and sending shivery echoes into the dark space below. He looked around and found a telephone from which he called the number that the priest had given him.

Davis was apologetic. He'd arranged to meet Philippe at the tube station, but then his wife had needed the car. Philippe would have to catch the bus out to Crouch End. As Davis explained which bus, and which stop to get off at, Philippe heard music playing in the background; there were crowded voices jumbling together, and sudden bursts of laughter. Twenty minutes later, as Philippe approached the front door, he saw the party in progress. Very little sound spilled out into the street. He rang the doorbell.

As he waited for someone to answer he looked along the street. The houses were in terraces, with narrow frontages so that all the front doors seemed close together, but the houses were three or four storeys high. They seemed built of denser stuff than anything Philippe was used to, dark red brick, as if the houses had been built originally on a larger scale, then shrunk down to their present size so that everything was compressed. It was quite a change from the soft, creamy-grey stone of the Paris boulevards, and from the wide, elegant streets which were what he'd previously known of London.

He heard the door open, and the music suddenly jumped in volume. Facing him was a slightly tubby man of medium height, with grey in his beard and in his rather long, unruly hair. Mid-forties, thought Philippe, married, children in their teens, late teens probably . . .

'Philippe?', said the man. 'Hello. Come in. Sorry about the noise.'

Philippe hesitated on the step. A tall girl suddenly appeared behind the man and clutched at his shoulder for support.

Philippe was reaching out to shake the man's hand when the girl swung round towards him and a bright blue flash of light splashed into Philippe's face. The girl swayed back, giggling, and waving a small camera.

'Gotcha!', she said, and laughed. The man turned and steered the girl gently away down the passageway.

'I'm sorry', he said. 'It's Allie's party . . .'

Philippe smiled. They shook hands, and the man led Philippe through the passageway, down a step, and into the

kitchen at the rear of the house. The kitchen was relatively quiet. In the centre stood a large, plain table of old pine, and round it half a dozen pine chairs, no two the same. The table-top was covered in party debris.

'What would you like to drink?' he asked. 'Beer?' He was opening the fridge and taking out a bottle.

'Beer is good', said Philippe. The man opened the bottle and passed it over.

'I'm Chris', he said. He took another bottle out of the fridge and opened it for himself. He reached across and the two men chinked their bottles together.

Philippe hadn't slept properly since the night he'd picked up Manza. He hadn't slept well in the Paris apartment, and he still hadn't slept well in Rothenburg. But in the brick-built terraced house in Crouch End he slept and slept. He woke at around eleven the next morning, warm and relaxed.

The bus journey the night before had helped, the mix of faces on the bus, in the streets; there was every sort of African and Asian face, and the shops that they passed, many still open, were Pakistani supermarkets, Halal butchers, Afro-Carib fishmongers and fruiterers. If he'd been looking for a place where he could pass completely unremarked, Philippe couldn't have done better.

And inside the house things had moved easily and effort-lessly aside to make space for him. Philippe had bathed the night before, a long soak in the bathtub in a little bathroom half-way up the house. When he emerged from the bathroom with a towel round his waist, there'd been a young couple slow-dancing, wrapped up in each other. The boy had long golden hair that fell in curls onto his shoulders. He wore a black leather jacket with 'Alien Sex Fiend' painted on the back. The girl had short, dark hair and a face completely without colour except for the dark purple of her lips. She wore a short, red velvet dress. They paused as Philippe appeared, and the girl smiled at him. They stepped aside and let him pass without a word. He climbed up the last two zig-zagging flights of stairs to his room, which was almost at the

top of the house, and he stopped for a moment to look back down towards the couple, but they were absorbed in each other once again. It was as if he were not there, as if his arrival had caused hardly a ripple.

While Philippe was sleeping in Crouch End, Bertrand's flight was on its way to Paris, and when Philippe woke the next morning, Bertrand had already let himself into the apartment on the Rue des Eaux.

The curtains were drawn so that, even though it was light, the room was in half-darkness. Bertrand stood as Philippe had stood, just inside the doorway, listening, and looking. He saw the LEDs on the stereo, and the answerphone blinking at the gloom.

He strode over to the window and drew the curtains, letting in the light. He looked at the answering machine and found the play button. He pressed it, and heard Marie's voice.

We found the presents, it said, but how had the presents got there? Philippe, were you in Kinshasa? Did you leave them? If you were in Kinshasa, why didn't we see you? Did you really just leave the presents and slip away? Was something wrong? Bertrand grinned.

The message ended. Bertrand opened up the answerphone and took out the tape. He took it over to the stereo and saw there was a twin tape-deck. He picked up a cassette, the Robert Cray Band. He went into the bathroom and tore off the corner from a sheet of toilet paper then walked slowly back to the stereo, chewing the paper and forming it with his tongue and teeth into a pellet. He put the pellet of paper into the record-protect notch in the Robert Cray cassette, then took a copy of the tape from the answerphone. Then he put the original tape back in the machine and listened as the device reset itself. He dropped the copy into the pocket of his abacost.

He searched the apartment for bank statements, credit card statements, correspondence. There was nothing. There were clothes in the wardrobe, toiletries in the bathroom, and there was the kitchen, with packets of food in the cupboards and

milk still in the refrigerator, but everything personal was gone. The place was like a hotel room; a guest had checked out and left a few things behind, but nothing more than you'd take with you on a routine business trip.

That evening, transferring in Brussels for the flight to Kinshasa, Bertrand bought himself a walkman. As the aircraft flew through the darkness, southwards over the Mediterranean and then on over Africa, Bertrand sat awake in the dimly-lit cabin listening to Marie's message. He listened to every little pause and hesitation, because everything inward shows itself eventually in something outward, just as Bertrand's concern for Marie showed itself, whether she knew it or not, in the battered brick-red Volkswagen parked just down from her house. Bertrand sat and listened to Marie's voice, and every time the music cut in at the end of her message he stopped the tape and rewound it, back to the start, and pressed play.

10

They met under Admiralty Arch. Philippe walked over from Charing Cross and crossed the lanes of traffic that keep Trafalgar Square surrounded. He wandered across the big, clumsily tilted expanse and looked at the National Gallery squatting at the high point, staring down with a bleak, grey frown.

He was standing under the arch itself, with his back to the square, when he felt a tap at his shoulder and turned to see a young man, somewhere in his late twenties, dressed in a grey chalkstripe suit. The clean-shaven face was a rosy pink, as if a layer of skin had been buffed off, and the man was smiling.

'Mr Thomas?' asked Philippe.

The man smiled. 'So you must be . . .'

'That's right,' said Philippe.

They shook hands and exchanged remarks about the weather, which was dry, but neither warm nor cold, neither bright nor dark, and have you been in London often before? And yes, a number of times. And what do you think of the place, not as warm as Kinshasa, I dare say? That's right.

They strolled under the archway and out into the Mall, which is an unusually quiet stretch of road, apart from the few state occasions when the whole wide avenue is lined by cheering crowds down its half-mile length to the Palace. They crossed over to walk alongside St James' Park. Philippe could see the Palace up ahead.

'I've had a chat about you', said the man in the suit. 'And the feeling is that you should stay on with us.'

'That's good', said Philippe.

'Yes', said the man. 'But, if you want any sort of formal, arrangement, you'll have to apply through the usual channels. Apply for asylum. There'd be no question of, er, detention. We don't generally grant full refugee status, but you should get leave to remain . . . it helps with, things like doctors and so on, or housing, I don't know if you'll need any help with . . .'

'Not with that', said Philippe. The man seemed pleased.

'They weren't terribly happy', said the man, 'about the, the, er, possibility of your being . . .'

'They will come after me. There's no question about that.'

'Well I can understand that', said the man. 'But, if you could be . . . discreet?'

'You mean, get myself shot quietly.'

The man smiled. 'Very droll', he said.

'I need to use another name', said Philippe.

'I suppose you know best.'

They had reached the small roundabout at the end of the Mall, with its overblown gilt statue set on a pedestal of stone. The Palace lay beyond, a subdued presence behind tall iron gates. There was no sign of life, just the bare driveway and the blank, blind windows.

'I want to bring my family out.'

The man gazed across at the Palace.

Philippe tried again, 'Can you help me with that?'

'It really is an awful mess, I'm afraid', said the man.

Philippe turned to look at him.

'I mean the Palace', he said. 'Sorry.' Then he checked his watch and Philippe saw the man's slender, pale wrist.

'And I'm afraid', said the man, 'I'll have to be going.'

He shook Philippe's hand. The man's hand was dry, and the grip surprisingly firm.

'Well, it's been very nice to meet you', he said. 'I hope you enjoy your stay.' Philippe looked blankly at him.

'I'm sorry', he said. 'That was . . . a little foolish, wasn't it.' He laughed.

'Not really', said Philippe, and smiled at the man.

They said goodbye. The man began to walk away. Very upright. Very neat. Philippe saw the man turn, a puzzled expression on his face.

'Oh', he said, 'You won't mind, will you? We might send someone round to have a chat with you, about, . . . your country. If that's all right?'

Philippe said fine. The man smiled his happy smile, then turned and walked away.

Philippe walked back through St James' Park. He crossed

Horse Guards Road, then over the parade ground and through a passageway into Whitehall. As he emerged from the passageway he saw two guardsmen in their dress uniforms, standing to attention on either side of the opening. They wore tall, conical helmets, dark blue and highly polished, with long ponytails of horsehair falling from the point. Their faces were expressionless, and Philippe stood for a moment or two, looking at them, watching them stare out unresponsively on everything that passed.

A few minutes later he was back at Charing Cross, back among the welcome bustle, the noise, the endless anonymous hurry of the station concourse.

Marie had never learned to drive, and when she had any distance to travel across the city she called for a taxi. The call gave Bertrand's men a little warning. It meant that the two men in the Volkswagen were ready to move as soon as the taxi arrived. After she'd called for the taxi she'd phoned her mother to say she was on her way, and from the sound of the mother's voice, said the man listening in on the line, it's nothing special.

Whenever Philippe was away from home, which was most of the time, Marie would visit her mother two or three times a week. When Eric came back from school she'd feed him and then they'd go round for the afternoon. Marie's family home wasn't as grand as the house she shared with Philippe, but there was a patch of ground where Eric could play, and the child's grandmother spoiled him with toys and sweets as well as she could. She expressed from time to time a little jealousy of Philippe's success, but then the family had arranged the marriage with betterment for the girl in view. And there were no complaints; Philippe looked after his wife and child well, he was generous. It had all worked out.

The taxi dropped Marie and Eric in the street outside her mother's house, and the men in the Volkswagen watched from a distance as Marie paid the driver and turned towards the pale blue gate. There was nothing in her manner to suggest that she knew she was being followed. When she closed

the gate behind her, disappearing into the garden, the man in the passenger seat slipped quietly out of the car and strolled along towards the gate. He paused, checked the street, then glanced through a gap in the fence to see Marie approaching the house. Eric ran on ahead, and as he reached the door, it opened. An older woman came out and greeted him, but then she called across to Marie, who was still a few yards away.

'It's Philippe', said the woman. She was holding a cordless telephone up for Marie to see it. 'Hurry up, he wants to talk to you.'

The man hurried back to the car and called in the location. Bertrand cursed. He'd tapped Philippe's parents' home in Bukavu, but not Marie's parents. He shouted at the technicians, who immediately set about arranging to intercept the line.

'And I want a trace', said Bertrand. 'Now!'

'Philippe!' said Marie. 'Did you get the message? I left a message on your answering machine. Did you get it? Is everything all right? Why didn't you . . .'

'Fine', he said. 'I've had to leave Paris for a while. I didn't get the message.'

'I thought there must be something wrong?' said Marie. 'How did you get the presents to us?'

'Everything's fine. I just didn't get chance to call you. Are you all right? How's Eric?'

'We're fine', said Marie. She gave him Eric's latest school news and he let her talk for a minute, hearing the anxiety drop from her voice. Then he told her he'd be away from Paris for another couple of months.

'Do you have a number where I can call you?' asked Marie.

'Not yet', said Philippe. 'But I might be able to arrange for you and Eric to come and stay with me for a while. Would you like that?'

'Can't you say where?'

There was a silence. Philippe looked at his watch. It was Marie who broke the silence.

'I'm sorry, Philippe', she said.

'It's OK', he said. 'I'll be in touch. Don't worry.'

'OK', she said, and there was another long pause. Philippe heard the sound of a train pulling in at a nearby platform.

'*Au revoir, Philippe*', said Marie.

'*Au'voir*', said Philippe. He replaced the receiver just as a train announcement with its string of locations sounded over the tannoy.

Back in Kinshasa, Bertrand took off the headphones and dropped them on the desk in front of him. The technicians had intercepted the call just seconds before it ended. Bertrand had heard only the final 'OK' from Marie, then the pause, then their goodbyes.

'Do you want to hear it again?' asked the technician, his finger resting on the play button. Bertrand nodded.

He listened to the recording. There was a note of regret in Marie's voice, or resignation, perhaps. The tone dropped markedly from the 'O' to the 'K'. But then maybe she was just sad that Philippe wasn't back in Kinshasa with her. Certainly she sounded sad on her '*Au revoir*', and wasn't that a little formal anyway? But Philippe's reply was unexceptional, not exactly cheerful, but clear and confident. Bertrand had heard the same goodbye himself from Philippe a hundred times. Bertrand rewound the tape and played it back again.

When the replay finished, Bertrand turned to the technician.

'Trace?' he asked.

'No', said the technician. 'Overseas, that's all. But if he phones again, we'll get him, don't worry.'

Bertrand sighed. 'He won't', he said.

11

Marie took a bottle of beer from the refrigerator and set it on the worktop beside the glass. She pulled open the drawer and began to root around for the bottle-opener. It was in there somewhere.

From the living room, Bertrand could hear the cutlery and kitchen gadgets rattling. Then Marie cried out and he went through to find her holding a wad of kitchen paper to a cut in her finger. There were drops of blood beside the glass and the bottle.

'I'm sorry', she said. 'I couldn't find the opener. It's in there somewhere', and she indicated the drawer, an awkward movement, one hand still holding the wad of paper to her finger.

Bertrand glanced into the drawer and took out the bottle opener. 'I knew it was there', she said, and tried to laugh.

'Let me help you with that', said Bertrand, looking at her finger. 'Have you a band-aid?'

She pointed to the first-aid box on a shelf and Bertrand reached it down. He fished out a roll of adhesive dressing.

'Let me have a look at it', he said.

He was standing close to her. She could smell him, aftershave, overdone. He took her hand. His skin felt damp.

He took a pair of scissors from the drawer and cut a strip of the dressing. He peeled back the plastic film to reveal the adhesive. He set the tiny pad of pale yellow lint over the cut and smoothed down the adhesive. It was a neat job. He stepped away from her.

'Thank you', she said. The dressing was a warm pink colour against her skin. She took a dishcloth and wiped up the drops of blood from the counter.

'Thank *you*', he said. He'd opened the bottle and was pouring its contents into the glass. She watched the beer sliding down the tilted side of the tumbler. He was pouring it too fast, the head of foam filling the glass.

'Let's go back through', she said.

In the living room, Eric was still playing with the computer game. He had the sound on, reedy electronic music, the same phrases over and over, the tune never resolving.

'Can I see it?' asked Bertrand, and smiled at the boy.

Eric frowned. He was still concentrating on the game. Then he gave a sigh of disappointment as the game ended and the machine fell silent. He passed it across to Bertrand.

'My dad gave it to me', he said.

'I see', said Bertrand. He pressed the buttons, but nothing happened. The boy stretched out his hand and took the game. Bertrand turned to look at Marie. Eric immediately went back to the game.

'I just wanted to check that you were all right', said Bertrand.

'Is it Philippe?' asked Marie. 'Is something wrong?'

'No, not at all', said Bertrand. 'Haven't you heard from him? I thought he might have called you. It looks as if he'll have to be away for a while longer. I thought he might have told you.'

Bertrand sat back in the settee, the beer glass resting on his stomach. Marie saw how a dribble of beer had run down the glass and made a mark on his shirt. She watched as he lifted the glass and drained it, then set it down in front of him on the coffee table. Again she watched as a drip of beer ran down onto the polished wood. It would leave a ring. The computer game kept up its nagging treble.

'Hasn't he rung you?' asked Bertrand.

'He called the other day', said Marie. 'I was at my mother's. I go there when he's away.'

'It's good to have your family close at hand', said Bertrand.

'He said he'd be away for a while', said Marie. 'He didn't say where.'

Bertrand smiled as if to reassure her. Marie shivered.

'It's just that, if there are any problems,' he went on, 'with him being away so long. Don't forget us. If we can help you, just give me a ring.'

He took a leather-bound notepad from his jacket pocket,

and a slim, gold-barrelled pen. He wrote down his number and tore the sheet out of the pad. He passed it over to Marie. She glanced at it.

'Are you in Kinshasa now?' asked Marie. 'I thought you were still in Kasai.' She laid the slip of paper on the coffee table.

'I'll be here for a little while', said Bertrand. 'Looking after some of Philippe's business, while he's away. Just like in Kasai.' He grinned.

'That's good', said Marie.

Bertrand was looking around the room, at the furnishings, at the television and stereo. Nothing damaged, nothing out of place. If Marie had noticed that they'd searched the place, he'd tell.

Everything in the house seemed new, and expensive. He'd talked to Kawena about freezing Philippe's account, but Kawena had advised against it. Marie was their best asset, he said. Philippe will have other accounts that we don't know about. Freeze the account in Kinshasa and the only one you hurt is Marie. The less she knows there's anything wrong, the better.

'You're all right for . . . I mean, you've no . . . money worries?' asked Bertrand.

'No,' said Marie, shaking her head. She was staring at the glass.

'You're sure everything's all right?' She nodded. She seemed lost in thought for a moment, then gave a little shake of the head.

'Your glass is empty', she said. 'Would you like another drink?'

He shook his head. 'No, thank you', he said. 'I'll be going.'

They both stood and, as if by some hidden agreement, they both looked at Eric, who was sitting on the floor with his back to them, still engrossed in the game.

'*Au revoir, Eric*', said Bertrand.

'*Au'voir*', said Eric, without turning round. Marie smiled at Bertrand and followed him to the door. They said goodbye and she watched as he walked to the gateway. She could see

the silver-grey Mercedes through the railings. As he climbed into it she waved to him, and she watched as it moved away from the kerb. Then she went back into the house. She went into the kitchen and scrubbed her hands, changing the dressing that Bertrand Kotosa had put on her finger. That done, she picked up the glass from the coffee table and took it into the kitchen. She dropped the bottle and the glass together into the waste bin, and took a damp cloth to the coffee table to wipe away the circle that the glass had left. She looked again at the slip of paper with Bertrand's telephone number. She crumpled it up and dropped it into the wastepaper basket. Eric remained absorbed in his game.

'Can't you shut that music off!' she shouted at him.

Eric turned towards her with a puzzled expression on his face, but he said nothing. He simply pressed a button on the game machine and went on playing. The only sound came from his fingers moving on the controls, it wasn't even distinct enough to be called a click, or a rattle, it was just a faint sound, almost nothing.

Back in the *deuxième Cité*, Bertrand sat and listened to the tape of Marie's two calls. She'd made them, said the technician, just moments after Bertrand left.

The first was to her mother. She asked if Philippe had called, and her mother said no. She explained that Philippe was going to be away for a while longer, and her mother asked if she was OK? She said yes. Her mother said, How about if you come and stay with us for a week or two? Marie said no, but maybe I'll call round more often. Her mother said that would be lovely, Marie said she'd ring. They said goodbye.

Then she'd called Philippe's apartment in Paris. Bertrand listened to Philippe's voice, very straightforward and business-like, inviting the caller to leave a message. It was reassuring to know that the answering machine was still working normally. Then Marie's message, just Philippe's name, a hesitation, then she put the phone down.

There was an intercept on the line to Philippe's family in Bukavu, but so far it had picked up nothing. They still hadn't

got the intercept organised in Paris. Bertrand could feel Marie's hand in his, he could smell the scent she'd been wearing.

'Do you want to hear it again?' asked the technician. Bertrand shook his head.

'What else do you want?' asked Kawena. Bertrand had given him a summary of the situation and they'd agreed not to bother pursuing the Paris intercept. Bertrand had put someone onto the apartment; the man would call in every day to see if there were any change, or any messages on the answerphone.

'And I'd like reports from the likely countries', said Bertrand. 'Any changes, new faces. I'd like an update each week. France, Germany, Belgium, England . . .? And I'd like a breakdown of the agencies he'd use, charities, institutions, if he decided to apply for asylum.'

'Sounds good', said Kawena. 'I'll set it going. I'll have it come to me, in the first instance; if there's anything interesting, I'll let you have it straight away. Anything else?'

'There is one other thing', said Bertrand.

'Tell me', said Kawena, just the ghost of a smile on his face.

'I'd like the file on the trial', said Bertrand. Kawena pursed his lips.

'Is there a transcript?', asked Bertrand.

'No', said Kawena. 'There isn't'.

'I thought there would be', said Bertrand.

'Something like that', said Kawena, 'would be dealt with at . . . a very high level. Very little that happens at that level is written down. You understand?' There on the wall was the photograph of Mobutu. The president was resplendent in a dark abacost and a leopardskin hat, with a heavy, gold-plated cane like a sceptre in his hand.

The warrior goes from strength to strength, and crushes the heads of his enemies. Mobutu was gazing out at distant horizons, before him lay the worlds that he would conquer, behind him there were clouds of smoke. He raised the sceptre

and his people were exalted, he struck down, and the nations were destroyed.

'It's always possible', said Kawena, and Bertrand turned to look at him. 'It's always possible that Philippe's still on our side. You do realise that, don't you? He may simply be insisting on working in his own way. You must remember how often he does that. You better than anyone.'

12

Philippe pushed open the heavy wooden door with its facing of battered steel. There was a hallway beyond with a floor of decorative tilework, geometrics in oxblood, cream and black, but many of the tiles were cracked or missing and the gaps had been filled with rough concrete. A 40-watt bulb dangled from a yellowed plastic cord. At the ceiling, where the flex was connected to the mains wiring, a small circular bakelite fitting should have shrouded the wires, but the fitting had slipped down the cord and hung at an angle just above the bulb so the hallway smelled of overheated bakelite, a mix of urine and fish.

He began to climb the stairs. They were of wood, and at some time in the distant past they'd been covered in linoleum. On some of the treads the linoleum, or patches of it, still remained. Mostly, however, the stairs were of bare wood, the lips of each tread worn down in a wide, careless grin. On some of the treads it seemed that someone had tried to reduce the wear by screwing a metal strip across the edge. The strips of metal were wearing in their turn. It was a place where small businesses and institutions came to die, a terminal ward where exhausted enterprises wheezed on until the corporate world finally put an end to their suffering; print brokers who had brokered their last, small time accountants, franchised agents for long-lost causes. On the third floor he found the offices of Asylum. He knocked and a woman's voice invited him to come in. When he saw her he guessed Nigeria, maybe, Guinea . . . somewhere in West Africa. She was about twenty-five, twenty-seven.

'Sit down', she said, and indicated a chair. On the seat of the chair was a pile of leaflets, he read 'Home Office' on the top of them.

'Just pass them over', she said, and he handed the pile of papers across. She looked around her for a moment, then found a space where they could squeeze in among the stacks

of paperwork, the files slithering over one another, sheets of paper, typed, handwritten, which had broken loose from their folders. Every folder a different case and everywhere a flutter of yellow post-it slips. There was a list of phone numbers pinned to the wall with three years' year-planners, with duty rotas, with children's drawings, political cartoons, and endless snapshots, dispossessed faces of Africans, Asians and South Americans.

'It's meant to convey an impression of order and efficiency', she said, and grinned. 'Makes the civil servants feel at home when they visit us.'

'Which they do often?' asked Philippe.

She laughed. She reached across her desk and he shook her hand.

'I'm Julie Morgan', she said.

'Pleased to meet you', said Philippe. The phone rang, and Julie talked briskly to it, taking notes in a firm, confident hand. She finished the call, then tore the note off her pad and turned in her chair. She posted the slip of paper on the pinboard behind her, then turned back towards Philippe.

'I'm sorry', she said. 'I'm on my own till one. Then I'm out of here.'

There were a half-dozen more phone interruptions before she switched on the answerphone, and after the first couple of calls came in she flicked another switch so that the machine answered without the caller's message being heard. She listened to Philippe's story first time through without comment, simply making notes. Then he went over it again and she asked questions. When he mentioned the UDPS, she interrupted.

'Tchisekedi, isn't it?' she said. He said yes.

She nodded.

At one o' clock the door opened and a white woman in her thirties appeared. She had the same strayed, creased appearance as the office itself. Her hair was showing streaks of grey.

'Linda', said Julie, as a gesture towards introduction. Philippe stood and shook her hand.

'He's a gentleman', said Julie, and Linda gave a mock curtsey.

'Shouldn't you be getting going?' asked Linda.

'Yes,' said Julie.

She started to fill in the application for asylum. Linda started on the phone messages, returning calls that Julie had taken earlier, then replaying the messages from the answering machine. By half past one the forms were done. Julie showed Linda the completed papers.

'Can you photocopy these for me?' she asked.

'Sure', said Linda.

'Oh', said Julie, and she turned to Philippe. 'We should take a photocopy of your passport, too. You'll have to send it in with the forms.'

'And if you have any problems', said Julie, putting on her coat. 'Give me a ring. If I'm not here, you can get me at my chambers.' She handed Philippe a business card. Then the phone rang. 'Thanks, Linda', she said, and she was gone.

Philippe looked at the business card. It was beautifully printed. Philippe didn't recognise the address, nor the name of the business — a string of English-sounding names. The word 'Temple' caught his eye.

'She's a lawyer', said Linda, holding her hand over the phone and nodding at the card. 'Very expensive.'

'Where's she from?', asked Philippe.

Linda said goodbye and put the receiver back on its cradle. She looked up and saw Philippe still waiting.

'Julie?' she said. 'Islington.'

Linda took him through to the photocopier, which was in the next office. She left him to photocopy the application forms and his passport, two copies of each. The passport photographs, at her suggestion, he obscured with a slip of plain paper before he took the copies. When he'd finished he handed her the originals and one set of copies. She wrote out the address on the envelope, and put the original forms into it. She took the passport and opened it.

'Paul', she said. 'Paul Nkanda? Is that how you say it?'

'That's how you say it', he said.

She dropped the passport into the envelope together with the forms, and sealed it. She put her set of copies into the file they'd started for Paul Nkanda, together with Julie's hand-written notes. Philippe watched as she opened the filing cabinet and found a place for the file.

Chris Davis decided to finish for the day. The radio commercial he'd been working on was done. He'd faxed it over to the client, and then fielded an ecstatic phone call. *It's perfect. It's just what we want. It's clever. It's direct, and it's oblique, both at the same time. You're brilliant, Chris. Can you come over when we record it, though, just in case . . .*

The light in the attic was fading. They'd turned it into an office, putting big skylights into the roof, and during the day it was gloriously bright. Even on a dull day the space was filled with light. The only problem was that the light bleached the colours out of everything, book covers, the little oriental rug; and cheap paper yellowed quickly.

Isobel, his wife, was working in Oxford, where she did three days a week for a small publisher on a consultancy basis. It meant she'd be late back. It fell to Chris to organise the evening meal. He switched off his Mac, switched off the photocopier, and went downstairs.

He'd just finished browning the onions and the meat when he heard the front door open and close. It was too quiet to be family, so he poked his head round the kitchen door and looked. Philippe was taking off his coat and hanging it up.

'*Ca va?*' asked Chris. 'Not bad, eh?'

Philippe grinned. 'Very good', he said.

'Come on through. I'm cooking.'

Philippe went through into the kitchen. With Chris directing, he opened two tins of Italian tomatoes and added them to the pan of meat and onions. He stirred it all together while Chris fussed round, gathering up small jars of spices which some unknown force had cast to the corners of the room. Then he added fresh orange juice and the two men tasted the result.

'I know what it needs', said Philippe. 'Mangoes'.

'Mango chutney', said Chris, and went to the far end of the kitchen where he ferreted about in a cupboard, emerging triumphantly a few moments later with a jar of mango chutney.

'It's mouldy on top', he said, 'but I can scrape that off.'

Eventually they left the sauce to simmer and, while Philippe made a pot of tea, Chris served up two bowls of ice cream. Finding the ice cream was the easy part. Finding space at the kitchen table was more tricky. It was covered with part-made children's masks.

'It's a project Isobel's doing', said Chris. 'They're publishing a kind of activity pack. A book about masks, with instructions for making different masks.' There were animal heads in bold reds and yellows, and masks in half-finished states with papier-mâché or modelling paste built up over armatures of wire. Chris picked up a small circular mask with two tall horns rising up from it. He held it to his face.

'What have you been doing today?' he asked, still looking at Philippe through the eye-holes of the mask.

'I've applied for asylum', said Philippe.

'Oh', said Chris, and put down the mask.

'I gave them your address. I hope that's OK,' said Philippe. 'Someone may want to get in touch. It's an organisation called Asylum. I talked to a Julie Morgan. Is that OK?'

'Why wouldn't it be OK?'

'How much do you know about Zaire?' asked Philippe.

Chris laughed. 'You mean, apart from Joseph Nsembe?'

Philippe gave a little, sardonic smile.

'Nothing, really', said Chris.

'Have you read much in the papers?'

Chris shook his head. 'I don't know that I've ever seen much about Zaire,' he said. 'There was an exhibition once, anthropology. It was a museum in London. We went there to see masks and things. It was a man called ... Tor-something ..?'

'Torday', said Philippe.

'That's right', said Chris.

'It's a long time since Torday was there', said Philippe.

For a while there was only the clink and scrape of spoons in dishes while both of them attended to their ice cream. Philippe gazed down at the soft half-melted vanilla cream and the stainless steel bowl of a spoon slipping through it, thin matt streaks of cream where the bowl of the spoon had come from his lips. He finished, and set the dish down on the table.

'I used another name', said Philippe, 'Paul Nkanda. It's possible that someone could come after me.'

Chris looked at him without comment.

'From Zaire,' said Philippe. 'From Security.'

'What would they want?'

'They might want to arrange for me to return to Zaire', said Philippe, and smiled. 'Or they might want to arrange something here. You might come home one day and find that Philippe has had an accident.'

Chris had finished his ice cream. He picked up the mug of tea and took a long sip from it. Still holding the mug to his mouth, he looked carefully at Philippe over the rim.

'If it were me', said Philippe, 'a place like Asylum would be the first place I'd look.'

Chris Davis put down his mug of tea. He shook his head.

'If it were you?'

'It's an obvious place to start', said Philippe. 'Places like that never have decent security. He could break in and go through the files. He could walk in through the door and pretend to be a refugee himself. People come and go all the time. He could easily get a chance to look through the files. Or see where the files were kept and then go back later.'

'And he'd use a false name.'

'He'd use a false name, that's right.'

'So,' said Chris, 'applying for asylum's quite a risk',

Philippe smiled. 'But there's no choice, is there?'

'If you're going to get Marie and Eric out.'

'If I'm going to get Marie and Eric out.'

Chris picked at the edge of the table. 'It's hard to believe', he said. 'You really think they'll come after you?'

'It's possible', said Philippe.

Half an hour later, Matt and Allie came in from school. They breezed into the kitchen to see what there was to eat and found their father stirring the sauce, the table already set.

13

It was almost six in the evening, and they still had six hours left before the changeover. The driver's seat in the brick-red Volkswagen was as far back as it would go and Justin still couldn't get enough room to be comfortable. Denis was snoring in the back seat.

Back at base, Bertrand sat and watched the spools on the tape deck slowly turning. All he could hear was the sound of the television. Then he picked up Marie's mother, her voice quiet, and he strained to make out the words. On Bertrand's left a technician turned up the gain and the speech became audible. It was Marie's name, spoken over and over. Then Marie herself, waking from sleep.

'You said to wake you at six', said her mother. Marie mumbled a reply.

'Eric's still fast asleep', said her mother. A yawn from Marie.

'Can you ring for a taxi?'

They heard the call go out to the usual taxi firm. 'Yes', said Marie's mother, 'it's just to take my daughter home again.' The dispatcher promised they'd be there in ten minutes. Bertrand nodded to the man on his right and the message went out to the Volkswagen that Marie was about to move. Justin turned awkwardly in his seat and delivered a firm thump to Denis' ribs. 'We're off', he said.

'Now?' asked Denis, sitting up.

'No, tomorrow', said Justin. Denis grunted an obscenity and settled back down into the upholstery.

The taxi arrived and Justin thumped Denis again.

'Now!'

Denis yawned. He opened the rear door and hoisted his feet out but remained sitting on the back seat. Marie carried Eric to the taxi. She opened the rear door and laid the child, still sleeping, on the seat. She turned and said goodbye to her mother, gave her a hug, then climbed into the front seat of the

taxi. The car moved away. Marie's mother waved after it for a moment then turned back to the house.

Justin started the Volkswagen's engine. The suspension gave a squeak of relief as Denis lifted himself out onto the pavement. He walked round to the Volkswagen's passenger door. He lowered himself down into the seat and reached out for the door handle to pull the door shut. Justin was pulling away from the kerb as the door closed, but the taxi had already turned out of the street. By the time Justin reached the main road there was too much traffic in the way.

'Just drive to the house', said Denis, 'If you don't say anything, I won't.'

Twenty minutes later they pulled in at Marie's house, and Denis radioed their position in to control. 'We're back', said Denis. 'They're inside.'

'No they're not', said Bertrand.

The time was six thirty-four. Bertrand ordered the roads closed, the Stanleyville road and the road to Matadi, and he gave out the taxi's registration number. The roadblocks were in place in minutes and tailbacks started to reach back into the city. Bertrand called for a check on the last sailing of the ferry over to Brazzaville, but it had left before Marie and Eric got into the taxi. He rang the railway station and held all the trains. At eleven minutes to seven a radio message came in from a checkpoint on the Ndjili road. They'd stopped the taxi; it was empty, on its way back from the airport. As Bertrand rushed out through the reception room of the *deuxième Cité* he saw Justin and Denis, handcuffed to a bench and close to tears.

Marie had presented the tickets at the check-in desk. A query first of all, she imagined, if you could just wait a moment . . . the queue would shrink back from her. The staff at the neighbouring check-in desks would start to steal glances at her. There'd be a long wait, people spying through the blinds of the upstairs office windows that overlooked the entrance hall.

The girl at the desk asked if she'd like smoking or non-smoking. She said non-smoking, and could she have a window seat for the child? Eric was still asleep and she was finding

him heavy on her shoulder. She tried to move his weight a little without waking him, and the girl at the desk smiled at her sympathetically. She handed Marie her boarding pass and pointed to the escalators that would take her up to the international departure lounge. Half way up the escalator, Eric woke. He looked all around him, baffled, still half asleep, but she told him they were going to meet Papa, and he smiled. When they reached the top of the escalator she put him down. She took his computer game from her jacket pocket and handed it to him.

At passport control the young clerk was fascinated by the computer game, but any thought he might have had of confiscating it came to an end when he saw the diplomatic accreditation on Marie's passport. Avoiding eye contact, he waved her through.

The lounge was quiet, not more than a hundred or so people spread across what seemed like acres of worn, navy blue carpet and royal blue upholstered chairs. She found seats in a corner, half-hidden by one of the large, white-painted concrete pillars. Close by, there was a young family with two children about Eric's age. She settled Eric down to play his game, and he promised her he'd stay there until she returned. She promised him it would only be a few minutes. When she looked back he seemed to be just a third child in the family group.

There was a shop selling large squares of brightly coloured cotton prints. She bought one, a pattern of parrots in scarlet and pink and yellow. In the toilet she slipped off the jacket she'd been wearing and stuffed it into a waste basket, piling used tissues on top of it. She arranged the cotton square into a headdress that veiled half her face and draped down over her shoulders like a shawl. She went back to check on Eric; he was still absorbed in the computer game. She noticed, however, that he looked up as she approached, recognising something in the sound of her steps even before he saw her.

The flight still wasn't boarding. She bought a newspaper. At the duty-free shop she browsed for a while through the drinks section, then bought a carton of cigarettes and a lighter. She

took them over to where Eric was sitting and transferred the contents of her handbag into the gaudy plastic carrier the checkout girl had given her. She took just one packet of cigarettes from the carton, dumping the rest behind the seat. Eric was watching her now with silent fascination. She took out a cigarette and lit it, then sat back on the seat. The lounge was starting to fill up.

'I've never seen you smoke', said Eric.

'I don't', she said. 'Never mind'. Eric shrugged and turned back to the game. She opened the newspaper and pretended to read. Another couple came and sat on the next set of seats to her left, with three more children, overtired and restless. They were just settling down when an older couple came over and began to talk to the first couple. Out of courtesy the younger couple stood, and Marie saw that they were screening Eric and herself from the rest of the lounge.

She heard the first call for the Brussels flight. The people to her left were still standing and talking. She leaned forward and looked past the concrete pillar out across the lounge. She saw a group of youths enter the lounge, about twenty of them, all wearing identical maroon blazers and carrying identical sports bags, being shepherded about by four older men who were trying to keep them together but failing. As they reached the centre of the lounge, Marie stood and led Eric towards the gates.

There was another lounge, but smaller, about the size of a tennis court, with the same navy carpet and the same royal blue chairs. A stewardess stood by the doorway that led out onto the tarmac. The girl was fidgeting, impatient. Marie settled down at one side of the lounge, and hid behind her newspaper again. As she glanced out past it, she saw two men in abacosts walking down the far side of the lounge. They strolled up to the stewardess and chatted with her for a few moments, and all three of them surveyed the lounge. Marie felt herself trembling, but when she looked at her hands they seemed steady. She tried to hide, but she couldn't help peeping out past the paper.

The two men were walking back up the lounge, on the side where Marie was sitting. They were almost level with her. She

glanced out past the newspaper again. They walked past. They kept on walking. Moments later she peeped again and saw them leave the lounge. She could hear a voice on the loudspeaker announcing that the Brussels flight was about to board. People were standing up and starting to form a queue. Eric's computer game burbled away beside her. The stewardess was chatting with the people at the front of the queue, checking their boarding passes, then talking to someone on a mobile phone. Marie saw her reach out her hand to a panel of switches beside the door. The girl pressed a switch and the door opened. The rest of the people in the lounge stood and began to drift over to the queue. She stood and took Eric's arm. They joined the queue. The door closed again. The girl was still smiling, chatting to the passengers. She spoke into the mobile phone again. She reached out and pressed the switch and the door opened; another batch of passengers walked through.

Marie was close to the front of the queue. She glanced around but the men in abacosts were nowhere to be seen. She could see out through the glass of the door. Beyond it, darkness had fallen, but there were lights. She could see the runway lights. She saw a train of baggage carts trundling in towards the terminal buildings. A coach pulled up just in front of the boarding gate and she saw its lighted interior. She saw the doors on the coach fold open, and the stewardess pressed the switch that opened the door that led out onto the tarmac. The queue shuffled forward. Marie held out her boarding pass and Eric proudly held out his. The girl ripped them in half and handed them back. They were out. Away in the distance she could see the aircraft. She could see the steps that led up to the doors at the front and the rear of it. One of the airport coaches was pulling away from the aircraft, turning, heading back towards the terminal building.

'Excuse me, Madame'. She heard the voice just as she felt the touch on her arm, just as she smelled Bertrand Kotosa's aftershave.

★

He led her to the dark Mercedes, parked on the tarmac just a few yards away from the airport coach, but hidden in shadow.

'It was the game', he said, and patted Eric on the head. 'I recognised the music', and he smiled his broad smile. 'If you can call it music.'

On the drive back into Kinshasa he studied the tickets. They'd been bought in Brussels two days previously. There was no onward connection. He looked at her passport, and compared the picture in it with the woman at his side.

'It doesn't do you justice', he said.

The Mercedes pulled up at Marie's home. The driver, like a courteous chauffeur, held the door open for Marie to get out. Eric followed her, and Bertrand joined them at the kerb.

'I thought we were going to see Papa?' said Eric.

'In a little while', said Bertrand. He stooped to bring his face down to Eric's level, and patted the side of the child's face. 'In a little while.'

He waited in the living room while Marie put Eric to bed. When she came back through from the child's room, Bertrand had switched on the television. He was sitting on the sofa, flipping from channel to channel. She sat down in an armchair and gazed blankly at the changing images.

'How's your finger?' he asked. Marie just stared at the television.

'Your finger. You cut it the other day. Do you remember? I put a dressing on it for you.'

'It's fine', she said, still looking at the television. Bertrand flipped channels again.

'Where did you get the tickets?'

'I don't know', she said.

'Where did you get them?'

'I don't know', she said. 'I came down this morning and they were there.' She pointed to the coffee table. Bertrand looked at the table's bare surface.

'They were on the coffee table', he said, as if he were checking a minor detail, the spelling of a name.

'I don't know how they got there', she said.

'It's a puzzle, isn't it', said Bertrand.

'I suppose it is.'

'And no note?'

She shook her head. 'It didn't need a note'.

'I suppose not', said Bertrand. 'Well, that's it, then.' He stood up and she glanced up at him.

'My mother knew nothing about this', she said.

'I know', said Bertrand.

'I'll hang on to your passport for the time being', he said.

She watched him leave. The house was quiet. The whole street was quiet. She heard the door of the Mercedes bang shut, and heard the car drive away. She really didn't know how the tickets had got there.

Back at the *deuxième Cité*, Bertrand pulled in the surveillance teams. He made them write down everything they'd seen, or said, or even thought of saying; every five minute period to be accounted for, what they'd eaten, when they'd passed water. 'And from now on,' he said, 'if you so much as fart, I want a note of it.'

But to Justin and Denis he never said a word. He stood and watched. He didn't blink. He saw them fastened to the wooden trestles and he watched for the first ten minutes or so. Then he went to the canteen and had supper. He took his time over supper. Then he went back to see Justin and Denis again, and watched, and listened. After a few minutes he spoke to the men who were working on them, 'I don't want Kawena to know about this'.

The men looked at each other with puzzled expressions, then back to Bertrand.

'Do you want us to stop?'

Bertrand looked at Justin and Denis.

'No', he said. Then he went home.

When Mickey Mouse has gone to bed, what follows, though protracted, noisy, and bloody, has little to do with the extraction of information. Nor does confession lead to absolution, unless of a final sort. Nor is it by accident that the colonial villa on Ngaliema, backing onto the river, is just above Kinsuka.

101

By eight in the morning Bertrand was in Kawena's office, telling him about the previous evening, leaving out the killing of Justin and Denis.

Kawena listened patiently.

'Bertrand, I don't want you to worry', he said. 'Everything you've done, I would have done myself', he said, 'except, perhaps ..'

Bertrand looked up anxiously.

'Except, perhaps,' said Kawena, 'perhaps I'd have let her go. It might have taken us closer to Philippe.'

'But if he *has* gone over', said Bertrand, 'his family's all we've got.'

'Maybe', said Kawena. 'But I asked you to do a job, and that job was just to see what happens. Don't try to *make* anything happen. Just be patient and tell me what you see. Don't worry about Marie, and don't take it personally. Just wait and see what happens, OK?'

'OK', said Bertrand.

'Just keep her wrapped', said Kawena.

'I will', said Bertrand. 'Don't worry, I will.'

Kawena still hadn't heard about Justin and Denis.

Philippe watched from a distance as the passengers from the Kinshasa flight emerged from immigration. He saw that Marie and Eric weren't among them, and he saw the two men in abacosts, but he was gone before they had a chance to see him. Brussels airport is one of the busiest in the world.

14

Back in the house in Crouch End they'd finished the meal when they heard a key in the front door. Chris Davis nodded to Matt, who got up from the table and went to the refrigerator. He returned with a bottle of champagne and passed it across to his father. The front door opened, and a moment later it closed again. They listened for voices.

Allie went across to the kitchen door, she opened it and looked along the passageway. Philippe was taking off his coat. She watched as he hung it on a hook behind the door. Allie turned and looked at the bottle of champagne.

'Put it away', she whispered. The family stared at her.

'He's on his own', she said. Chris Davis stood. He picked up the bottle and took it back to the refrigerator. He closed the refrigerator door and paused for a moment with his back to the rest of the family. When he turned, Philippe was standing in the kitchen, trying to smile.

'She didn't make it', said Chris.

Philippe still tried to smile.

'What will you do?' asked Allie.

There was a long silence before Philippe spoke.

'I'll try again', he said. 'But it will take time to work out the best way . . .'

Isobel went over to the cooker and began to warm up what was left of the food.

'Would you like a drink?' asked Chris.

Philippe smiled. 'That would be good', he said.

It was late. There was a Spurs game on the TV. Chris and Philippe sat and watched it together. Matt and Allie were out with their respective groups of friends, and Isobel was working in the attic. The game finished, they sat and watched the discussion and the replays of the goals. No-one spoke, and when the programme was over Chris switched the TV off with the remote control. They sat in silence for a while, then

Chris reached across to the settee where the day's paper lay open.

Chris tidied up the newspaper and then began to look through it.

'There was a bit in today', he said, and shuffled through the pages. 'If I can find it'.

'Here', he said. 'It's about a man from Zaire. Did you see it?' Philippe shook his head.

'He's been deported', said Chris. 'Even though . . . hang on. He's a teacher . . . "arrested last year during an anti-government strike in Kinshasa. His account of maltreatment by his guards was corroborated by the Medical Foundation for the Care of Victims of Torture, which found his deafness, spinal trouble and depression consistent with his allegations of brutality" . . . and they sent him back . . . told the judge they'd keep him in Britain . . . then put him on a flight to Kinshasa . . . here, look.'

Chris passed the paper across to Philippe, who began to read the article.

'Do you know anything about it?' asked Chris.

'I think I know who he is', said Philippe.

'What'll happen to him?'

'It says they handed him over to Immigration.'

'They won't just let him go ..?'

Chris glanced at Philippe's face. Philippe was looking at him.

'What do you think', asked Philippe, 'when you hear the word "refugee"?'

Chris looked away. He stared at the blank grey television screen.

'I'm not sure', he said. Philippe waited.

'I suppose I think of people trying to get out of Germany . . . get away from the Nazis. Jews, I mean. I suppose I think of them being put onto trains or boats, children, parents waving them off. Or I think of people in huge camps in Africa, dirt, mud, dirty water . . . cholera, dysentery . . . people who've had to leave everything behind . . . like the man in the paper, maybe, people who've been . . . beaten up, tortured?' He

glanced across at Philippe, who was looking impassively at him. He stared at the television screen again. He pointed at it, 'We get it all on there', he said, 'pictures. After a while they . . .'

'I am a refugee', said Philippe, and Chris turned to look at him again. For a moment he held Philippe's gaze.

'But I wasn't tortured', said Philippe.

'I was simply asked to do one thing', said Philippe. 'And if I had done that one thing, my government would have given me a great reward.'

Chris gazed at the screen.

'But this man', said Chris, still not looking at Philippe. 'He was tortured. They say. You believe it?'

'I believe it', said Philippe. 'It's common. If he took part in a demonstration . . . he could easily have been picked up ..'

'Have you seen it happening?'

Chris turned to look at Philippe, and still Philippe gazed back at him, as if he hadn't heard the question. Chris looked away again.

'Did you ever . . .?'

'No-one can say they don't know it goes on', said Philippe.

'But you were working in Security', said Chris.

'I was not a torturer.'

'But you knew about it.' Chris turned again and glanced at Philippe's expression for a moment. It was as if a shutter had come down. There was a long silence before Philippe answered.

'I knew about it.'

'You were there when it was actually happening?'

He glanced at Philippe again. No reaction.

'And you had a senior position?' asked Chris.

'You could say it was a senior position.'

'So you . . . trained people ..?'

'I trained people to be interrogators', said Philippe. 'It's not the same thing.'

'But some of them were torturers?'

'Yes'.

'And you trained them?'

'Not to torture. That wasn't necessary. People . . . some people were . . . I don't know the word in English, *sadiques*?'

'Sadists?' said Chris.

'They found their own ways . . . their own techniques. We didn't need to train them to do that.'

'But you knew what they were doing?'

'No-one can say they don't know what happens.'

'I heard once, you can tell what stage someone has reached . . . by the kind of noises they make . . . you heard them?'

'It's like this house', said Philippe. 'Matt and Allie. They have their friends round sometimes . . . they go into their rooms . . . you don't follow them around, but you have an idea . . . or, if someone comes into the house, to repair something, a plumber, say. You don't stand over him and watch every little thing he does. But you know what's going on. You can't say you don't know what's happening in the house. Isn't that right?'

'I suppose so', said Chris. 'But sometimes you only have a very vague idea . . . I don't know what Allie talks about with her friends . . . I mean, I have an idea . . . but ..'

The telephone rang. Chris went into the hallway to answer it.

'Philippe', he called. 'It's for you. I guess. Paul Nkanda? Is that you? It's Julie .. something.'

While Philippe was speaking to the woman from Asylum, Chris gathered up the empty beer bottles from the sitting room and took them through into the kitchen. He tried not to listen to the conversation, busying himself with the dishes from the evening meal, scraping the last scraps of food from the plates and loading the dishwasher. He pressed the switch and the sound of water rushing into the machine was enough to drown Philippe's quiet voice from the hallway. Then the conversation was over and Philippe joined Chris in the kitchen.

'It's Asylum', said Philippe. 'It's the organisation I went to when I applied to the Home Office . . . for refugee status.

They're trying to help with this man's case, the teacher in the paper. They want to know what's happened to him since he was handed over in Kinshasa.'

'And you can help them?' asked Chris.

'It's possible', said Philippe. 'I know some of the people in Immigration. It's possible that some of them would talk to me . . . I don't know how much they'll know. Probably not much.'

'Are you going to call them?' asked Chris.

Philippe pulled out a chair from the kitchen table and sat down.

'Don't worry about phoning from here', said Chris. The dishwasher suddenly clicked into the next part of its cycle.

'I don't know if it would do any good', said Philippe. 'I don't know if it would make any difference.'

'But it might?' asked Chris.

The dishwasher fell silent.

'You don't mind if I ring?' asked Philippe.

'No', said Chris. 'I'd be glad if you did.'

Kinshasa was too far away. In Britain it made sense, the words would squeeze along the wires like beads down a tube, and because the country was so small, they never really had far to go. But for the words to reach Kinshasa surely they'd have to rush, would fray or blur by virtue of the speed. And if they could survive the journey, what must they be like, fiery little packets of light flying along a fibre-optic highway, flicking across the darkened curve of the world.

Philippe stood and went into the hallway. Chris began to fuss over the production of a pot of tea. He ran the water into the kettle and plugged it in. He fished the used teabags out of the teapot and rinsed it out. He could hear the water in the kettle starting to rumble as it heated up; he poured a little into the teapot and swirled it around to warm the pot. He took down two mugs from the rack on the wall and went to the refrigerator for milk. He saw the champagne bottle. He closed the fridge door. He could just hear Philippe's voice from the hallway, but he couldn't make out the words.

Chris reached down the tin of teabags, he took two teabags

out and dropped them into the warmed teapot. The water was almost boiling, he waited beside the kettle for the click that cut off the power. He heard the click, he lifted the kettle and poured the water into the teapot. He put the kettle down, he put the lid on the teapot, he put the teacosy on the teapot. The dishwasher started a rinse.

Philippe came back into the kitchen.

'Did you get anything?' asked Chris. Philippe shook his head.

'I couldn't get hold of anyone I knew well enough', he said.

The man in the Immigration office at Ndjili put down the telephone and sat, motionless, at his desk. It took him almost five minutes to make up his mind, then he picked up the telephone again and rang Kawena. It was eight-thirty in Kinshasa, a warm dry evening; seven-thirty in London. At almost one by the kitchen clock the phone rang again in the hallway of the house in Crouch End.

Philippe answered, Chris followed him into the hallway. Philippe was talking French. It was a short conversation. Chris made out 'Merci', and saw Philippe put down the receiver.

Philippe turned to look at Chris, and smiled a wry smile.

'Good news?', asked Chris.

'It depends', said Philippe.

'About the teacher?'

'No.'

Chris waited.

'They know I called about him. There is a man . . . he used to work for me . . . he knows I called.'

'A friend?'

'Not really.'

'So . . . how much do they know?'

'What do you mean?'

'I mean, did they trace the call?'

'It's Zaire. We don't have the equipment. Not for every overseas call. Not automatically, but . . . If they think about the teacher's situation they'll narrow it down to Britain . . .'

108

'But if they didn't trace the call it's OK?'
'It might be.'
'If they didn't trace the call?'
'If who didn't trace the call?'

15

The envelope had appeared like an apport on the coffee table. She'd studied the tickets and the instructions on the sheet of paper. She'd disposed of the paper, as it said, burning it to ashes in the kitchen sink then washing the ashes away, soft grey ash and a few dark, brittle fragments. She'd said nothing, not a word, not to Eric, not to her mother. She'd looked round the house and told herself, and this she'd vocalised, that none of it mattered, the home, mementoes, luxuries, so long as . . . and that bit she hadn't vocalised. She'd said goodbye to her mother for the last time in her life without telling a soul what was really going on. She'd memorised everything she had to do, and she'd done it to the letter.

Then she'd sat in the back seat of the Mercedes on the way back from Ndjili, with the smell of Bertrand's aftershave. And then Bertrand had simply taken her passport from her and delivered her to her own home. It was only when he'd left her that she'd slumped sideways on the settee and begun to cry.

She woke in the small hours, cold and cramped, and took herself off to bed. In the morning Eric went through to her room and woke her, and she managed to make the child his breakfast before seeing him off to school. Then she sat and watched the television all day until Eric came home. She asked him about school, and listened while he spoke about quarrels in the class, about his teacher, about the work they'd done. She fed him chicken dinosaurs and sat with him while he watched a Tintin video. She got him off to bed, saw him washed, teeth cleaned, and when he laughed she managed to smile with him. Then she went to bed herself. She woke in the middle of the night when someone in the street slammed a car door, someone drunk and shouting incoherently.

She lay motionless, except for her lips and faint movements of jaw and tongue that showed as a slight shifting of her cheek. Her tongue was hardly moving at all, just fidgeting softly against her teeth, teeth barely apart, just touching softly

against each other, or her tongue lapping over the edge of upper or lower teeth, touching, dry, against her lips, against the ridge of tissue just behind her upper front teeth. Her mouth was so dry that when her tongue touched against her lips, against the roof of her mouth, it dragged for an instant on the dryness. And all of this movement was so slight it was almost invisible.

She watched as the early morning light crept into the room. She listened to the first traffic in the street. Then it was time to get Eric off to school again; she chattered to him while she made his breakfast, while he ate, while she walked with him to the garden gate. She waved to him from the gate as he walked off down the road, then she rushed back into the house.

Bertrand, listening in from the operations room, heard her being sick. He heard the toilet flush, and then he heard Marie run water into the basin, heard her washing herself. She went into her bedroom and he heard the sound of her zip being unfastened, then the clatter of clothes on hangers in the wardrobe, then he heard her rush to the bathroom again and listened as, time and again, she retched, groaning between times, and then she began to cry. After a while he heard the shower running.

Kawena paced back and forth behind his desk while Bertrand sat in the Bauhaus chair and sweated.

'You know they have families? Had families, I should say.'

'Yes', said Bertrand. 'But I thought it was more important to ..'

'You thought? How long did you think for?'

Bertrand said nothing.

'*Encourager les autres!*' said Kawena. 'Encourage them to do what? Encourage loyalty?'

'I wanted to make them afraid to . . .'

'To what? To help Philippe?'

'To be careless, lazy', said Bertrand.

Kawena sighed. He stood for a moment, staring down at the surface of his desk, at the folders, at the diary, the

newspaper. Then he looked up, saw Bertrand's anxious face, and smiled gently at him.

'Listen, Bertrand', he said, and his voice was calm. 'I know you've never been afraid to use . . . forceful means. But, sometimes that's not appropriate. I've asked you to watch what happens. Yes?'

Bertrand nodded.

'If we watch what happens we will learn', said Kawena. 'We will learn about Philippe, and we will learn about our *own* organisation. That's basic, yes? But you're stirring up the mud. You're making it harder to see. Do you understand?'

Bertrand nodded again.

'We know that Philippe's out of the country, yes?'

'Yes', said Bertrand. 'But we don't know . . .'

'And we know that somehow he got tickets to Marie?' he waited for Bertrand to nod again. 'And we also know that . . .'

'That Justin or Denis must have let someone go into the house without . . . or that one of them must have taken the tickets to Marie! Someone . . .'

'Who? How are we ever going to know, now? More to the point, Bertrand, how well do you think your men are going to trust you?'

'What made the man from Immigration phone you, then?'

'It might have been fear, Bertrand. It might even have been a sense of duty. It might have been that the man held a grudge against Philippe. I don't know.'

'So what should I have done with Justin and Denis?'

'Nothing, Bertrand. You should have done absolutely nothing. You should have noted the possibilities. But to kill them, just simply to kill them, it was . . . thoughtless. Do you understand?'

'But if Philippe has gone over to the other side . . .?'

'Think, Bertrand.'

Kawena picked up the newspaper. 'Have you read this?' he asked.

It was a French newspaper. Bertrand shook his head.

'Well listen', said Kawena, and began to read.

It was a simple piece. Since the end of the cold war, it said,

the African dictatorships, propped up by Western or by Soviet money, were expensive luxuries that neither Russia nor America could afford. As the evidence mounted of internal repression, of corruption, it became harder and harder for America in particular to justify supporting the hard men who'd been so valuable in the past.

'When Mobutu reads that', said Kawena. 'How do you think he's going to react?'

Bertrand stared at his boss.

'Do you think he'll be pleased?' asked Kawena.

Bertrand was staring at the surface of Kawena's desk and seeing the table in Marie's house where the tickets had appeared.

'If he hears that Bertrand Kotosa has been driving half the Security service into the arms of Etienne Tchisekedi?'

Bertrand looked up at Kawena, a miserable expression on his face.

'We have to learn to tread a little more lightly, Bertrand. Understand?'

'No-one lives for ever', said Kawena, and glanced at Bertrand. 'And if Philippe's trying to make himself credible as a refugee, what's more natural than trying to get his family out.'

'And if he's doing his job', said Bertrand, 'He'll be in London.'

'So the man from Immigration's probably right.'

'So I should go to London?'

'I think', said Kawena, 'that it would be a good idea for you to leave Kinshasa for a while. I want you to go to London and see if you can find Philippe, and I want you to tell me what you see. Do you understand? I don't want you to make anything happen, I just want you to watch, and tell me what you see.'

'But you think he's gone over?'

'I think he has gone over, yes. I don't think he'd mess about with Marie . . . I think he really wants her out.'

'She's . . .', said Bertrand. His voice trailed away to nothing as he saw Kawena glaring at him.

★

113

Philippe dialled the number in Kinshasa and heard the ringing tone. He heard her pick up the phone, and heard her voice, heard her say 'Hello', and heard the question in her voice.

'Marie', he said.

'Philippe! Where are you? Are you all right?'

'Listen', he said. 'I'm all right. Don't worry. Everything will be all right.' He put the phone down.

Bertrand looked anxiously at the technician beside him. The man shook his head.

Bertrand thumped the table. 'And he knows we're listening', he said.

'Of course he knows', said the technician.

16

The sky was dark over London but, as the aircraft emerged above the cloud layer, brightness filled the cabin. Philippe settled back in his seat. He closed his eyes. The aircraft turned and sunlight slid across his face. He could feel its warmth and see the orange glow as the light shone through his eyelids. The frown eased. Then, it seemed just like moments later, the aircraft began its descent towards Brussels.

He'd arranged to meet Ndeko in a quiet city square not far from the embassy. The weather in Brussels was a little kinder, a cool day, but bright and fresh. It had rained that morning and left the streets slick, the air newly rinsed. There was a garden in the centre of the square, broad lawns of short-mown grass with tall trees casting broken shade, and thin sunlight shining through the leaves. Philippe found an empty bench and sat down. He leaned back against the bench, his arms stretched out along its back, and tried once again to relax.

'*Boni*', it was Ndeko's voice, always with a trace of laughter.

'*Malamu*', said Philippe.

Ndeko sat down beside Philippe. They shook hands, the handshake lingering.

'How are you really?' asked Ndeko. Philippe laughed.

'How do you think, Maurice?'

'Have you brought me the photograph?'

Philippe took out his wallet and passed over the last of his passport-sized photographs of Marie. Ndeko studied it.

'It doesn't look much like her', he said. 'Not from how I remember her.'

'I wish it looked less like her.'

'And you want her maiden name.'

'Yes.'

'Yembe?'

'That's right.'

'And Eric, you want him on it.' Philippe said yes, and gave him Eric's date of birth.

'It'll take me about a week. I'll phone you when it's ready, OK?' Ndeko recited the London number, and Philippe confirmed that he had it accurately. Ndeko took out his own wallet and slipped the picture of Marie inside.

They sat for a while without speaking, then Ndeko broke the silence.

'Word has got around, Philippe', he said.

'That's only to be expected.'

'I don't just mean within the business', said Ndeko. 'I mean that word has reached Etienne. He wants to know if you've really jumped ship.'

Philippe said nothing.

'He wants to know if you've made any decisions.'

'How do you know all this?' asked Philippe, and grinned.

Ndeko smiled. 'I want to know', he said, 'if I can pass on your phone number to Etienne. Will you let me do that?'

'You can give him my number', said Philippe. 'But tell him that I can't predict the future.'

'I'll tell him that', said Ndeko.

They paused while a young couple strolled past them, hand in hand.

'Also', said Ndeko. 'Bertrand Kotosa's on his way to London. I spoke this morning with a man in our travel section. Kotosa rang him and got the numbers of all the passports they issued in the last two months.'

'And they gave him that information?'

'Of course they did.'

'That's good', said Philippe. 'If Bertrand comes to London, I mean.'

'Just be careful, Philippe. Did you hear about Justin?'

Philippe turned his head sharply towards Ndeko. 'What happened?'

Ndeko shook his head slowly from side to side.

'*Abattoir?*'

'Denis too.'

'I didn't use them', said Philippe.

'Nobody said you did.'

'I never thought he would do that', said Philippe.

'You should know him as well as anyone.'

'I didn't think he'd lose control so easily.'

'The word is, my friend, that he's made up his mind . . .'

'We all have to make up our minds, Maurice.'

Philippe glanced at Ndeko, and saw the disappointment in his face.

'I'm sorry', said Philippe. He rested his hand on Ndeko's arm.

'I'll give you a ring when the passport's ready', said Maurice. 'But in the meantime, keep your distance. I can't be sure how safe the embassy is.'

'Here?'

'Anywhere, for that matter.' He stood, and Philippe stood too. They shook hands, and again the handshake lingered.

'Good luck', said Ndeko.

'And you', said Philippe. 'And give my regards to Etienne.'

Ndeko sighed. '*A bientôt*', he said.

'*A bientôt*', said Philippe.

Chris Davis spent the morning at his Mac in the attic, and worked on through lunchtime without a break. It seemed pointless, somehow, to go downstairs and make a proper meal when he was on his own. Better to plough on.

There were days he hated working from home, hated being self-employed. It's the worst boss a man can have, he said. Nobody else would make you work the hours you make yourself work. And the worst of it was that the work was always there, in the next room, just up the stairs, and if you were honest with yourself there was always something that needed to be done. He rubbed his face with his hands, and pushed back his hair.

He couldn't lose the brightness of the screen, so he reached over and switched it off and the monitor went grey. He gazed down at the keyboard and let the image drift out of focus. For a moment he saw double, two images overlapping, butting into each other, each trying to claim his attention. Then

suddenly the two images merged into one super-relief, extra-3D image. The keys seemed to tower up out of the keyboard, the spaces between them plunging downwards. He saw the H and K flickering together on one single super-3D key. He could see them both at the same time, both fighting for the same space. The G and the J were battling it out for the next key, the H and the F, and he could feel the struggle in his own eyes. He reached out a finger to touch a key and felt the two images pulling apart, as if someone were physically swivelling his two eyes apart. Then the image collapsed into normal vision and he saw that his finger was resting on the K.

He rubbed his eyes and looked at his watch. It was half past two. He should have a cup of tea, at least. He pushed his chair back from the desk, stood up, and went down into the kitchen. On the way he paused by the door into Philippe's room. He was tempted to look in but, after a moment's hesitation, he shook his head and left the room alone.

Philippe's flight back from Brussels to Heathrow was over-booked. The girl at the check-in desk was all apologies, but Philippe told her not to worry, and he let her book him on a later flight. When he finally took off the light was fading. They climbed up through the cloud layer and into the clear sky above it, but the cabin didn't fill with light. He remembered Denis as a tall, heavily built man, known to like his food, difficult to rush. He couldn't picture Justin at all.

It was dark when the flight arrived at Heathrow. The tube was quiet, right across London, after the homeward rush and before the evening crowds appeared. He trudged up the steps from the platform at Finsbury Park and out along the dull, tiled tunnel into the bus station.

Chris had made his mug of tea and taken it back up to the study, but he couldn't settle down to work. He sat for a while in the overstuffed armchair under the skylight and sipped at his tea. Then he picked up the book about Lumumba that he'd found the day before in a second-hand bookshop in Bloomsbury, down in the basement that smelled of mould.

The book was printed in the early 1960s by some desperate Marxist press, exposing the role of international monopoly finance in the turbulent history of the Congolese Republic since independence.

He flipped through the stiff pages to the little collection of photographs. There was Pauline Lumumba, holding a white handkerchief to her eyes. He tried to see her face, but it was in darkness. Then Lumumba, smiling, with a young boy in his arms, a shy, smiling child of maybe four, or five. A plump black man on the right of the picture, a slightly older child standing in the foreground, looking up and to the side. Lumumba wore spectacles. It was a wide smile, it reached right to his eyes. Chris tried to smile a wide smile like Lumumba's, but it came out like Jack Nicholson's demonic Joker grin.

He closed the book and, just as he was about to let it fall to the ground, the cover picture caught his eye. It was Lumumba, in an open-necked white shirt. He seemed to be sitting – not in a chair, it was as if he were sitting on the floor – but the photographer was looking up at his face. Sitting on some kind of raised platform, the back of a truck, maybe? It seemed that his hands were tied behind his back. There was a soldier beyond him, with his back to the camera, his right hand resting on a rifle. There was no smile on Lumumba's face, just a suggestion of a frown. The spectacles were missing. Lumumba's mouth was closed and his eyes seemed to be lowered. In front of him was another black man, also sitting, half out of the picture. It was hard to make out his expression, fear, perhaps. Or it could be indignation, irritation.

But it was Lumumba's face which held Chris Davis' attention. The gentle frown, a little puffiness around the eyes. Chris tried to picture Philippe, to hold Philippe's face in his mind's eye alongside the face of Lumumba. They were like the two halves of a stereo image, like the same face seen from two slightly different angles, with the eye constructing one 3-D image from the two, so that the differences in the images were what gave the illusion of depth. He gazed at the cover of the book and held Philippe's image beside it, until suddenly the two images merged and one dark face stared back at him.

17

It was late August 1960, and Eisenhower was still in the White House. Allen Dulles was Director of the CIA. Dulles had responded to the Congo's independence by installing Lawrence Devlin as Chief of Station within the American Embassy in Leopoldville. On the 18th, Devlin cabled CIA headquarters:

> Embassy and Station believe Congo experiencing classic Communist takeover . . . Whether or not Lumumba actually Commie or just playing Commie game to assist his solidifying power, anti-west forces rapidly increasing power Congo and there may be little time left in which take action . . .

A week later, on the 25th of August, the National Security Council's special group on covert operations met to discuss the Congo. At President Eisenhower's request, the group agreed that 'planning for the Congo would not necessarily rule out consideration of any particular kind of activity which might contribute to getting rid of Lumumba.' Dulles ordered Lumumba's assassination as 'an urgent and prime objective'.

The pictures were still in black and white.

Monday, September 5th
By mid-evening *Le Royal*, a tall, graceless apartment block of glass and steel in the centre of Leopoldville, blazed light from every window. On the sixth floor, Rajeshwar Dayal, the Indian diplomat who'd just arrived in the Congo to take over the UN operation, was finding his way around the suite of offices. There was a strangely tense atmosphere, he noticed, but Andrew Cordier, the American still in charge, wasn't due to formally hand over for another three days; there was plenty of time for Dayal to acclimatise himself.

So far, it seemed, the situation was more farce than tragedy. Earlier in the evening, for instance, Ian Scott, the British ambassador, had turned up at *Le Royal* insisting that the UN

take immediate action to prevent the imminent mutiny of Congolese soldiers.

'What mutiny?' asked Urquhart, one of the UN's political advisers. He remained seated behind his desk, his eyes still on the pile of correspondence in front of him.

'You mean you don't know?' demanded Scott.

'No I don't', said Urquhart. 'How do you know?'

Scott leaned over Urquhart's desk. 'I have my own sources of information', he whispered.

Urquhart looked up at him. 'And what, may I ask, are these?'

Scott leaned closer. 'My military attaché', he whispered, 'overheard a conversation between Congolese soldiers as he moved inconspicuously among them.'

'I see', said Urquhart, and returned to the study of his papers. Lieutenant-Colonel, the Honourable John Sinclair, Scott's attaché, was six feet three inches tall, with bright ginger hair and moustache. Sinclair was a proud Scotsman, particularly proud of the kilt, which he always wore.

On the fifth floor, Thomas Manza's reception was getting underway. Before long he would fly to New York as Lumumba's ambassador to the UN, and he'd gathered together the team of young Congolese diplomats who would go with him. It was the first time they'd all met, and Manza decided to let them chat for a while, to get to know one another, before addressing them more formally.

The telephone rang and broke the chatter. Manza picked it up impatiently. It was his sister, Sophie. He was about to rebuke her for interrupting the reception when his face fell. He put the receiver down without saying a word. As it dropped into its cradle there was a hush in the room. His staff watched as, head down, he walked across to the radio.

The scene was repeated in room after room. On every floor of the building, conversation stopped. The bustle died away to silence, and into the silence poured Kasavubu's dull, depressive drone. Not everyone in the building was as surprised as Manza.

★

When Manza called him at his residence, Lumumba was already on the move.

'I can't talk, Thomas', he said. 'My car's waiting at the door. I'm going to the radio station. There'll be a meeting of the Council of Ministers later this evening. If you want to help, just make sure everyone listens to what I have to say.'

By nine o' clock Lumumba was on the air.

'The national radio has just broadcast a statement by the Head of State, Monsieur Joseph Kasavubu', said Lumumba. 'A statement demanding that the government I lead be dismissed.'

Manza smiled.

'In the name of that government', said Lumumba, 'I should like to make a formal refutation of what he has said. The government has had no discussion on the matter with the Head of State. Having been democratically elected by the nation, and having received the unanimous confidence of parliament . . . our government cannot be dismissed unless it should lose the people's confidence. At present the government still has their confidence, and the entire nation is behind us.'

Manza gave a loud clap.

The first speech was the best. 'We shall remain in power and continue the work we have been given to do.' Lumumba's voice was sharp and cutting, but there was not a single inflammatory word. At nine-thirty Lumumba broadcast again with a new speech. A recording of the second speech went out again at ten o' clock. It was in the second speech that Lumumba announced that, because of Monsieur Kasavubu's 'public betrayal of our nation', he was no longer Head of State.

By eleven that night the driveway in front of Lumumba's residence was packed with ministerial limousines. The Prime Minister had called a special meeting of his cabinet. Pauline was trying to organise the staff, while every five minutes she rushed upstairs to shoo Patrice and Juliana, the two eldest children, back into their rooms. As soon as she came down-

stairs again the two small faces would appear on the landing, peeping between the banisters, down into the grand hallway where the government was gathering.

Manza, like everyone else, looked all around, trying to work out who wasn't there. All the loyalists had turned up, except Bomboko. Mobutu was there, sitting quietly at the back of the room, looking infinitely sad. Delvaux was missing, Bolikango was missing – still, presumably, under arrest . . .

Lumumba approached him, waving a sheet of paper.

'Thomas, look', he said, and thrust the sheet of paper under Manza's nose.

'It's Kasavubu's speech', he said. 'I found it at the radio station. He left it sitting in front of the microphone, and when I went in to broadcast it was still there. Look! It isn't countersigned.'

Kasavubu's announcement, brief and formal, had simply been to the effect that Lumumba was dismissed from the post of Prime Minister. Six ministers were also dismissed, all, said Kasavubu, under the powers granted to him as Head of State by the *Loi Fondamentale*, the Congo's Constitution.

'It isn't signed', said Lumumba. 'He has to have it signed by two ministers. It isn't legal.'

Manza glanced again around the room.

'Patrice', said Manza. 'I know Kasavubu. I know him fairly well I think, since he's been so antagonistic towards my family.'

Lumumba nodded vigorously.

'Listen', said Manza. 'Kasavubu is a timid man. Yes?'

'Yes. Yes', said Lumumba.

'He's timid, and so he's very prudent. He's very careful in making his decisions, especially when he's announcing them publicly. *We* will have to be careful. He would never have dared to make that speech if he hadn't first received formal guarantees . . .'

'You mean the Belgians', said Lumumba. 'I said that. "It is by a Belgian manoeuvre that Kasavubu has done what he has done today", I said that on the radio.'

'I know that', said Manza. 'But think, Patrice, think . . .'

'I have thought, Thomas', said Lumumba. 'I have thought it. I can't understand how Joseph could have betrayed me like that. It was me who made him Head of State. It's thanks to me that he was . . .'

'If it isn't signed, Patrice, that doesn't mean it *won't* be signed. It isn't just the Belgians . . .'

But Lumumba had turned his back and was making his way to his chair.

It took the meeting until three in the morning to reach a set of decisions which simply recapitulated what Lumumba had broadcast during the previous evening. Kasavubu, they agreed, had violated the *Loi Fondamentale* and had committed an act of high treason which automatically made it illegal for him to carry out his constitutional functions.

'You mean you *knew!*'

'Of course we knew', said Cordier.

'And you didn't tell me! You didn't tell Hammarskjöld!'

'I couldn't tell you. You were in the goddamn *air*', said Cordier. He was genial, he was happy, he was completely at ease with the world. 'And I telexed Hammarskjöld as soon as Kasavubu told me what he was going to do. But that was only this afternoon.'

Dayal stared at the American's flabby, avuncular face.

'Kasavubu came to me and told me what he was going to broadcast. He asked me for a guard at the radio station and a guard at his official residence. I couldn't say no to that, not if there was any risk of violence. Then he asked me to send UN troops to arrest Lumumba, and I told him that was out of the question. Hammarskjöld's reply was to avoid interfering with internal Congolese politics, and I have done. When Lumumba appeared at the radio station, he simply walked in unhindered. The guard did nothing to stop him.'

Van Bilsen marched into the office unannounced. Dayal and Cordier turned towards him.

'President Kasavubu has sent me', said the Belgian. 'This is a list of his demands.' Cordier took the sheet of paper without comment, and began to read it out in the manner of a

schoolmaster reviewing an exercise by a not very promising pupil.

'First, the UN must arrest the following members of the government of Monsieur Patrice Lumumba, including Monsieur Lumumba himself . . .'

'Second, the UN must immediately take steps to close the radio station, and ensure that no further political broadcasts are made . . .'

'Third, the UN will immediately effect the closure of all airports throughout the Congolese Republic . . .'

Cordier worked through the list of ten demands, then passed the paper to Dayal, who scanned it without comment.

'The United Nations takes note of the President's requests', said Cordier, 'but our decisions will be based on the mandate of the Security Council.'

'You mean you're refusing', asked Van Bilsen.

'I'm giving you no undertaking whatsoever', said Cordier, 'other than this, that the United Nations Operation in the Congo will take whatever action *it* considers necessary in the interest of public order.'

Van Bilsen was at bursting point. Dayal and Cordier surveyed him carefully. He turned to Dayal.

'Do you support Mr Cordier's attitude?'

Dayal shook his head gently. 'I'm afraid I'm not in a position to comment. Until I formally take over, Mr Cordier remains the principal UN authority in the Congo. You'll have to pursue your dispute with him on your own account.'

Van Bilsen turned on his heels and marched out of the room.

Tuesday, September 6th
The last of Lumumba's ministers left the Prime Minister's residence at about half past three in the morning. At half past five Lumumba was on the air again, broadcasting the resolution that the meeting had drawn up.

Dayal was still tired after the journey from New York, but he rose early. He'd been given a villa owned by the Belgian

minerals company, the *Union Minière*. It was an austere Victorian building. The floors and walls were tiled, and the furnishing was spartan, so the empty rooms echoed with every footstep and the house managed to feel chilly in spite of the city's warmth.

Dayal and his wife, Shusheela, had slept badly. Dayal had returned from *Le Royal* shortly after midnight to find Shusheela brandishing a long bamboo pole, jabbing at the high ceilings of the house.

'Bats!' she said, and called him to the chase.

But they'd failed to clear even their bedroom of the creatures. All night long they'd lain awake, listening to the scratching of claws on the wooden ceilings, huddling under the covers as the bats' aerobatics brought them within inches of the bed.

Like so many of the villas, including Lumumba's residence and the British ambassador's next door but one, Dayal's villa backed onto the river. He strolled out onto the verandah that morning to take in the river view, and found a crowd of Congolese in the garden. They seemed agitated, and several were carrying machetes, but they were clearly endeavouring to avoid any loud disturbance. They were gathered round a large tree beside the river, poking at its branches with sticks.

It can't be bats, Dayal muttered under his breath, and made his way down into the garden. As he walked towards the tree he saw what the attraction was; a large python had climbed up from the river bank and taken refuge in the branches.

One of the Congolese, seeing Dayal's approach, turned away from the gathering to speak to him. 'We will save you a big piece, patron', he said.

Dayal turned and walked back to the house.

He reached *Le Royal* at lunchtime and found that Cordier's staff were being bombarded with telephone calls, particularly from the American and British embassies, demanding information. Meanwhile a series of Congolese politicians had been trooping through the radio studios, sharing their thoughts with the nation. On the whole, their speeches were critical of

126

Kasavubu. Many of them had driven straight from the radio station to *Le Royal*, where they demanded UN intervention to reverse Kasavubu's order.

Dayal saw that Cordier was busy on the telephone, and walked across the office to the radio, switching it on to hear the broadcasts for himself. There was silence. He began to fiddle with the dial.

'It's out of action', said Cordier.

'Isn't that inconvenient?' said Dayal, over his shoulder. 'I mean, shouldn't we be listening?'

'The radio station's out of action', said Cordier. 'I closed it down.'

Dayal slowly turned to look at him.

'As Kasavubu asked?'

'I decided the broadcasts were inciting civil war.'

'But I heard, on the way up just now. I heard people listening to the radio.'

'Ah', said Cordier. 'Well, there's a problem.'

Dayal raised his eyebrows.

'There's a radio station in Brazzaville', said Cordier. 'They're letting Kasavubu use it.'

'And they're not letting Lumumba use it, I suppose.'

'No.'

'So you've closed down Lumumba, but you haven't closed down Kasavubu.'

'It just worked out that way.'

'And I suppose Tshombe's still broadcasting from Elizabethville?'

Cordier was chewing his lip.

'And the airports?'

'We thought, if Lumumba flies in ANC troops who are loyal to *him* . . . we know that Kasavubu's got troops loyal to him in Leo already . . . I decided there was a threat of civil war.'

'So you've given Kasavubu exactly what he wants.'

'It wasn't intentional', said Cordier. Dayal stared at him.

'And you still haven't got any UN troops in Katanga. So Tshombe's Belgians can still use the airport in Katanga.'

Cordier lifted his hands as if he were the helpless victim of events.

Manza turned up for the Council of Ministers just before eleven the same morning. Both Bomboko and Delvaux, he noticed, were already there. Seeing Manza, Bomboko called him over, and the two men strolled out into the garden together.

'Listen, Thomas', he said. 'What has happened is a lesson for Patrice.'

Manza stopped, and laid his hand on Bomboko's arm. Bomboko lifted the hand away.

'I'm sick of all these pointless discussions', said Bomboko. 'I'm going to see Kasavubu. I'll tell you what happens. You stay here and tell me what happens at this end. Be careful.'

'Justin. Have you signed the dismissal?'

'Not yet', said Bomboko. 'But I think I will. Patrice treats us like a bunch of kids. We've got to teach him a lesson.'

'And it has to be you who signs? You're his foreign minister, for God's sake. Justin, think what you're doing.'

'I have', said Bomboko. He strode away towards his car.

Manza returned to the meeting. He took no part in the discussion, though he followed what was said. Only Delvaux, he noticed, had realised that Kasavubu wouldn't have acted without receiving guarantees of support.

Wednesday, September 7th
Parliament met in the *Palais de la Nation* to debate the last two days' events. Lumumba, in fine form, made a long speech, which dealt in detail with every charge that Kasavubu had brought against him. At the end of the debate the motion was simply to annul the two 'mutual dismissals'. Sixty deputies voted for annulment, against only nineteen.

Nevertheless, over the next few days Kasavubu and Lumumba each ordered Joseph Mobutu, Chief of Staff of the Congolese Army, to arrest the other. Mobutu refused to make the arrests. Instead he offered his resignation to both Kasavubu and Lumumba. Both refused to accept Mobutu's resignation

and each insisted that only *he* had the authority to do so. The UN, meanwhile, continued its even-handed treatment of the two. Kasavubu broadcast from Brazzaville, and Tshombe from Elisabethville, while Radio Leopoldville, Lumumba's only station, remained silent. When Kasavubu appointed Joseph Ileo to the post of Prime Minister, Ileo was duly allowed to use the Congo's airports and flew around the country canvassing support for his cabinet. General Lundula, Commander of the ANC, and Cleophas Kamitatu, both key Lumumba supporters, were prevented from flying back to the capital. Dayal took over from Cordier on the 8th. On the 12th he lifted the ban on radio broadcasts and re-opened the airports. On the 13th, parliament repeated its endorsement of Lumumba as Prime Minister. It voted full powers to his government, and appointed a parliamentary commission to attempt a reconciliation between Lumumba and Kasavubu.

Wednesday, September 14th

Mobutu was already waiting in the sixth floor reception room. He was sitting on one of the low sofas and wearing his Belgian-colonial outfit, a khaki shirt thick with insignia, and a pair of khaki shorts which showed off his spindly legs. He looked up as Dayal entered the room and he gave the diplomat a weak smile.

'Joseph, how are you', said Dayal. 'It's good to see you again.' Each evening since Dayal took over, Mobutu had visited him like this. The diplomat braced himself for another hour of maudlin complaint.

'Would you like a drink?'

'Thank you', said Mobutu. Dayal poured a generous glass of whisky and handed it over. Mobutu took it as if it were a draught of poison.

'I am very worried', said Mobutu.

'Aha?'

'I owe everything to Patrice, you know.'

'I know, Joseph. You've told me.'

'He was the one who wanted me in the government. He was the one who wanted me to take charge of the army.'

'Yes.'

'But it's impossible. I want to get them trained, but I can't even get them to obey their own officers, Congolese officers. They won't do as they're told.'

'But General Kettani is helping you, isn't he?' Kettani, the UN's chief military adviser, spoke warmly of Mobutu and treated him almost like a son.

'Yes he is, but . . .'

'And you have a UN guard?'

'I know, but . . .' Mobutu took a mouthful of whisky. Dayal heard the gulp as he swallowed.

'I'm worried about Patrice', he said.

'Aha?'

'This argument with Kasavubu. It's making life impossible. And everyone's just trying to push themselves forward . . . I'm tired of politicians. I don't understand them.' He drained the glass and set it on the table in front of him. He looked up and met Dayal's gaze, and glanced down at the glass again. Dayal picked up the glass and refilled it.

'All this talk of arrests', said Mobutu. 'I hate it. Two governments. I don't think Ileo can keep a cabinet together, but I don't think Patrice can go on either.'

'It's very difficult for all of us, Joseph.'

Mobutu swirled the whisky in his glass. He seemed unable to look up at Dayal. He seemed, if it were possible, more nervous and unsettled than on previous nights.

'What is it, Joseph?'

Mobutu glanced up at Dayal for a moment, then lowered his head again.

'I thought I should tell you', he said. Dayal waited. Anything but his sister-in-law, he thought. I can take anything but that.

'I've made a decision.' Dayal smiled encouragingly, but Mobutu was studying the carpet.

'I've decided to neutralise them both', he said, and he looked up for encouragement. Dayal sat very still. He heard the clock ticking and glanced across to it. It was a quarter past eight.

'What, precisely, do you mean by *neutralise*, Joseph?'

'If they are both neutralised', said Mobutu, 'they will have to stop and think. That's all I want them to do. I just want to put them . . . on ice . . . for a while. When they've calmed down, then they can get on with running the country again.'

'You want to put them on *ice* for a while.'

'Until about the end of the year', said Mobutu. 'I'm going to announce it tonight.'

'Tonight! When?'

'It's going out on the radio at half past', he said. 'I thought it might be a good idea if I stayed here with you . . .'

'It would not be a good idea, Joseph.' Dayal checked the clock. It was sixteen minutes past. He stood up.

'I think you'd better leave, Joseph. Very quickly, please. If you're here when the broadcast goes out, no-one will ever believe it wasn't a UN decision. I will not be made responsible for a *coup d'état*.'

'It's not a *coup d'état*.'

'Please, Joseph. You have to leave, now.' Mobutu rose slowly to his feet. Dayal took the whisky glass from his hand and set it down on the table. He took Mobutu's arm and began to steer him towards the door.

'It's not a *coup d'état*', Mobutu protested.

'When the army dismisses the Prime Minister and the President, Joseph, that is a *coup d'état*. That is what a *coup d'état* is.'

At eighteen minutes past eight Joseph Mobutu left the headquarters of the United Nations Operation in the Congo. Ten minutes later Dayal's senior staff assembled on the sixth floor.

Once again, a hush descended on *Le Royal*. When the broadcast was over Dayal looked round the room.

'None of you knew?', he asked.

None of them knew. Dayal stared for a moment at Kettani. Kettani who was just like a father to Mobutu.

'I swear', said Kettani, 'I swear I didn't know.'

The farce in Leopoldville played out without a single killing. In Kasai and Katanga, things were rather different. In northern

Katanga, pro-Lumumba Luba were massacred by Tshombe's Belgian-officered *Gendarmerie*. In southern Kasai, pro-Lumumba ANC troops, together with their local supporters, set themselves against the local, separatist Luba population. Long-standing family feuds precipitated and were swallowed in fresh episodes of killing. Kalonji, Kasai's 'emperor', stayed hiding in Elizabethville until, on the 18th of September, Mobutu ordered the recall of the ANC. Kasavubu rubber-stamped the order five days later. By then Kalonji was back on his throne in Bakwanga, or, as it came to be known, 'the slaughterhouse', the *abattoir*.

By late September time was running out. With the election only weeks away, John F. Kennedy was showing strongly. Joseph Scheider, CIA technician, arrived in the Congo. In Scheider's suitcase was a tube of toothpaste, the very same Belgian brand, by chance, which Lumumba was known to use. In some freak circumstance, Scheider's toothpaste had become contaminated with a rare virus. This was a virus found only in the Congo. Scheider, whether he knew it or not, was in great danger; if the virus should accidentally get into his system, it would prove fatal. There was no known remedy.

18

The taxi turned into Avenue de l'Equateur. On either side grand mansions overlooked the road.

'We're here', said the driver, and pulled in at the kerb. Marie glanced through the rear window. The street seemed empty. She paid the driver and stepped out onto the pavement.

The gates were more than twice her height, of heavy iron bars painted a glossy black. Inside, on either side of the gateway, stood soldiers in unfamiliar uniforms. Beyond the soldiers was a massive building, painted white, and on its roof a flagpole. She tried to make out the flag, there was red and white and blue, but the flag hung limply against its pole and she couldn't see its design properly.

She stepped up to the iron gate and took hold of one of the bars. She tried to shake it, but the gate stayed firm and only her body swayed. The guard on the right glanced at her, and pointed away past Marie's left. She turned and found a doorway in the wall, with a heavy wooden door standing open. She smiled at the guard, but already he was staring blankly at his opposite number.

She turned and looked along the street again. There was still no movement. She hesitated for a moment, then ducked through the doorway and into the embassy compound.

It had been over a week since they picked her up at the airport. A week of routine; wake Eric and give him his breakfast, see him off to school. In the afternoons, more often than not, they took a taxi to Marie's mother's, returning in the early evening. Marie still hadn't managed to tell her mother about the trip to the airport and back, and Eric was sworn to silence on the matter.

Then, this morning, when she'd seen Eric off from the garden gate, she'd come back into the house and found the envelope sitting on the coffee table, just as before, with nothing to tell her how it had got there.

She had sat on the sofa and stared at the envelope, as if staring at it would eventually make it disappear. She was damp with sweat, yet every now and then a shiver, a shudder, would shake her. In the street she heard a car door slam, and she jumped as if it had been a gunshot. Mostly she sat very still. There were stories of spirits that lived in trees or rocks, with no bodies of their own, no capacity for movement or expression. Then the telephone rang and she jolted into movement.

It was her mother, and would she be coming over that afternoon. Yes, said Marie.

'Are you all right?' asked her mother.

'Yes, of course', she said. 'Just .. I didn't sleep well. I worry about Philippe . . .'

'Why don't you come and stay over for a few nights?'

'No. No. It's better for Eric, I think. I want to keep things normal.'

Her voice sounded tired.

'I'll see you this afternoon, then?'

She said goodbye and put the phone down. She reached across and picked up the envelope. When she tore it open the sound seemed deafening. She tipped the contents of the envelope out onto her lap.

She looked at the passport first. She opened it, and saw her own picture inside, but under-exposed, very dark and shadowy. She read her own maiden name as if it were a stranger's, but Eric's name was on the passport too. She rubbed the passport between finger and thumb. She dropped it onto the table and heard the light slap of its contact.

She picked up the note and looked at the handwriting. It wasn't Philippe's. She read it. It was in French, but she could manage, just about, just a few of the words left over like the parts of a dismantled and reassembled machine, parts of speech that ought to fit somewhere but somehow you'd missed them out. The note told her to go, that morning, to the British embassy. She was to apply for a visa to visit her sister in England. She had no sister in England. Then she was to carry on as if nothing had happened.

She looked at the passport again. It had been issued, it said, a

year ago. She checked her date of birth. It was right. Eric's was right. It seemed genuine.

In the situation room Kawena had listened to her calling for a taxi.

Shopping, she'd said, when the dispatcher asked her where she wanted to go.

Then the radio message came in from the Volkswagen to say the taxi had arrived, and what the number was on its license plate.

'Stay where you are', said Kawena.

The taxi left. As it turned out of the street, another car followed it into the city. Kawena radioed the taxi's number through. He had people in the Place du 27. Octobre, in the Avenue Republique Tchad, and the Avenue du l'Equateur. Ten minutes later the report came back. The taxi had stopped outside the British embassy in the Avenue du l'Equateur. There was a trace of a smile, no more, on Kawena's face.

'Don't bother as she goes in', said Kawena. 'Just get her on the way out. As many as you can.'

The man in the passenger seat checked his camera. He focused the long lens on the doorway beside the main gate. He checked the exposure. There was plenty of light, enough for the fast shutter speed that would freeze Marie's movement and eliminate any camera–shake. He checked the status of the battery in the motordrive.

There was a huge reception desk, and a girl who looked African but spoke what Marie guessed was English. The girl glanced briefly at Marie's passport and then, smiling pleasantly, she passed it back. Marie couldn't understand what the girl said, but she looked where the girl was pointing and saw a small door on the far side of the lobby.

Through the doorway, Marie found herself in a long, gloomy corridor with dull green linoleum tiles. At the far end she saw a bench, a low, backless bench of slatted wood, and a small group of people sitting and waiting.

It helped that there were others there. She sat down beside

them and greeted them in Lingala. They grinned and replied in the same language. You wait here, they said, and watch the door, there. When someone comes out, the next person just knocks and goes straight in. They'll talk to you in English, but if you don't speak English they'll talk to you in French. Can you speak French?

Marie could speak a little French.

The interviews seemed to take forever. As each applicant emerged, the group on the bench would study his or her expression. The unsuccessful ones came out with their heads bowed and walked away without saying anything. The others came out with a broad beam on their faces, and stopped to offer a few words of encouragement to those still waiting.

It was after eleven o' clock when Marie's turn came.

It was a small room, with just one man in it, sitting behind a plain wooden desk. He gestured to the chair in front of the desk and Marie sat down.

'Merci', she said. The man looked at her and smiled.

He is very young, thought Marie. The man wore spectacles, and they kept slipping down his nose. He pushed them back, and moments later they slid down again. He tilted his head back a little and peered at her. She smiled.

He asked her the purpose of her visit to England, and she explained about her sister.

'Where does she live?', asked the man. There was a thin film of sweat on his forehead.

'Beermeeng-am', said Marie. It had said so on the note. The young man wrote it down.

'And she is married to a British subject?' Marie nodded and smiled again.

He asked for her passport and she handed it over. He studied it carefully. He held the pages up to the light and squinted at them.

'We get a lot of forgeries', he said.

'But this is fine', he said, and beamed at her. His face was shining.

He began to copy down the details on a printed form.

'Who is the child's father?' he asked. She stared at him. She could taste something, something metallic, like blood.

'I said', said the young man, speaking more slowly and deliberately, 'Who is the child's father?'

She gave Philippe's name. The man copied it down.

'Where does he live?' She shook her head.

'Do you not know where he lives?'

'No'. It was no more than a whisper. She looked down at her lap and saw her hands clenched together.

'I'm afraid', said the young man. She looked up at him. 'I'm afraid we'll need to know more about the boy's father before we can issue you with a visa. If he's living in England, we may have to investigate his status before we can allow you to join him . . . Do you understand?' She understood that he was saying no. She nodded her head.

'*Comprends*', she said, and looked down at her lap. She heard the thump of a rubber stamp. She looked up and saw that he was writing something. Then he was sliding the passport back across the desk towards her.

'I'm very sorry', he said. She tried to smile at him as she stood.

Kawena took the prints and began to leaf through them.

'She didn't get it', he said, and grinned.

That afternoon, when Marie and Eric were at her mother's, Kawena himself went with the team that searched Marie's house. It was carefully done and, as before, when it was finished there was nothing to show that they'd been there. But they didn't find the passport. It was hidden in a compartment Philippe had created months beforehand, hidden behind an electrical socket.

'Sometime', he'd said to her, 'it may be important to hide something in here.' He'd shown her how to unfasten the screws and slide the metal box out of the wall.

'Look', he said. 'It still works'. He plugged in a lamp and switched it on.

When Marie arrived home she put Eric to bed and then went straight to the hiding place. It was still there. She took

the passport out and leafed through it. There, on the last page, was the stamp from the embassy. She couldn't make out what it said, beyond the date, and the address of the embassy. She kept hearing the man in the embassy asking her, 'Where does he live'. She slipped the passport back into its hiding place and went to bed.

Philippe picked up the receiver.

'This is Etienne', said the voice. Philippe took a deep breath.

'Hello?' he said. There was a pause.

'I'm sorry to be calling you so late, my friend', said the voice, and it sounded older than Philippe remembered it, 'But we had a little difficulty with the telephones. It's not always possible to get through . . . there's some sort of fault on the line . . . I'm sure you understand.'

'Of course', said Philippe. 'There's no problem.'

'I have some news for you', said the voice. 'I'm sorry. It's not good news. Your friend was hoping to visit you. It looks as though it won't be possible for a while. I'm sorry to disappoint you.'

'Thank you for letting me know', said Philippe. 'Can you tell me, is she well?'

'As far as we can tell, she's fine', said the voice. 'It's simply that the travel arrangements fell through at the last minute.'

Philippe sighed.

'I would be happy to keep an eye on her', said the voice. 'I'll let you know if there is any change. I may be able to help her . . . if she tries to make further arrangements.'

'That would be very good of you', said Philippe.

'But I wondered if you might be able to help me, too?'

'Aha?'

'I wondered . . . a few of us are getting together, with a view to . . . starting a small business. I believe we spoke about this before, if you remember?'

'I remember', said Philippe.

'We still have a problem with Security'. Philippe laughed, and heard laughter from the other end.

'I can imagine', said Philippe.

'I wondered if you might be willing to help us with that? If your circumstances have changed at all?'

'I'm afraid, as far as that's concerned, the situation really hasn't changed . . . sufficiently', said Philippe.

'I'm sorry to hear that', said Tchisekedi. There was little disappointment in his voice.

'I did wonder, though', he said, 'if you might be willing to do something else for me?'

'It depends what it is', said Philippe. 'Tell me what it is.'

'You know about a man called Manza.'

The room burst into light. Philippe heard the slapping sound and the breaking glass as Robert's two shots extinguished the lamps.

'Hello?' said Tchisekedi. 'Philippe?'

'I know who you mean', said Philippe.

'He was doing something for me', said Tchisekedi. 'It was a report . . . an appraisal. I'm afraid he was unable to finish it . . . you may have heard about his difficulty.'

'I heard', said Philippe.

'It would be a great help to me to see that report. I believe he must have been close to finishing it. I believe he may have left it behind when he left home.'

Philippe closed the door of Manza's house and felt the lock snap shut, undamaged when it had been opened just a few minutes earlier. He glanced back at the house.

'Would you be able to go to his home and recover the report?'

The door from the sitting room opened and Chris Davis emerged.

'I'm going to have a beer', he said. 'Do you fancy one?'

Philippe glanced up at him and shook his head. He could hear the television. It was the end of the News at Ten. The door swung closed again and the music faded.

'I'm not sure that Madame Manza would make me welcome', said Philippe.

'I understand', said Tchisekedi. 'But it would be a very great help to me. And I'm sure she wouldn't hurt you..'

In the last moment, before the lights went, Philippe had seen Annette Manza's face, her eyes closed after the shock of light, her mouth wide open as if she were about to scream.

'I'm sorry if it's not ..'

'I'll do it', said Philippe.

'Thank you', said the voice. 'If you get it, give it to your friend in Brussels.'

'OK', said Philippe. He heard Tchisekedi's repeated thanks, he heard the goodbyes exchanged and the phone go dead. He put the receiver down, and heard footsteps in the hallway.

'Everything OK?' asked Chris.

19

Julie Morgan looked at the African man sitting across the desk from her.

'Whereabouts in Zaire are you from, Mr Makele?' she asked him.

'Kinshasa', he said. 'But my family comes from Shaba.'

'Katanga?'

'It used to be.'

Every place with two names. You peeled off the top surface, like peeling off a rubber mask, and underneath it were the scars, the histories.

'You know much about Zaire?' he asked.

'We try to keep an eye open . . . press cuttings . . . but most of it comes from the refugees themselves.' She picked up a hefty pile of folders from her desk. 'Look at this lot', she said. 'All in the last month. And that's not all. We've got drawers full of them.' She pointed to a filing cabinet. 'That's just this year's. Then . . .' She turned and unpinned a press cutting from the wall.

'In the first six months of 1991', she said, 'there were, . . . four thousand two hundred and seventy-seven people from Zaire who entered Britain seeking asylum. That's Home Office figures; that's the ones they know about. Even so, it's the most. Only Angola comes close ..', she studied the press cutting. 'Three thousand two hundred and eighty-one. And if you blame UNITA for them, then it lands back in Zaire's court, doesn't it.'

'I don't know . . . I suppose ..'

'Kamina?' she asked, and saw his eyes widen a fraction. 'The biggest airbase in Africa? You don't know about the States, flying weapons in for Savimbi ..?'

'Four thousand ..?'

'.. two hundred and seventy-seven.'

'And you've seen . . . how many?'

'Oh', she laughed, 'only a fraction of them. But let's just

stick with your own story, for the moment.' She smiled at him.

They were big numbers. Then there were all the people he'd seen, at the airport, on the train into London, on the streets, in shops and restaurants. It seemed that half of London was black, that Africa had been turned inside out and its people spilled across the world.

'Mr Makele? . . . André?' She was looking at him again.

'I said, could you let me see your passport?'

'I'm sorry', he said. 'I didn't bring it with me.'

'Well, we'll need it if we're going to make an application for you. You understand that? If you apply for asylum you'll have to surrender your passport. You can take a copy for reference, and we'll keep a copy here, but it means you can't travel out of Britain. You do realise that? And I'm afraid the average time just to process an application is two years . . . Mr Makele? Are you feeling all right? Can you understand what I'm saying?'

'I'm fine', he said. 'I'm sorry. I'll come back again. With my passport.'

He stood up. She stood too, and held out her hand. He saw the coffee colour of her palm. He took her hand and shook it gently.

'I'm sorry', he said.

'That's all right', she said. 'Don't worry. If it seems confusing, well, that's normal. It takes a while to adjust.'

Isobel had made coffee and toast and brought it through into the sitting room. Chris pointed the remote control at the television and the screen went blank. The house was quiet. Allie was out at friends and Matt, for once, was spending the evening on his school work.

'It looks as though I'll have to go away for a few days', said Philippe.

'That's OK', said Chris. 'Your room's there as long as you want it.'

'Thank you', said Philippe.

'Is this to do with Marie?' asked Isobel.

'Uh-huh', said Philippe, and sipped at his coffee. The question slipped off him like water off a duck's back. Or, it was like a blade of grass in the wind; the wind blows, and the grass gives, and as the wind falls again, the blade of grass springs back.

'How are you feeling?' asked Isobel.

Philippe smiled. 'Actually I have a headache', he said. 'It happens a lot.'

'Have you taken anything?' said Isobel.

'No.'

'I've got some new stuff . . . here . . .', she left the room and they heard her rummaging in her bag in the hallway. She came back a moment later with a small packet. She opened it and, popping the tablets out through a metal foil, she handed two of them to Philippe. He took them and swallowed them with a mouthful of coffee.

'Thank you', he said.

'Stress', said Chris. Philippe shook his head.

'When I was sixteen', he said. 'I had a motor bike. I was very proud of it. It was in Bukavu. I was going along the street one day when a car swerved out, and there was nowhere for me to go to avoid it. I hit the wall. They said I was lucky to survive, but ever since I've had these headaches.'

'Bukavu's where you grew up?' said Chris.

'That's right', said Philippe, and smiled. 'Kivu. Very . . . clean, and green.'

'A green and pleasant land', said Chris, and grinned.

'Yes', said Philippe. 'It is a green . . . and pleasant land.'

The lock was easy. Bertrand, crouching by the door, paused and listened carefully. There was no sound in the building. He opened the door, slipped into the office, and closed the door behind him. He paused again, listened. Nothing. Again he waited, while his eyes adjusted to the darkness.

He went to Julie Morgan's desk and sat down in her chair. He switched on a small torch and shone its light onto the heap of files she'd showed him that afternoon. He opened them one after another, looking for adult males, unaccompanied.

There were four. He checked the dates. All of them had made their applications after the date when Philippe had left Kinshasa. He turned to the copies of their passports.

'Shit', he said, seeing how the photographs had been obscured. He checked the ages. All four were in their late twenties or early thirties.

He took out his notebook and, with his neat, gold-barrelled pen, he copied down the names and the addresses. He noted the dates of issue and the issue numbers then he checked the numbers against the list of recent issues from the travel sections in Brussels and Kinshasa. None of them matched. He replaced the four files in the stack and turned to the filing cabinet which Julie had indicated.

He pulled at the top drawer. It was stuck. He tried the next one down and it opened. He pulled out the first file. It was full of press clippings about Angola. The next file was a single Angolan woman, then a child of eleven, also from Angola. He flipped quickly through the rest of the drawer. At the rear were files of Zairean refugees, but all the application dates were old, more than six months ago.

He checked the bottom two drawers. Both were full of African applications, none from Zaire. He tried the top drawer again, pulling more vigorously. A fan, perched on the top of the cabinet, slipped and crashed to the floor. He froze, listening.

The building was quiet. He joggled and pulled at the drawer and eventually it came open. He picked up the fan and set it back in its place.

As before, the first file in the drawer was full of press cuttings, but this time about Zaire. He flipped past it to the case files and began checking through them. All of them were recent and there were three single males with applications in the last month. He took down the details, and once again there were none that matched the numbers issued by Security within the last two months. He put the case files back in the drawer and took out the first file, the press cuttings. He took it over to the desk and sat down to read. He struggled a little with the English, but names and places stood out. He

recognised a group of cuttings about the teacher's case. He glanced at them and put them back. Then cuttings about other cases where people had been 'repatriated'. Then he saw 'Mbuji–Mayi', and he stopped.

He picked up the cutting to study it more carefully. He held the torch in his mouth and tried to decipher the text. He checked the date that someone had scribbled underneath the headline. It was two weeks ago. He could make out the words 'students', 'massacre', 'security'. So many words that seemed familiar. The numbers were easy, 42, in numerals. The gist of the piece was all too clear; he recognised more of the words, 'bottle', very like the French, 'machete' was just the same, 'throat' he knew. He saw the jagged edges of the Coke bottle, the blood smeared across it, on his hands.

There was Tchisekedi's name, but there were no other individual names. He saw the words 'Baluba' and 'Lulua', a reference to 1960. He put the clipping back into the file, replaced the folder in the cabinet, and left.

20

Philippe landed at Zürich-Kloten in mid-morning, the weather fine and clear, sunlight winking on the Limmat and the Zürichsee as the aircraft made its final approach.

He took the railway link into the Hauptbahnhof and then when he was travelling by taxi out to the Manzas' home he had to ask the driver to pull in by the roadside for a moment. He opened the car door and breathed in the cold, fresh air.

When he reached the Manzas' house he saw a property agent's sign fixed to the gate. He paid the driver and, without hesitating, he climbed the steps to the door. He lifted his hand to ring the bell. He saw his finger on the bell-push, saw his fingernail start to whiten as his finger took up the pressure of the spring, and the bell still hadn't sounded. He took his finger away. He rested his hand against the door and breathed in. There was a spyhole in the door, dark like the pupil of an eye.

He rang the bell. There was a wait, then he heard footsteps approaching the door. He looked straight at the spyhole.

The door opened a little. There was a chain. He could see Madame Manza's face peering at him from the shadows. Her face was just as he remembered it, no older. Just as before, he saw, she was afraid.

'Madame Manza', he said. 'I've come from Etienne'.

'You're the one who telephoned?'

'Yes. And Etienne, he phoned as well?'

'You'd better come in.' She opened the door and stepped back to let him into the house.

'You've no luggage?' she asked.

'No. It shouldn't take long', he said.

She smiled at him. He tried to smile back at her. I killed your husband.

People talk about heights, about standing at the top of a high building, say, or on a cliff edge. How something pulls at you, how you almost want it, to lean out, to fall. Just the possibility of falling is enough to tighten the muscles, lock,

146

stiffen, to make you lose that natural capacity of dynamic balance. I'm going to say it. I am going to open my mouth to say something completely innocuous, and out the words will come, and down I will fall.

'Let me take your coat, at least', she said. He shrugged it off and she took it to the hallstand. Her own coat and hat were there, otherwise it was empty.

'Come through into the study', she said, and led the way. 'Find a chair, and I'll bring you . . . what would you like? Coffee? Tea? I think sometimes chocolate is good, it's a cold morning. What would you like?'

'Chocolate is good', he said.

She opened the study door and gestured for him to go on into the room. He stepped into the doorway.

'I won't be a moment', she said. 'Have a look around.'

He stepped into the room. The door swung to behind him, but rested, just ajar, on the catch.

The room was peaceful. There was no trace of violence, nothing of its bitter, bloody smell. There were new shades, he saw, on the lamps. He looked to see where the bullets must have struck the wall. There were no marks. He checked the window. There was new putty round the glass. Everything was tidy, dusted, polished. The computer sat on the desk. The monitor had been restored to its position on the system box.

He turned and looked out of the window. In the middle distance was the Zürich skyline, the steep pitched roofs, the church towers. Hardly a modern block to break the old–town jumble. The sun lay lightly on it all. He turned away from the view. As the sunlight streamed into the room he saw the tiny dust–motes dancing in the air. The sudden, lightning burst, the noise, the darkness following the shock. The door opened and Madame Manza came into the room.

'One of the good things about living in Zürich', she said. 'Is that you can get excellent chocolate.'

'Like Belgium', he said.

'You'd think they grew it themselves, wouldn't you', she said, and there was a twinkle in her eye. She laid the tray on the desk.

'Sit down', she said, and pointed to the desk chair.

He glanced at her.

'It's all right', she said. 'Go on, sit down.'

She poured the chocolate from a pot. There was a plate with biscuits. He took one and fiddled with it aimlessly. She sat, straight-backed, on an upright chair facing the desk.

'I see you're selling the house', he said.

'There didn't seem much point in staying on', she said. 'It was really much too big for us. We kept it on because we sometimes had guests . . . diplomatic people. My husband tried to stay in touch . . . There won't be many guests now, I suppose.'

'Will you manage?'

'Oh, yes. There's still twenty-six years left of the lease. I should get something for that . . . I'll rent somewhere small. I think I'll move away from Zürich. Somewhere I can speak French . . . or Lingala!' She laughed.

'And I have a pension', she said. 'Would you believe it! They take him away like that, and they still pay the pension. I had the cheque just last week. It used to be addressed to Thomas, and now there's my name on it. They must know what happened to him.'

'I'm sorry', said Philippe.

'Don't be sorry for me', she said. 'We always knew it was on the cards. He always said . . . they've picked off almost every-one, he said, over the years.'

'How long is it, since you came . . .'

'Sixty-one. We stayed on for a while after Patrice was killed, then we came here. He always knew, you know . . .' She stood and went over to a bookcase. She took down a well-worn book and flicked through the pages. Then, finding what she was looking for, she took it over to Philippe and held it out for him to read.

'It's Dante', she said. 'Thomas used to quote it to me.'

Philippe looked at the text where her finger was pointing. He saw the well-thumbed page. He read out the stanza she'd indicated;

> Tell us if in our city still burn bright
> Courage and courtesy, as they did of old,
> Or are their embers now extinguished quite?

He looked up at her, questioning.
'Read on', she said. 'Read the next verse.'
He found the place and read it out;

> A glut of self-made men and quick-got gain
> Have bred excess in thee and pride, forsooth,
> O Florence! till e'en now thou criest for pain.

Philippe gave a sad smile. Madame Manza put the book back on its shelf and returned to her chair.

'What about you?' she said. 'Joseph Nsembe tells me you're an exile, too. Is that right?'

Philippe raised his eyebrows. Madame Manza smiled.

'Exiles need to stick together', said Madame Manza. 'It's true, isn't it? You're an exile?'

'Not for long.'

'You mean you haven't been an exile for long, or you don't intend to remain one for long?'

Philippe smiled. 'I became an exile a short time ago', he said. 'I hope it won't be for long.'

'And before that?'

Philippe sighed. 'Yes', he said.

'You used to work for Mobutu.'

Philippe looked away through the window. Tight-lipped, he breathed in deeply through his nose, then blew the breath out again.

'Did you know the men who took my husband?'

He looked at her face, then looked down at his cup of chocolate.

'Listen', she said. He looked up. There was no anger in her face. The lines in her face had been set years ago, more by laughter and smiling, he saw, than by anger.

'Listen, I want you to tell those men. I want them to know. I can understand how little choice they would have had.'

'Choice is a difficult . . .'

'They were young, I suppose?'

'Quite young, yes', said Philippe.

'They never knew him. I know that. I don't want my last years to be poisoned. We both knew it would happen one day. Will you tell them? Will you tell them that I don't bear them any . . . ill will.'

'If I see them', said Philippe, 'I will tell them.'

When she left the study he tried to start the PC. He flicked the switch on the side of the system case, and another one on the monitor. He heard the hard disk clicking its way through the boot sequence, but nothing was showing on the monitor. He checked the cable that took the display signal from the back of the PC to the monitor; it was fine. He clicked the monitor's power switch on and off. Nothing. He saw the room in darkness, Thomas Manza's face illuminated by the blue glow from the screen. Then the struggle, and a crash as something heavy fell from the desk.

He left the study and went to look for Madame Manza. He found her in the kitchen, preparing food.

'I'm making some lunch', she said. 'Will you stay?'

She looked up at him.

'Is there a problem?' she asked.

'The screen's broken', said Philippe. 'I'll have to get another one. It may take a day or so.'

'Where are you staying?' she asked.

'I haven't booked anything. I didn't think it would take more than a couple of hours. I'm sorry.'

'Then you can stay here', she said.

'But that's not fair . . .'

'It'll be good to have someone in the house again', she said.

'Please', said Philippe. 'I can find somewhere in town. I'll have to go into the town to try and find a new screen.'

'Find a new screen, bring it back here, and if you stay here you can take your time finding the report.'

'All right', said Philippe. 'Thank you.'

'Good', said Madame Manza. 'We'll have lunch in about half an hour.'

Back in the study, Philippe switched off the power then disconnected the monitor and set it aside on the floor. There was only a cryptic alphanumeric label on the monitor itself, nothing to indicate what display standards it could cope with. Philippe opened the system box and as he drew off its cover the thin screech of metal on metal set his teeth on edge. He laid the cover on the floor beside the desk.

There was nothing special inside the PC; disk controller, a card with serial and parallel ports, the display card. He ran his finger along the thin, chalky plastic edge of the cards. He tried to read the print, embossed in white near the top of the display card, but it was in shadow. He switched on the desk lamp and bent closer to try and read the print, but as he stooped he caught the lamp's glare. He closed his eyes too late to stop the sudden pain.

After lunch, Philippe went into town. He found a computer dealer in one of the streets off Bahnhofstrasse, but all they had in stock were complete systems. They promised him that they could get a monitor, though, SVGA, no problem. And it could be delivered the next day. Philippe gave them Madame Manza's address and paid for the monitor in cash.

He left the shop and wandered towards the river. He had plenty of time. He found the Rathaus Brücke and strolled across it, pausing mid-way to look down at the water. He leaned on the parapet and watched the ripples on the surface of the water, how the light caught them, how they broke the surface like fish, glistening and cool. He looked downstream and saw the Limmat widening towards the lake.

The Zunfthaus zur Saffran was easy to find. Inside, it was cavernous and rather bleak. He took a table and sat nursing a coffee until Robert arrived.

'We've got it', he said. 'Just a few minutes ago. We'll get it back within the hour.'

The monitor arrived at half-past nine the next morning.

Philippe unpacked it in the study and connected it to the PC. He switched the system on and saw to his relief the initial memory check displayed on the screen. Then config.sys and autoexec.bat ran. He caught a glimpse of driver filenames zipping up the screen. Finally the Windows logo appeared, 3.1, and a few moments later there was the Program Manager.

He scanned the program groups for Manza's word processor. It was easy enough to spot. He'd been using Ami Pro. Philippe double-clicked on the icon and the Lotus logo came up on the screen, followed by an empty edit window with the menu bar across the top. He clicked on the File menu and there, in the list of last-used files, was ETIENNE.SAM. He opened the file and began to read it.

Manza had been trying to assess the likely response at the United Nations if Tchisekedi were to come to power, depending on what brought him to power. The message was that hardly anyone outside of Africa would shed a tear if Mobutu went, even in a coup. And from within Africa, only a handful of countries would raise a protest. But more than this assessment, the document gave the names of diplomats who, privately, had pledged to Manza their willingness to support a Tchisekedi government. Those names and dates, those promises, would be like gold if Tchisekedi's moment were to come. The report seemed complete. Only the final summary had been cut short. Philippe switched on the printer and pulled down the File menu again. He printed two copies.

Madame Manza opened the study door and looked in.

'Have you found what you were looking for?' she asked.

'I have', said Philippe.

'And do you think that Tchisekedi has a chance?'

Philippe smiled. 'I think we'll have to wait and see', he said. 'But I think he'll like what he reads.' Borrowing an envelope, Philippe addressed one copy to Tchisekedi's home in Kinshasa.

She offered him lunch again, and again he tried to decline but she persisted. Then, just as the day before, she tried to mother him; was the soup all right, did he want salt and

pepper? Did he like brown bread, and was butter all right, or would he rather have margarine?

Things went more smoothly when she settled down to eat her own meal. She talked easily about her husband, and Philippe was happy to listen; the many times that ministers, driven into exile, had come to Thomas Manza for help. How one after another had been the hope of better things for Zaire. How one after another had fallen, somehow, by the wayside, or among thieves. It seemed that for a time Manza had even hoped that he himself might return and form a government. Annette smiled wryly at the thought, and Philippe smiled with her.

He was fine until, shortly after lunch, they said their good-byes. She stood in the doorway of the house, and Philippe had just stepped out. He turned back towards her and took her outstretched hand to shake it. She held his hand in a firm grip, and looked into his eyes.

'I want you to understand', she said. 'That I don't bear a grudge. That I forgive them.'

He couldn't look away. She was still holding his hand. She reached up with her left hand and slipped it round the back of his neck, then drew his head down towards hers. She kissed his cheek softly, then released him.

He straightened up slowly. She held his gaze.

'Good luck', she said.

'And you', he said, 'And, thank you.'

That evening, when Marie got back from her mother's, she decided to hoover the sitting room. She was working her way around the room's perimeter when she noticed, on the floor just below the electrical socket, a small spill of plaster crumbs and dust. With the vacuum cleaner's motor howling in her ear, she knelt to check the socket. It seemed loose. She'd left it tightly closed. She went to the kitchen and fetched a screwdriver.

When she drew the metal box out from the wall she saw the passport sitting there. She took it out and looked through its pages to check. The details were unchanged. She turned to

the back, and there was the stamp from the British embassy. She turned the pages again, and this time she noticed it. It was a visa for entry to Switzerland, issued by the Swiss embassy in Kinshasa. It was valid for 45 days, starting in two days' time.

21

Kawena was in the situation room when Marie made the call to Bukavu. He heard her shy greeting, and the warm reply.

'Can I come and visit you for a while', she said.

'Of course', said Philippe's mother. 'Are you bringing Eric?'

'Yes. The fresh air'll do us both good, and . . .'

'Is everything all right?'

'Oh, yes. I was just going to say, Kinshasa gets so sticky.'

'Tell me. I don't know how you can live there. I suppose there's not much choice, though, is there, for you. How's Philippe, anyway? I haven't heard from him for weeks.'

'He's out of the country. He's been gone .. about two weeks. He's away for a couple of months.'

'Oh. He hasn't rung. I suppose . . . when he's ready.'

Kawena laughed.

'I thought I'd fly out tomorrow', said Marie. 'There's a flight that arrives about four o' clock.'

'That's fine', said Philippe's mother. 'We'll meet you at the airport.'

She packed clothes for about a week, light summery frocks for the daytime and warmer clothes for the cold evenings. Then a shoulder bag for Eric's things; she'd need one hand free to look after him. She tried the bags for weight. It was too much. Eric would have to carry some of his own clothes.

When Eric got back from school she told him about the trip. He cheered and clapped his hands together.

'Can we go to the lake?' he asked, with a wide smile that made wrinkles round his eyes.

'Yes, we can go to the lake', she said.

Eric picked out the things he wanted to take. The computer game had pride of place, and then a little stack of books about dinosaurs.

'You can't take everything, Eric', she said. But on the way

to her mother's that afternoon she stopped in the city centre and found a small knapsack that Eric could manage.

Her mother never said a word. They spent the afternoon as usual. Eric played happily with the neighbour's children in the garden while Marie helped her mother prepare the meal. The conversation while they ate was stilted, breaking down into silences, and when they said goodbye they hugged a little longer than usual. Instead of going straight back into the house, Marie's mother watched and waved as the car drove along the street, and she kept waving until the car had turned out of sight.

That night, with Eric finally settled down, Marie packed and repacked her own bag. She changed her mind a half a dozen times about the clothes that she should take, and she tried to find mementos that would travel easily. She took her few pieces of jewellery, the diamond earrings to remind her of their time in Kasai. An envelope with photographs of the family, of Eric in the garden in Kinshasa, of Eric with both sets of grandparents. She slipped his birth certificate into another envelope. She checked and re-checked her handbag; the cheque book – she'd have to leave it. She took the passport out of its hiding place. And when she was ready she phoned the taxi company to book a car for the next day. The technician logged the call, and later that night he passed the day's report up to Kawena.

Kawena was sitting at his desk when the report came in. In front of him was a photocopy of the document that Philippe had sent to Tchisekedi. The man who had brought the report hovered nervously in front of Kawena.

'What do you want us to do in the morning?' he asked.

Kawena looked up. 'Let her go', he said. 'Follow her to the airport, see she gets the flight to Bukavu. If she goes via Goma, let me know and we'll watch the transfer. That's all.'

The man left. Kawena called the station in Bukavu. They'd follow the family from their home to the airport, keep an eye on them, and check they met Marie. But they were to stay well out of the way. 'Don't frighten her', he said. 'She's frightened enough as it is.'

Kawena looked again at Manza's assessment. He glanced at the picture of Mobutu, then opened the right hand drawer of his desk. He took out a photograph.

The man was tied to a chair. You could see that he was a big man. You could see that he was strongly built. And you could see he must be strong inside, because, as far as you could make out the expression on his face, it was angry and defiant. There was something proud about the way he held his head. You could see that, even though it wasn't obvious, at first glance, who he was. Because he was shining, dark shadows and bright reflections. It was as if someone had painted him. He was stripped to the waist, and glistening, as if he'd just been painted from the crown of his head down to his waist, deep scarlet. There were splashes of colour on his trousers and the colour dripped from what could be seen of the frame of the wooden chair. He was glaring at the camera, and in the foreground was a hand, a wrist, and in the hand a doubled leather belt, the buckle shining like gold and streaked with red.

The belt was a mistake. Anyone familiar with the presidential guard would recognise the belt for what it was, Israeli-issue. The whites of Tchisekedi's eyes shone out of the wash of blood, and the pupils stared into Kawena's face.

Marie looked all around the lobby. A few yards away stood two men in abacosts, they seemed to be chatting to one another. She saw no sign of them glancing in her direction.

She bought the tickets to Bukavu and steered Eric over to the check-in desk. She checked in her suitcase and tried to persuade Eric to check in the knapsack, but he refused to be parted from it.

The men in abacosts were standing either side of the doorway. They were wearing dark glasses, and spoke to no-one. She tried to walk past as if they weren't there, and they seemed to ignore her completely.

The flight was late. It would be two hours before they could go to the gate. She tried to settle Eric down but he was fretting for the computer game. She went across to the shop and bought him a book but he fidgeted with it. She let him be,

simply sat and stared out, unseeing, across the departure lounge. Eric's questions and complaints flew past her like small birds, and he fell quiet for a while until, gazing up at his mother's vacant expression, he grew bold enough to open his knapsack and take out the computer game. The burbling, electronic music began, and still Marie sat still. Two men in abacosts strolled round the lounge; she didn't move. Only when the flight was called did she snap out of the trance. She gathered Eric up, together with the little luggage that they carried, and headed for the gate.

She showed her boarding pass to the girl and noticed a man staring at her. She glanced at him, but saw only the blank face, the lights reflected in his dark glasses. Then she was outside, walking towards the aeroplane. Eric was beside her, his hand in hers, and no-one had tried to stop her. Kawena listened as his watchers radioed in the messages. She was on the plane. The aircraft doors were closed. It was taxi-ing out to the runway.

As the aircraft took off, Marie was rigid in her seat, every muscle braced, everything buckled in tight. As the wheels lifted off the runway she felt the pull of gravity as if it were the city pulling at her, trying to hold her back; she was holding her breath, and then the roaring of the engines eased and they were in a shallow turn towards the east. She breathed out. Eric was pointing out the city, far below, the cars like toys, and even at that height the river's broad and gleaming rusty brown expanse. She listened to the steady humming of the engines and, having spent the night awake, she let herself fall asleep.

Philippe's father drove the family down to the airport. If he noticed the grey Mercedes that followed at a distance, he gave no indication of it. He parked in the airport car park and they strolled into the terminal, Philippe's father, his mother, and his youngest sister. The grey Mercedes parked a hundred yards away and one of the men got out. He was wearing pale cotton slacks and a bright blue casual shirt.

There was no information about the flight, so the family found a place in the terminal to have coffee. The man in the

blue shirt wandered round the stalls in front of the terminal, and bought a couple of oranges. There was no rush. He went back to the car and gave his partner one of the oranges. They ate them together, messing about with the pips, squeezing them between finger and thumb to shoot them at each other. After a while the man in the blue shirt walked back into the airport building. The family were still there. He went into the washroom to sluice the stickiness from the orange off his hands.

Philippe's family had finished their coffee, but his mother and sister stayed for a while in the restaurant while Philippe's father went to enquire about the flight. A while later he returned with the news about the two-hour delay.

'We'll come back later', he said.

They drove back to the house and the grey Mercedes followed them.

Two hours later they were back at the airport. Philippe's family watched as the passengers from Kinshasa gathered up their luggage and came out into the lobby. From the distance, the man in the blue shirt surveyed the scene. When the last of the passengers had left the airport, Philippe's family and the man in the blue shirt were still waiting.

Philippe's father checked the schedule. The man in the blue shirt was standing beside him; and without acknowledging each other, the two men studied the flight display together. There were no more scheduled arrivals due that day, nor departures. Philippe's father had a small plastic bottle of mineral water with him. He lifted the bottle to his lips and, still watching the flight display, he took a sip. The plastic of the bottle was a pale, translucent blue. The water caught a shaft of light from a window high in the lobby, and quivered as it slid towards the neck of the bottle. The two men turned away at the same time. Philippe's father glanced at the man in the blue shirt, but he turned away as if he were embarrassed. Philippe's father allowed himself a smile.

Marie looked down as the shining lake grew small beneath the little Cessna and fell away behind them. As they swung into a turn, she looked out to her right and saw the huge

valley floor stretching away to the south. She could just make out Lake Tanganyika in the soft blue distance. An hour later, with Eric sleeping beside her, she looked down and saw Lake Victoria stretching out before them like an ocean. They flew across its southern margin, over the scatter of small green islands. Even the sun seemed far behind them. Ahead of them was the falling night, and, sparkling as they approached, the city of Nairobi.

There had been the same rigidity, the same held breath, as they climbed up and away from Bukavu. But as the aircraft taxied in towards the terminal at Kenyatta she found herself shaking, and weeping uncontrollably. Eric was looking at her anxiously, close to tears himself, not understanding why. The pilot looked back over his shoulder at Marie, and asked if she was all right.

'Yes', she said, and smiled. 'I think so. I really think I am all right.'

'That's good', said the pilot. 'Because I can't stay with you, you know. When you get into the terminal you're on your own.'

Marie reached out and took Eric's hand. The child looked up at her, more calm now, but still puzzled.

'We'll be fine', she said. Eric's face broke into a broad grin.

Kawena took the telephone call from the man in the blue shirt.

'That's all right', he said. 'Don't worry. We can handle it.'

22

It was late, but Kenyatta was still busy, a swirl of human currents, faces all preoccupied, and all around the sound of Swahili, in which she could manage only the simplest of exchanges. Now and again in the crowd there was a phrase of English or French, then there were languages she couldn't identify at all. Somewhere nearby she heard two women speaking in Lingala, but when she tried to push through the crowd towards them they were gone. She was carried along in the flow of passengers towards the exit and it was all she could do to hang on to the luggage while keeping firm hold of Eric's hand. Then she found herself on the broad pavement outside the airport building. Night had fallen, and she could recognise nothing.

She'd memorised the name of the hotel, 'The Planter'. If she could reach it, the note had said, there was a room reserved for her and the child. But the hotel was in Nairobi itself, and as she looked around her she could see only a handful of office buildings and warehouses, car parks and roadways, a scatter of flimsy huts and shuttered stalls. Then, as she brushed away yet another offer to help her with her luggage, another beseeching cry of 'taxee?', 'taxee?', she saw a short, wiry-looking man holding up a torn piece of card with her name written on it.

She went up to him. *'Nimi Marie'*, she said. I am Marie. Eric seemed afraid of the man, and hung back behind her.

The man looked at her suspiciously. *'Mtoto iko wapi?'*. And the child?

'Mtoto moja, Eric', she said, dragging him into view.

The man grinned. '*Salaamu*', he said and, picking up Marie's suitcase in one hand, he took her by the arm and steered her confidently out across the road. As they reached the other side they came up against another crowd of people at a bus stop, milling aimlessly about. The man plunged boldly at them – *'Njia! Njia!'*, make way for the lady!

161

The car, when they reached it, had seen better days. Once there had been paint, perhaps; the only thing undented about the vehicle was its owner's pride in it. He gave a neat bang on the boot, which sprang open, and he loaded their bags. Then he scooted round to the car door and held it open for Marie. She climbed in and, as Eric followed her, the man gave a little bow. Then he settled himself behind the wheel and they were off; twenty minutes of belligerent driving and every time he overtook another vehicle he muttered, half beneath his breath, *'Mzuri. Mzuri.'* Excellent. Marie was glad of the distraction that the lighted streets provided when, eventually, they came into the city itself. Then the car swerved in to the kerb and, with a sudden deceleration that threw them forward, it stopped.

'Hoteli yenu', he said. She looked out of the car and saw the name of the hotel, 'The Planter' in huge golden letters over the porch. The driver was already out of the car and unloading the luggage from the boot. She tried to open her door, but it was stuck. A moment later, however, he'd opened it from outside, and was standing almost to attention, holding the door for her. She climbed out and Eric followed her. The driver waved her on ahead then gathered up the baggage and scurried after her. He caught up with her just as she approached the reception desk.

'Yembe Memsaab!' he said to the receptionist, as if he were introducing royalty. The girl held out her hand to Marie, and then spoke to her in French. Marie shook her hand and thanked her, and the girl leaned over the desk to greet Eric, whose airport fears were gone.

'Bon soir', said Eric, catching the formal mood.

'Bon soir, M'sieur', said the girl.

Marie began to search in her purse for money to pay the driver, then stopped. She had only Zaires with her. It was about the only currency the driver would be certain not to accept.

'That's all right', said the receptionist. 'It's already paid for.'

She turned to the driver and gestured apologetically at her empty purse, but he was still beaming from ear to ear.

'*Asante*', she said, and held out her hand. He shook it enthusiastically, bowing the while, and backing away from her.

'*Kwa heri*', he said. Goodbye. Then turned and strode out of the door.

As soon as she got to the room she tore open the envelope they'd given her in reception. After all the anonymous notes, at last there was Philippe's familiar handwriting and, thank God, a telephone number.

She called Eric across to her and dialled the number. Eric was watching, a little puzzled, but bright and starting to enjoy the whole adventure. She heard the phone ringing, and the click as the receiver was lifted. She held the phone out for Eric to take it, mouthing at him, '*Papa*'.

He grabbed the phone and bellowed into it, '*Papa!*'. In London, Isobel held the receiver away from her ear and looked at it, baffled. She listened again.

'Hello?', she said.

Eric turned to his mother. '*Ce n'est pas Papa!*', he said. Then spoke into the phone again. '*Papa?*'

Isobel called up the stairs to Philippe.

Philippe leaned over the banisters and looked down into the hallway. 'It's someone asking for Papa', said Isobel. Philippe grinned and came charging down the stairs. Isobel gave him the phone and retreated into the kitchen. She could hear, from there, Philippe's voice, usually so quiet on the telephone. She couldn't make out what he was saying, but the happiness in his voice was obvious.

Marie, too, was enjoying the pleasure in her son's voice, the innocent, childish chatter. Then, after the first excited moments, as Eric's voice became a little more calm, her own patience snapped and she took the phone back from him.

'Philippe? Are you all right?', she asked. 'I thought you might be at the airport? Is everything all right?'

'Everything's fine', said Philippe. 'I'll meet you in Zürich. Did you get the tickets?'

'Yes', said Marie.

'The flight's in the morning', said Philippe. 'Can you check the time?'

She picked up the tickets. 'It's 11.45', she said.

'Good', said Philippe. 'It's a direct flight. I'll fly over from London tomorrow. I'll meet you when you arrive. Can you manage? The hotel should have a car booked for you, to get you to the airport. All you have to do is get on the flight, and you'll be with me tomorrow. Marie? Are you all right?'

'Mmm.'

'You just have to manage till tomorrow evening. Are you there? Marie?'

'I'm fine', she said. Eric was bouncing on his bed. 'I'm fine', she said, and started to cry, then stopped herself.

'The worst's over', he said. 'You've managed the worst part. You've been great. And Eric's fine?'

'We're both fine', said Marie. She'd found a handkerchief in her bag. She wiped her eyes and blew her nose.

'Philippe?', she said. 'How did you manage it?'

'We've still got friends', he said.

'Can I phone my mother?' she asked. 'What about your family. They'll be worried, when I didn't meet them ..?'

'It's OK', said Philippe. 'Don't phone them yet. I'll get a message through to them, tell them you're OK. OK?'

'OK', she said. 'I'll really see you tomorrow?'

'You'll really see me tomorrow', he said. 'Now, get some sleep, both of you. All right?'

'All right', she said. '*Je t'embrasse*'.

'*A tout à l'heure*', said Philippe, and put the telephone down.

'If you know the way', said Chris. 'I think you're better driving it. It takes hours on the tube. You're Piccadilly line all the way, and it drags on for hours. All you do is sit there. It'll do you in. And it'll cost a fortune in a cab.' He paused. 'Look', he said, 'how long are you going to be?'

'We'll go for the visa the next day', said Philippe. 'If we get the visa, we can fly back that afternoon.'

'So you're back here tomorrow evening. Right?'

'Right.'

'So you can borrow the car. Isobel's in Oxford again tomorrow, so she's going by train. I'm not going out tomorrow. You can borrow the car. You've got a licence?'

'Aha.'

'So that's settled. North Circular Road, M4, Heathrow. Leave the car at Heathrow, then you can bring them back in it tomorrow. Lot better than dragging them all along the tube, all the luggage, on and off the bus. Do it properly.'

'OK', said Philippe.

'And if you're running a bit late', said Chris. 'You can just leg it the last bit. Feels a lot better than sitting on a slow train.'

'OK', said Philippe.

'I'll give you one thing', said Chris. 'You're gracious in defeat.'

As it turned out, Chris was right. Philippe got caught behind a refuse truck in Crouch End and by the time he reached the North Circular there was only half an hour to go before he was due to check in for the flight.

He got as far as the Chiswick roundabout, then he missed the turn-off for the M4 and had to go round a second time. He saw the sign and peeled off onto the slip road. It climbs a little, up to an elevated section where the carriageway, squeezed down to two lanes, runs like a drain between drab office blocks. OK, M4, Heathrow, great. He glanced at his watch. Twenty minutes before he was supposed to check in, but they say an hour and when you get there, a few minutes is always enough. He glanced ahead to the streams of traffic preparing to come off the sliproad and onto the motorway proper.

He looked to see how much more room he had to move out into the nearside lane. Hardly any, he realised. There's hardly any distance left. He looked to his right and saw a blue Volvo level with him. He was running out of space fast and he eased off on the throttle. He would have to make up the time further on.

Somewhere behind him a horn started blaring. He turned, and saw the Volvo right beside him. He glanced across and

saw the crash barriers, the sliproad coming to an end, the metal barriers slanting in towards him. Everything slowed down. There was no room to the left. He looked across and saw the driver of the blue Volvo, the man was smoking, the cigarette almost down to the stub. This is going to be bad for your health. He saw the driver's face contort, saw him pull over to his right. I've missed the flight. I don't know how bad this is going to be, but it's going to make me miss the flight. But there's a Swissair flight at ten to two, gets in at a quarter to six. If it's on time I might just get there before they do. If I can get on it. He hit the barrier at the end of the slip road, heard the sudden smashing sound and felt the car punched over to the right, felt the impact with the Volvo, felt the car start to spin. He saw the motorbike spinning away from him, saw the sunlit wall in Bukavu, the vertical wall tipped to the horizontal, still spinning, he heard the squeal of brakes. Please God, he thought, don't let it be too bad.

He came round in the ambulance. He struggled to lift himself up from the stretcher, and the medic pushed him gently back.

'Just stay there, mate', he said.

'What time is it?' asked Philippe. He began to look round the inside of the ambulance, looking for a clock.

'Never mind', said the medic. 'Just keep still. We'll get you to hospital in no time.'

'No. What time is it? Please. Tell me what time is it?'

'OK', said the medic, and looked at his watch. 'It's almost twelve.'

'I've got to get to the airport', he was trying to get up, but something was stopping him.

The medic shook his head.

'Not for a while yet, mate', he said. Philippe let his head fall back onto the pillow, and winced with pain.

'Is anyone else hurt?' he asked.

'Not really', said the medic. 'Bloody lucky. You're probably the worst.'

'Have you got a phone?' asked Philippe. 'Have you got a mobile?'

The medic shook his head.

'Let it wait until the hospital', he said. 'They'll sort you out there.'

They X-rayed his skull, and his right arm. There was nothing broken, just bad bruising to the arm and to the right temple where he'd crashed against the door, but they wanted to keep him in for observation and the police were waiting to interview him.

'You're not travelling for a couple of days', said the doctor. 'No way', and he showed the policeman into Philippe's cubicle.

'I've got to telephone', said Philippe.

'Not till I've talked to you', said the policeman.

'I've got to telephone. It's important, look.' He tried to reach for his jacket, which was hanging beside the bed, but when he tried to lift his arm it felt as if it were going to break.

'Look', he said. 'Please. In the jacket. In the inside pocket. Get my passport. Please!'

The policeman reached across and found the passport. He opened it and saw the diplomatic accreditation.

'Was that an embassy car you smashed up?' he asked. 'I didn't see any plates.'

'Look, please', said Philippe. 'I've got to make a call. I've got to meet someone in Zürich this afternoon. It's urgent. Please, can I make a call? I promise, if I can just make a call, you can do whatever you have to do. It won't be a problem. Please.'

The policeman looked at the passport again, then closed it and put it back into Philippe's jacket pocket.

'I'll see what I can do', he said.

Ten minutes later the policeman reappeared, with a hospital porter pushing a telephone on a trolley. The porter plugged in the phone to a socket by the bed, then stood and looked at Philippe.

'Needs money, dunnit', said the porter. He turned and left the cubicle. Philippe managed, struggling with his left hand, to get change from his trouser pocket. The telephone was on his

right. He tried to lift his right hand. The policeman stood and watched the effort.

'OK', he said, and took the money from Philippe's hand. He lifted the receiver and dropped a pound coin into the slot. 'You tell me which buttons to press', he said.

Kenya Airways flight KQ112 from Jomo Kenyatta International touched down two minutes ahead of time, at twelve minutes to six in the evening, local time, at Zürich-Kloten. Passenger Marie Yembe, with her son Eric, proceeded without difficulty through Immigration and emerged from Arrivals into the main airport lobby.

She couldn't see him.

All around her, other people from the flight were being greeted by their friends and relatives. He wasn't there. They'd missed each other in the bustle. She searched the faces again. He wasn't there, and as the crowds of passengers and friends and relatives thinned away she could see he really, really wasn't there.

'Marie? Marie Yembe?' A woman's voice.

She turned and saw a white woman about her own age.

'Vous êtes Marie et Eric?'

Eric looked up at his mother and began to cry.

'Soi sage', said Marie.

'Marie Yembe?' said the woman.

'Yes', said Marie.

'I'm Catherine Bonnard', she said. 'Your husband's been held up, but it's all right. He's all right, but he couldn't meet you. We'll take you to a friend's house. Don't worry.'

She had no choice but to trust the woman. They left the airport and found a taxi. Twenty minutes later the taxi pulled up outside a large suburban house.

Catherine was paying the driver when an elderly black woman appeared.

'Mbote', she said, and took Marie's hands in her own. *'Mbote.'*

Marie just threw her arms around her and cried.

★

She woke to the sun-filled bedroom and fresh flowers by her bedside. There was someone knocking at the door, and Marie heard a woman's voice calling her name.

'Come in', she said. Annette Manza came into the room, followed by a smiling Eric. There was a tray with breakfast. Annette folded out a little set of legs from beneath the tray, and, with Marie sitting up, set the tray in front of her. Then she sat down herself on a chair beside the bed.

'We're good friends already, me and Eric', she said. Marie gave a sad smile. Annette took her hand.

'Don't be afraid. Philippe's all right. It's nothing serious.'

Marie swallowed. She glanced at Eric.

'He's been good', said Annette. 'He helped me get your breakfast ready.' Eric's face was full of pride. Marie's smile strengthened a little. She turned her attention to the breakfast tray and found, as she began to eat, that she had quite an appetite.

'Eric', said Annette. 'Can you remember where the biscuits are?'

He nodded.

'Would you like one?' He grinned.

'Off you go then', said Annette.

When Eric was out of the room Annette's face became more grave.

'Marie', she said. 'I know you're frightened. I had to do what you've done, thirty years ago. I know how frightening it is. But listen, it's going to be all right. You can do it. If I could do it, you can do it. And we had thirty years of it. You won't have anything like that.'

Marie bit her lip.

'You can do it', said Annette. 'Remember that'.

'And your husband?' said Marie.

'He died', said Annette.

'I'm very sorry', said Marie. She reached towards Annette and they clasped hands for a moment, gripping tight.

'See what I'm telling you', said Annette. 'You're strong. You're stronger than you think.'

Annette stood up and briskly smoothed out the creases in her dress.

'Catherine will come soon', she said. 'She'll look after you. She'll go with you to the consulate.'

The British Consulate is in Dufourstrasse, behind the Opera House, on the first floor of a plain office building.

Marie showed the official her passport.

'And you want a visa so that you can visit ..?'

'My sister', said Marie. 'She lives in Birmingham.'

'I see', said the official. Marie could see the window of the office reflected in the lenses of his spectacles.

'And you will be in Britain for ..?'

'Two weeks', said Marie.

'Well, that should be . . .' he was flicking through the pages of the passport.

'Oh', he said. Marie glanced at Catherine Bonnard, who was sitting beside her for moral support.

'You applied for a visa in Kinshasa?'

'Yes.'

'Well, that makes things difficult. It says here that you began an application in Kinshasa, but it hasn't been resolved. Is that correct?'

'Yes', said Marie. She wasn't sure what he meant by 'resolved'.

'Then I'm afraid we'll have to send to the embassy in Kinshasa, to get your file. We can't do anything without the papers from Kinshasa. I'm sorry. You'll have to wait.'

'How long will it take', asked Catherine.

'It usually takes a couple of months.'

'But I've only got a visa for 45 days', said Marie.

The official studied the passport.

'So you have', he said.

'You can't expedite matters?', said Catherine. He closed his eyes and swivelled his head from side to side. When he opened his eyes again he saw that Marie was bowed, with her head in her hands. She was rocking a little backwards and forwards, but not making a sound.

'I'm ever so sorry', he said. 'Really.'

23

Madame Manza opened the door to find Marie leaning against Catherine and crying. They got her into the house and settled her in an easy chair in the study. By the time Eric came into the room, Marie had regained a little of her composure.

'I'll phone Philippe', said Catherine. Marie managed a feeble smile.

Philippe was propped up in bed in his room. The doctor had let him out of hospital only when Philippe gave his word that he'd spend the next two days in bed. Chris and Isobel took turns to police him, and when he insisted on getting out of bed every time the telephone rang, they swapped the phones over. The house line in the hallway now had the cordless phone from the attic, and the receiver sat at Philippe's bedside.

Catherine gave him the news.

'Why on earth did no-one spot it?' he demanded.

'How should I know?' said Catherine. 'I only went with your wife to the consulate. I didn't arrange this cloak and dagger stuff!'

'I'm sorry', said Philippe.

'What are you going to do?' asked Catherine.

'I don't know', said Philippe.

Catherine handed the telephone to Marie.

'Philippe?' she said. She'd been crying.

'I'll work something out', he said. 'Don't worry.'

'Why can't you come?'

'I can't', said Philippe. 'Not today. In a couple of days. Can you wait?'

There was no answer, just a loud wooden bang as Marie put the receiver down on the desk.

'You'd better get something worked out quickly.' It was Catherine's voice. Madame Manza stood beside Marie. She laid her hand on Marie's arm.

Catherine put the phone down. When she turned round, there was Eric, looking up at her.

Ndeko was alone in his office. His telephone rang and he reached out casually to pick it up. When he heard the voice at the other end of the line he glanced around instinctively.

'Philippe', he whispered. 'This isn't safe.'

'There's no choice', said Philippe.

'I told you before. This isn't safe. They'll work it out. They worked out it was you put Manza's wife onto Vungbo? Did you know that? And everybody knows you got Marie out to Nairobi.'

'Listen', said Philippe. 'I need to find a way to get her into Britain from Zürich. I need a new ID. Can you do it?'

'I could do it. It's easy. But it's not safe. I can't take the chance. They know you've broken away.'

'They don't know. Not for sure.'

'They know you're getting help . . .'

'Sooner or later you're going to have to make up your mind which side *you're* on.'

'Philippe!'

'I'm sorry', said Philippe. 'But sooner or later you'll have to jump too.'

'I know', said Ndeko. 'Do you think I don't know?'

There was a long pause. Ndeko spoke first.

'I can get her an EC identity card, French. That would do it.'

'When can you get it to me?'

'You must be joking.'

'If I'm going to travel with her ..'

'You can forget that. One happy family? One French woman with child, one Zairean diplomat, completely different name . . . all you'll do is . . .'

'I can travel on the same . . . train, ferry, whatever ..'

'And do what? If you don't look at her, she'll look at you. And what if Eric says "Daddy"?'

There was a pause.

'You stay in England', said Ndeko. 'If something goes wrong

at your end . . . You need someone else to travel with her. And your best bet's someone white.'

'You're right', said Philippe. 'You're right. I'm sorry.'

'I'll get it to her soon as I can. Give me an address in Switzerland. All I need to do is put it in the post. Philippe?'

Philippe's concentration had gone.

'Philippe? Are you there?'

'What is it?'

'I said, "Can you give me an address in Switzerland?"'

Philippe gave him the address.

'Manza's?'

Philippe could see Marie and Eric. They were standing on a long conveyor belt. They were reaching out towards him but the conveyor belt was pulling them slowly away, a whole line of people, stretching out into the distance, moving steadily further and further away and his own feet were rooted to the ground.

'Philippe?'

'Yes', he said. 'It's Manza's address.'

'Well, that's one they wouldn't guess', said Ndeko, and Philippe heard him laugh, then the line went dead. He looked down at the telephone. There was a knocking sound. A pause, then the sound came again.

'Philippe?' He looked up to see the door opening, and Chris Davis coming into the room with lunch on a tray.

'Are you all right?' asked Chris.

Philippe switched the cordless phone back to standby.

'I'm fine', he said, but his voice was dull.

'Is there a problem with Marie?'

Philippe set the cordless phone down on the bedside table, and Chris set the tray in his lap. Philippe looked down at the tray.

'Shock', said Chris. 'There's nothing you can do about it.'

Philippe shook his head slowly from side to side.

'She can't get a visa', he said.

Chris sat down. Job's comforters, ineffective as they were, at least had the decency, at least at the start, just to sit for a week without speaking.

173

'What will you do?' asked Chris.

'I'll have to get her a new ID', said Philippe. 'And someone else will have to travel with her, and I don't know who can do it.'

Chris studied the palms of his hands for a moment.

'This Catherine woman?' he said. 'That met her at the airport?'

'I can't think of anyone else', said Philippe. 'But I don't know her. She's a friend of the Manzas. I don't know. This isn't a business where you trust people easily. You have to . . . they have to earn your trust. It takes time.'

'Well you can't go yourself', said Chris. 'Not for a few days, anyway.'

'I told Marie I would', said Philippe. 'But it won't work. It has to be somebody white.'

Philippe picked up the cup of coffee and sipped at it.

'You didn't know anything about us, did you?' said Chris. 'Not until you came here.'

There was no answer.

'But you knew Joseph Nsembe.'

'Yes.'

'And you know Madame Manza. You have to trust her judgment, don't you.'

Philippe could see Eric and Marie on the conveyor belt, moving away from him. Further along he could see Thomas Manza, struggling to get away from the two men who were holding him. Two white men.

'Philippe, you're still in shock. Don't feel guilty about it. You just have to rest for a couple of days and it'll pass.'

'I know', said Philippe.

They were due to travel on an evening train from Zürich. Catherine had agreed to go with Marie, and the French ID had arrived that morning. Annette Manza had done Marie's few days' worth of washing, and now she was helping with the packing. Catherine had taken Eric down into the town to show him the sights.

'Why is she helping?' asked Marie.

Madame Manza was busy folding a blouse. She finished the job, patted it, and passed it to Marie.

'You'd have to ask her that', said Annette.

'But you must have known she'd help.'

'I thought she might.'

'She isn't part of your family.'

'No.'

'She isn't from Africa?'

'No. Her family were from . . .'

'She's Swiss?'

'Yes, she's Swiss. She's not family, but she's the nearest thing to family we've got.'

Madame Manza picked up one of Eric's shirts.

'When we came here', she said. 'We knew hardly anyone. Thomas needed to run an office, he needed someone to help him. He advertised for a secretary.'

She checked over the shirt, checking that the buttons were all secure. Then she folded it again and passed it over to Marie.

'We had a dozen answers, and as soon as they came to the door, they started to make excuses. Except Catherine's mother.'

'You knew her mother?'

Annette nodded.

'She was just married. She . . . neither of them, they'd no family in Switzerland either. So Anna became Thomas' secretary, and we became friends, Anna and Stefan. Then Catherine was born, and Stefan became ill, and he died.'

She picked up the next shirt. Marie watched her check it, then fold it. Annette passed the shirt across and Marie took it and put it in the suitcase.

'Anna was on her own with Catherine', said Annette. 'And we were on our own, and we couldn't have any children. So Anna came every day to help Thomas, and I looked after Catherine ..'

'What happened to Anna's family?'

Annette was fidgeting with the pile of washing, not picking anything up, just picking at seams, picking at the surface of the fabric. Then she stopped and laid her hand on the bedspread.

'This was 1962. Stefan and Anna were much the same age as Thomas and I. Can't you work it out?'

Marie looked at Annette. The older woman's mouth was pinched and her eyes seemed suddenly hard and angry. Then Annette realised that Marie was looking at her, and her expression softened.

'You don't know. I'm sorry. I thought everybody knew.'

'What happened?' asked Marie.

'Stefan and Anna came out of Germany during the war, they were both of them just . . . I don't know, younger than Eric . . . they went into an orphanage. They grew up together . . .'

'What happened to their families?'

Annette reached out and took Marie's hand.

'They say the Luba people', said Annette, 'are the Jews of Zaire. Philippe is Luba, isn't he?'

'Yes, but . . .'

'They died, that's all.'

Annette patted Marie's hand, then picked up Eric's t-shirt and folded it before laying it in the suitcase.

They finished the packing in silence. At last the case was closed and only Marie's passport remained.

'You'd better give that to Catherine', said Annette.

The following morning Philippe was sitting up in bed, holding the photograph his brother had taken at Lake Kivu.

He rang Madame Manza.

'Are you sure they got onto the train?' he asked.

'I'm sure', said Annette. 'You'll just have to wait. Catherine said they'd telephone from Calais. They're not due there until after eleven.'

Philippe looked at his watch. It was almost eleven.

'Just be patient', said Annette. 'Catherine's going to take good care of them.'

Philippe put the telephone down. He sat and watched the second hand ticking round. At every tick the conveyor belt moved a fraction towards him, then stopped, and slid back. Marie and Eric stood like statues, reaching out towards him,

staring at him, their mouths open, speech frozen on their tongues. The second hand kept moving slowly round the watch face, but the minute hand had stopped and the hour hand seemed set in place as firmly as a mountain. He glanced at the photograph, at expressions that would never, ever change, the smile on Eric's face, the awkward, embarrassed expression on Marie's.

At twenty to twelve the telephone rang. Philippe grabbed at it and felt a jolt of pain from his bruised right arm. He switched on the phone and heard Catherine's voice speaking his name.

'We're in Calais', she said. 'The ferry sails in an hour. We should be with you this evening.'

24

On the 8th of November 1960 the United States of America went to the polls and had a hard time deciding between Nixon and Kennedy.

The same day Joseph Kasavubu, President of the Republic of the Congo, addressed the UN. He made a calm and dignified speech, outlining his claim to be the sole authority within the Congo competent to appoint representatives to the UN. 'No claim', he declared, 'by any other so-called representative of the Republic of the Congo to speak on its behalf can be admitted'. Then he settled down to enjoy the comforts of New York and stated that he would not go back to the Congo until his delegation had been recognised.

Over the following fortnight the UN had a hard time deciding whether to recognise Kasavubu's delegation or the delegation led by Thomas Manza, appointed by Patrice Lumumba, Prime Minister of the Republic of the Congo. On the 22nd of November, however, the UN General Assembly finally voted in favour of Kasavubu. The French newspaper *Le Monde* called the vote *'un succès du gros bâton américain'*. As Kennedy began to make his government appointments the initial indications were that he would keep Allen Dulles as head of the CIA.

Saturday, November 26th
A variety of illegal warrants were out for Lumumba's arrest, but Dayal insisted that the UN couldn't help in apprehending him. From late October there'd been a guard on the Prime Minister's residence with orders to arrest Lumumba the moment he emerged. After a few weeks the line of Congolese soldiers round the building had become ragged and careless. The guard changed at irregular intervals, and on a number of occasions over the last few days the British ambassador, Ian Scott, had returned to his house next door to find it being guarded by mistake. It had become such a nuisance that he

had been driven to consult his Lingala grammar, where, happily, he found the phrase '*ndako na ngai*', my house, used to illustrate possessive pronouns. '*Ndako na ngai*', he would declare, banging the flat of his hand against his chest. He could never follow it up, however, except in French. When challenged he would fall back on '*Je suis l'ambassadeur Britannique*'. He would say his piece and wave his identity card at the soldiers, although he knew that few of them spoke French, and wasn't sure how many of them could read. Only once did he receive a reply in French.

'*Tu mens*', said the soldier, deploying his only French phrase, taught him, by means of endless repetition, by the Belgians. You're lying, you're lying, you're lying.

Inside the ring of ANC soldiers was a UN guard made up of Moroccan troops. Their function was to protect Lumumba so long as he stayed within his house; if he were to venture out, their orders were very clear, they couldn't intervene, whatever the Congolese soldiers did.

Nendaka, head of the Congolese *Sûreté*, had given orders to cut the telephone line to Lumumba's residence, but the Moroccan soldiers had their own line linking them to the UN headquarters in *Le Royal*. Since Thomas Manza still had an apartment there he was able from time to time, with the help of the Moroccan officer in charge, to talk to Lumumba.

When Manza called that Saturday afternoon, the mood was sombre. Lumumba had been depressed since hearing that the UN Assembly was backing Kasavubu, but then, just after he received that news, he heard that his new-born daughter had died of tubercolosis.

'They won't even let me fly to Stanleyville for the funeral', said Lumumba. 'I wanted her to be buried either in Lulua-bourg, or in Stanleyville, and the UN won't let me fly, not anywhere, not even for my own daughter's funeral. Can't you do anything down there, Thomas, surely . . .'

'There's nothing I can do, Patrice', said Manza. 'I'm sorry. I believe Dayal would like to help . . . but the people in New York won't let him . . .'

'Kasavubu can fly wherever he wants!'

'I know, Patrice, I know . . .'

'The US got him out to New York when it suited their purposes, and now they've got the whole of the UN behind him . . .'

'Patrice, the minute you leave the house . . .'

'If the UN gave me a guard I could go anywhere I wanted. If Kasavubu can travel around the world, why can't I even travel within the Congo . . .'

'Because the Congo isn't safe for you . . .'

'Stanleyville is safe. Gizenga's already there. If we go to Stanleyville, Thomas, we can set up a new government from there . . . we've got all of Kivu province, Stanleyville, North Katanga, North Kasai . . . we've got half the country, Thomas, and we've still got parliament behind us. I was *elected*, Thomas, *elected*. When was Mobutu ever elected?'

'Patrice, please!' Manza lowered his voice to a whisper. 'If you talk like that and then go to Stanleyville, no-one will believe it's for your daughter's funeral.'

'Thomas.'

'The moment you step outside your own front door . . . It only takes one bullet, Patrice. They don't care about your daughter. I'm sorry, but it's true. They don't . . .'

'Who is *they*?'

'Mobutu is they. Kasavubu is they. Nendaka is they. Hammarskjöld is they and the government of the United States of America is they. Patrice, *they* are all round your house . . . and ever since Kokolo was killed trying to get rid of Welbeck . . .'

'I had nothing to do with that. You know I had nothing to do with that. I was in my own house when that happened. It was UN soldiers who killed him. How is that my fault?'

'I didn't say it was. Patrice, it doesn't matter what the truth is any more. It only matters for you to stay alive. If you can just stay alive long enough for this mess to get sorted out . . .'

'And what happens to Tshombe in the meantime? What happens to Kasavubu and Mobutu? They get stronger every day. Every day, Thomas. Do you think I don't know what's going on?'

Manza sighed and passed the receiver to his father. 'You

try', he said. But Achille Manza could get no further than Thomas had done, and after he'd spoken to Lumumba for a few minutes, he passed the telephone back to his son.

Lumumba's voice sounded more calm, as if he'd remembered that Nendaka would be listening.

'Patrice', said Manza. 'Things won't stay like this forever; if you have to stay in your house for years, eventually your enemies will have to make their peace with you. They'll have no choice. But if you leave your house now . . .' He paused. There was silence from Lumumba.

'It's farewell for ever', said Manza. 'They'll grab you, and that's it.'

'Perhaps that's how it has to be, Thomas', said Lumumba. 'They'll arrest me, torture me, and then they'll kill me. But one of us must sacrifice himself . . .'

'Patrice!' There was another pause.

'Thomas', said Lumumba, and this time it sounded almost as if he were joking, 'don't take me too seriously. I shan't leave the house. I'm counting on an interview with the UN's Conciliation people. They should be in Leo any day now; they'll listen to me. But, look, in the meantime, I'll see if I can send written instructions to you. Promise me you'll follow them?'

'I promise', said Manza. 'If I can possibly do it, I will.'

'To the letter, Thomas', said Lumumba. 'To the letter.'

Just after midnight a car with UN registration plates drove across the tarmac at Ndjili. It came to a halt not far from the base of the steps that led up to the Sabena DC4, almost ready to depart for the night flight to Cairo.

Abdel Aziz got out of the passenger seat and closed the car door gently. A second Egyptian diplomat climbed out of the rear of the car, carrying a large bundle wrapped up in a woollen blanket. Aziz reached into the back and lifted out another bundle. The driver climbed quickly up the steps to the aircraft and spoke with the stewardess, showing her his diplomatic passport and then pointing to the two men who stood at the foot of the steps.

Aziz and his companion carried the two children up and

into the aircraft while the driver went back for a third. From the rear of the first class cabin the stewardess beckoned to Aziz. The seats were reserved. Aziz and his friend laid the children down, and then his friend left the aircraft. Moments later the UN car was speeding back towards the perimeter.

Once the children were settled the stewardess asked Aziz for his passport. He showed her the entry with his children's names.

'I ought really to check them', she said, glancing at the children. The blankets were wrapped all around them, veiling their faces.

'Please, if you could leave them undisturbed', said Aziz. 'It's very late, and I don't want to wake them unnecessarily.'

The stewardess looked at her watch. The aircraft door was still open, and the pilot had asked her to hurry up the preparations for departure. She glanced again at the children, and at Aziz's passport. He smiled at her.

'All right', she said, and handed the passport back. 'Now, please, if you take your seat, we can . . .'

'Thank you, Miss', said Aziz. He slipped the passport back into his pocket and sat down.

Ten minutes later the children, François, Patrice and Juliana Lumumba, finally closed their eyes, terrified by the roaring of the aircraft's engines as they wound up for the take-off. Ten minutes later in *Le Royal*, the Moroccan officer who had come off duty at Lumumba's residence at midnight knocked on the door of Thomas Manza's apartment. He handed a letter to Manza, who thanked him courteously, and then the man left.

Sunday, November 27th
The heavy tropical storm had lasted for over an hour. In his residence next to Lumumba's house Ian Scott watched as the rain lashed down and the river, dark beneath the heavy clouds, was lit again and again by violent flashes of lightning. The grass around the house, struggling at the best of times to knit the thin soil together, had vanished under pools of rusty coloured water.

'If it goes on like this', said Scott to his wife, 'We'll all be down the river, garden, house, the lot of us, and Lumumba with us too, the whole street chopped to pieces in the falls.'

'At least', said his wife, 'it's driven off the soldiers.'

It was true. Looking across to Lumumba's residence, there was neither hide nor hair of a Congolese soldier to be seen. Only the Moroccans had stuck to their posts and stood, drenched to the skin, in a ring around the house.

'Poor buggers', said Scott, and turned back into the room.

Kasavubu was on the final leg of his journey back from the UN in New York. At the airport the storm was so bad that they almost turned the flight away, but the mood of triumph was far too strong upon King Kasa, and he dismissed with contempt the pilot's suggestion that they seek another place to land.

'I am coming back in glory', said Kasavubu, 'riding on the storm.'

The aircraft finally touched down. The storm was still thundering on but the red carpet was rolled out regardless. Mobutu was beaming from ear to ear as he stood in the downpour with his guard of honour and his College of Commissioners, all in their Sunday best to greet the President. From the airport they drove in a convoy to the presidential palace, and there a banquet was laid out to celebrate Kasavubu's diplomatic victory. In the barracks at Camp Leopold the ANC soldiers, who finally seemed loyal to Mobutu, celebrated long into the night.

Outside the Prime Minister's residence, the big colonial villa close by the river, Pauline Lumumba climbed into the car and drew down the blinds. In the darkness and the deluge the car passed without remark through the cordon of Moroccan soldiers, out into the night.

25

The dark green Vauxhall saloon drove slowly along the street and paused a few doors away from the Davis house. Paused, then drove slowly on. During the afternoon other vehicles came and went, but the street seemed always full and nothing drew attention to itself. The houses marched uphill, their roof-lines stepped, their grimy redbrick fronts all just the same apart from the colours and conditions of the paintwork, the this and that of decoration, a scrubby piece of privet hedge, a patch of concrete with a rhododendron dying slowly in a tub, a child's tricycle, a plastic sack of gravel split and sprouting weeds from the ragged gash. Half an hour after the first pass the Vauxhall appeared again at the top end of the street and found a parking space in at the kerb. The house was seventy, eighty yards away. No-one noticed Bertrand there at all, or if they did they saw a black man sitting idly at the wheel, talking occasionally into a mobile phone; a minicab driver, perhaps, hardly worth a second thought.

Bertrand had misread the number, that was what it was. He'd scribbled the addresses down in a hurry, all those names, street names, passport numbers, an easy mistake; when he went back to his notes to check, he saw it was an eight, and not a three, the left side of the loops just disappearing in the faintness of the pen.

When he'd checked the passport numbers from the Asylum files, checked them against the numbers from the embassy in Brussels, he'd found that none matched false IDs issued by the Travel section in the past two months. When he'd checked them all against the records of the *real* passport office in Kinshasa, he'd found that three of them were false. It was a safe bet that Philippe's would be one of the three. The others would be black market fakes.

So he'd visited all three. Sometimes in the Vauxhall, sometimes in the van, and sat for hours, watching. No-one ever bothered. It seemed that every street in London was choked

with cars, parked in solid lines along each kerb; new, expensive cars and limousines, and battered vehicles, neglected, bruised and rusting, products of the motor industries of a dozen countries. He'd sat like that for two days in Crouch End, night and day, watching number thirty-three, noting down who came and went, when the lights went on or off. Nobody, he smiled at the American expression, 'of colour'. No Philippe, no lonely black man, no Zairean at all. And after two long days of it, Bertrand was ready to move on.

The next two, one in Hammersmith and one in Balham, were much easier. Both houses had been cut up into poky, low-rent flats. Both times, as he sat and watched, he saw people come and go who looked as if they could be from Zaire, and when he forced the doors, the early mornings when the post had been delivered, he found mail addressed to people who matched the names he'd scribbled down; and though black faces came and went, he never saw Philippe. Philippe Lukoji, there was finally no other option, must be Paul Nkanda, living at number thirty-three in the narrow terraced street in Crouch End. And then he checked his notes, checked the hurried scrawl, and saw the number, eighty-three where he'd seen thirty-three before, and so he parked the car once more in that ordinary street and settled down to wait while the afternoon passed into evening. But this was the right place. It had to be. He was so sure of it that he decided to call Kawena.

He held the mobile phone up to catch the shadowy yellow-brown light from the street lamps and, peering at the buttons, he dialled Kawena's number. It was answered almost straight away by Kawena's secretary.

'It's Bertrand', he said, 'Bertrand Kotosa. Can I speak to . . .'

'Mr Kawena isn't here at the moment'.

Bertrand mouthed a silent curse.

'Can you tell him that Bertrand called, and that I'll be at this number whenever he can ring back. If he comes in again tonight, can you tell him?'

The secretary took down Bertrand's number. When the

call was over Bertrand looked carefully along the street. Nothing had changed; there was neither sound nor movement. He looked across at number eighty-three. There was a light on in a downstairs window, but the curtains were drawn, only a thin sliver of brightness showed where the curtains didn't quite meet in the middle, a narrow gap near the top of the window where the fabric didn't quite overlap. Maybe Philippe was sitting there, watching television, eating a meal, or reading, just a faint crease across his forehead, a hint of tension round the eyes and mouth, just as Bertrand had seen him sitting and studying reports a hundred times. And if I can see him so clearly, surely he must be there; only the thin sheet of glass, the fabric of the curtain, only the thin skin of brick to keep us apart.

Park the car a little higher up the hill. Philippe comes out of the doorway, out onto the pavement, his head down, frowning, perhaps, trying to work something out . . . he's not really looking where he's going, he sets off down the hill. Leave the car out of gear, lift off the brake, he doesn't notice the sound . . . there's a gap in the line of parked cars . . . the car mounts the kerb, plunges across and crushes him. Out of the car and away. But in the last second, as Bertrand ran the scenario, Philippe turned to see the car, their eyes met, and it was Bertrand who recoiled in alarm while Philippe leapt clear.

Ever since the trial, Bertrand had found it impossible to look Philippe in the eye. And Philippe had never said a word against Bertrand, had just accepted it, just part of the business they were in. No harm done.

Philippe came into the room. He stood for a moment while his eyes adjusted to the semi-darkness. Bertrand waited for permission to carry on.

'That's enough', said Philippe.

The man was sitting on a metal chair; his hands were cuffed behind his back, his ankles chained to the chair legs. He was naked, but there was very little blood. There was the stench of faeces and urine, sweat from both Bertrand and the man.

There was another smell, too, as if someone in the next room had just put a steak on the grill – meat searing and spitting, turning from bloody to pale. The man was silent. You couldn't even hear him breathing.

Bertrand waved the shock baton in the man's face and he reared back away from it. Now you could hear him breathing, gasping for breath, trying to gulp it down his ruined throat.

'Let him go.'

'Another hour, patron', said Bertrand. The man was staring at Bertrand, eyes wide. Philippe could see the flesh in big, puffy blisters all around the man's mouth, blisters that had burst and were seeping blood and lymph.

The man looked from Bertrand to Philippe.

Bertrand took a step towards the man. He held the tip of the baton in the man's face. The man pulled his head back and Bertrand followed with the baton. It was almost in the man's eyes. Bertrand pressed the switch and the two metal prongs that stuck out from the tip of the baton, silvery pins against the dull black, fizzed and crackled with a flickering light, intense blue, leaping between them like a persistent lightning strike. The man cried out, though the baton wasn't quite touching him. Bertrand laughed and switched the baton off.

'Another hour', he said. The man stared at Philippe.

'I said let him go.'

'We can't. We picked him up with . . .'

'With a foreign newspaper. There's no law against it.'

'But if he's reading . . .'

'Education', said Philippe, his voice heavy with irony. 'To educate the people is to build the new Zaire'.

'He's a subversive. He'll tell us the names of others.'

'He'll tell us anything he thinks will stop all this.'

Philippe walked over to a table set against the wall. He picked up the motorcycle chain and felt its weight, then set it back down again. He picked up the bull-nosed pliers and closed their jaws. There was still a shallow oval where the jaws didn't meet, the sides of the oval lined with sharp teeth where you'd use the pliers to grip a pipe, copper pipe, where

hardened steel would grip the softer copper, cartilage, or bone. Philippe opened the jaws again; there was ground up debris clogging the teeth, fatty debris, streaky on the dull steel. Philippe put the pliers down again on the table. He trailed his finger tips across a pair of bolt-cutters, across the flame-blued nozzle of a blow torch, the row of spare butane cartridges; one by one he touched the clean, cool canisters. His back was still to Bertrand.

'Besides', said Philippe. 'I told you to let him go.'

Philippe left the room, closing the door quietly behind him. Half an hour later, still naked, the man was tumbled out from the back of the truck as it slowed in front of his house.

The phone rang, and in the enclosed space it sounded loud. Bertrand answered it, glancing around as if he were afraid that someone in the street might have heard.

'Bertrand?' It was Kawena.

'Patron.'

'Have you found him?'

'I think so. I'm sitting in the street just along from the house. I'm certain he's inside.'

'Well done, Bertrand. Well done.'

'I thought I should let you know . . .'

Kawena waited.

'I wondered, what should I do now?'

'What do you mean?'

'Well, if we're sure that he has . . . that he's no longer with us. Why else would he try to get his wife and child out of the country . . .?'

'I told you. The main thing is to wait and see what happens. If you're sure he's there . . . he isn't going to run off again. If you keep out of sight. Can you arrange something nearby, rent a room?'

'Isn't it simpler if I . . .'

Kawena waited for Bertrand to finish the sentence. Bertrand's mouth was shut tight.

'We'd lose information', said Kawena. 'This isn't just about Philippe. We need to know . . .'

'So we bring him in.'

'We wait.'

'Suppose he joins up with Lambert? Or Tchisekedi?'

'The more he does, the more we find out. Bertrand, are you sure you trust my judgment?'

Kawena's voice was perfectly calm, as if he simply wanted to reassure Bertrand, as if he were asking after Bertrand's health. Bertrand closed his eyes.

'Of course, patron.' It was the same question that Philippe had asked him the day after he dumped the man back at his house. And Bertrand had said, 'Of course, patron', just as he'd said it now to Kawena. And then Bertrand had called Kawena and told him that Philippe had let the man go. But when they'd ordered Philippe back from Kasai to Kinshasa, when the message had come through to Philippe and Bertrand had been there in the room with him, Philippe had just nodded at Bertrand, and never said a word.

Bertrand glanced at the mobile phone. There was no sound coming from it. It seemed completely inert, sitting in his hand. You wouldn't think it was even switched on. It was like looking at a gun. You couldn't tell, just from looking at it, if it was loaded or not, if the clip in the handle was empty or full. You had to pick it up to test its weight.

'Patron?'

'Yes, Bertrand?'

'I'm sorry.'

'That's all right, Bertrand. I'm not offended. It's good for you to think for yourself. But trust me. It's better if we leave Philippe alone for the moment. And, don't worry. You've done well . . .'

Bertrand was watching, as he listened, the door of number eighty-three. The door opened, and out into the amber-coloured light from the streetlamps stepped Philippe. Bertrand tried to slide down lower into the seat. Philippe was closing the door.

'Bertrand? Bertrand, listen, you've done well. Just remember what I've said.'

'Bertrand?'

He whispered into the phone, 'It's Philippe, patron. He just came out of the house . . .'

'Has he seen you?'

'I don't think so. He's walking away from the house.'

'Let him go. Sit tight and keep an eye on the house.'

'Yes, patron.' Bertrand heard the line broken. He switched off the mobile and breathed out, slowly, then a deep breath, in, hold, and out. The sweat, he suddenly realised, was dripping from his chin.

There had been, of course, no formal charge, and when they'd called Bertrand into the room to testify, he'd seen only a spotlit circle on the floor, and a hand reaching out into the cone of light. A voice came out of the darkness and told him to step forward. He stepped under the light and he kissed the hand, but he couldn't tell whose hand it was. He never knew who was in the room with him, he didn't recognise the voices, apart from Kawena's. And even Kawena's was distorted, put through some kind of electronic apparatus to disguise it, but the apparatus couldn't hide the rhythm of his speech, the pattern of intonation. There were at least another four voices, all altered by the apparatus, but there could have been a dozen people in the room. Bertrand could only hear the voices, and then sometimes the smoke would drift out from the darkness and catch the light that fell around him, and there was a sweet smell in the room, and something else, a sour metallic smell.

There were stories, a jumble of rumour and guesswork that filtered down the organisation, stories of the President's Senegalese adviser, of the trust Mobutu placed in magic. Bertrand had sworn only the basic service oath, blood-loyalty to the Revolution, to the Party, to the Guide himself, 'to the point of self-giving'. There were stories about far more fearful oaths. Bertrand shuddered to recall the hand he'd kissed; whoever's hand it was, they were hidden in the darkness, holding out a hand all bathed in blood, and though he tried, for days he couldn't wash the taste of blood out from his mouth.

When the trial was over, Kawena had taken Bertrand aside and tried to reassure him, had told him not to worry, that

everyone appreciated that he'd done the right thing, and if he were ever in the same situation again, worried about anything, he should just do as he'd done this time, just pick up the phone, Bertrand, and tell me about it. And listen, don't worry; you've done well.

26

Calais. There was no-one to wave to. They stood at the railings up near the front of the boat and looked the long distance down to the dirty water. In the shadow of the concrete piling the water was the colour of a dark storm cloud but its surface was flat. The water seemed thickened, leathery, oily. There was hardly a ripple as the ferry began to move away from the quay. Marie looked back at the dock-side and in the hard sunlight the fluorescent yellow of a workman's safety jacket was banded with bright silver as if somehow more light than fell on it shone back from the reflective strip. The rusting hull of a boat they were passing was a warm, earthy orange, and wavelight shook and shivered across the under-edge of its prow. Then they were sliding through the water and where the sun fell on it, it was a pale grey-green.

The air was cold, and as they pushed out into the channel Marie felt it begin to sting her cheeks. The boat began to roll and she tugged at Catherine's arm.

'I'm going inside for a while', she said.

'OK', said Catherine. 'I'll look after Eric . . . Eric?'

The boy looked up at Catherine and grinned.

The boat was crowded, and its inside seemed to be only a succession of bars and restaurants, all packed, linked by corridors where people stood and smoked and drank, or there were seating areas where people sat and smoked and drank, always in groups, always surrounded by harbour walls of luggage, suitcases, backpacks, huge plain forces duffel bags, canvas, and sports bags in nylon or vinyl. One-armed bandits and game machines lined the corridors with flashing lights and raucous action music. A child went by with a lion's face painted on, and a zebra-girl chased after him. The atmosphere, thick with tobacco smoke, was hot, close, uncomfortable. Marie felt the floor heave up towards her and then drop from under her as the boat moved out into bigger water. She found her way

back to the open walkway, back to where Catherine and Eric were standing by the railings.

'Are you all right?', asked Catherine. Marie could hardly hear her for the wind and the rushing, swooshing sound of the water.

'It's better out here', she said, almost shouting.

The wind was tearing at them now. Eric was enjoying it, leaning into the wind so that it held his weight, then leaning back until it almost blew him over and he had to grab at the railings to support himself.

'He seems happy', shouted Catherine. Marie barely acknowledged the remark.

'I'll go and get us some coffee', said Catherine, mouthing the words slowly and distinctly. Marie took Eric's hand.

The water had darkened and lost its quayside opacity. You could see down into the deep blue-green and the surface was breaking into huge chunks of a fierce, clean white that the sun caught like snow, yet as you looked out to the horizon the water dulled in the distance to neutral, hazy grey-blue. She smelled the salt and felt droplets of water blown into her face. She felt Eric's hand warm in hers and she began to smile.

Catherine appeared at her side a while later with two plastic cups of coffee. Her face looked pale and queasy. Marie took a cup from her and, letting go of Eric's hand, steadied Catherine against the rail. She leaned over it and stared down at the sea where the hull was chopping through it.

'Look up', shouted Marie. Catherine turned to her with a puzzled expression.

'Look out at the horizon', shouted Marie, and, slipping her hand beneath Catherine's chin, raised her face to look out into the distance. Then, suddenly excited, she cried out 'Look! Look!' and Catherine turned to look in the direction they were going. Up ahead, a pale whitish-grey line, were the white cliffs of Dover.

'*C'est Angleterre?*' asked Eric.

'*Angleterre!*' shouted Catherine. Marie bent down and lifted Eric into her arms and hugged him tight. She stood and held him while the coastline crept towards them, the cliffs

rearing higher and higher till the line of the grassland over the lime-white rock was as sharp and fresh as the green fields of Kivu. Then at last the huge, thick mile-long arms of the breakwater reached out and the ferry slipped in between them, between the twin lighthouses, under the shadow of the castle, into the dock, and was shackled to the land.

They were in shirt sleeves, the customs officers. The terminal was brightly lit with fluorescent tubes. The harsh light bounced off shiny, white-painted walls and up from the pale linoleum floor.

Marie watched as Catherine showed her passport and was waved through. Then the queue that Marie was in shuffled her forward and presented her at the desk. It was less than a desk. It was just a plain table, with black metal legs and a top of white melamine. Behind it stood a man with navy blue trousers and a white shirt; a man in his mid-thirties, with a little, bristly moustache, and shirtsleeves that weren't quite long enough, revealing his hairy wrists. Marie held out the identity card and the officer took it. He glanced at the photograph and glanced at Marie.

'Thank you, Miss Bosson', he said. 'Monique Bosson?' She nodded.

'*Française?*'

She nodded again.

'*Parlez vous* English?' She shook her head.

He wrinkled his upper lip and the moustache scrubbed the base of his nose. He turned away from her and spoke to a colleague who was standing nearby. Then he turned back to Marie and, saying nothing, stood and looked at her. The queue behind Marie was growing audibly restless. The man remained impassive.

Eventually an interpreter arrived, a young woman dressed in the same navy blue and white. She carried a clipboard and was looking at a sheet of paper on it. She barely glanced at Marie.

'*Bonjour*', she said, as if it were the first thing on the form. Marie smiled, but the woman wasn't looking at her.

'*Française?*'

'Not originally', she said. 'Congo-Brazzaville.'

'I see', said the woman. 'How long have you lived in France itself?'

'For two years', said Marie.

The interpreter whispered to the customs officer. He whispered back to her.

'And this is your son . . .', asked the woman, and paused.

The man checked the ID card, '. . . Eric?'

Eric looked up at the mention of his name and smiled at the man. The man gave a brief smile back.

'And your visit to England?' said the woman. 'Can you tell me what is the purpose of your visit?'

'To visit my sister', said Marie. 'It is her wedding anniversary, and she is having a party. She lives in Birmingham.'

The man pointed to her suitcase. 'Can you let me see that, please?' She lifted it onto the table. She heard another groan of disappointment from the people behind her in the queue. She glanced back and saw the line of grim-faced, luggage-laden travellers stretching away from her.

'Could you open it, please?' She leaned across and undid the clasps.

'Thank you', said the officer, and opened the case. Eric huddled close against his mother and she reached down to take his hand, squeezing it for comfort.

The man riffled through the clothes. Then he came to the brown envelope with the photographs. He opened the envelope and carefully took out a photograph. It was Marie's mother, with Eric in her arms, taken just outside her mother's house in Kinshasa. Marie tried to look at the photograph as the Customs officer studied it. Just a house. Just a house in a town somewhere. The man's moustache was moving from side to side, the base of his nose flexing, his lips pursed.

'It was taken in Marseille', said Marie. The man stopped studying the photograph and looked carefully at Marie.

He slipped the photograph back into the envelope and took out another one. It was a family picture, Philippe's family, beside Lake Kivu. The lake in the background was a rich, deep blue.

'And this?' he said.

'It was taken on holiday', she said.

'Whereabouts?' asked the woman.

'It was a holiday in Italy', said Marie. The man slipped the photograph back into the envelope.

Catherine stood just beyond the doorway that led through into the rest of the terminal. She pretended to be fiddling with the strap of her bag, but kept looking back towards Marie. She couldn't go back, and she couldn't stay in the doorway for long. She turned and walked away, looking for somewhere to sit, somewhere she could sit and watch the doorway.

The customs officer dropped the envelope of photographs back into the case. He closed the case and clicked the clasps shut. He stood the case up on the table and smiled at Marie. Then he turned and held another whispered conversation with the interpreter.

'I wonder', said the interpreter, 'if you'd mind coming with us for a moment.' The officer lifted the case and stepped back from the desk. He signalled to a colleague, who came to take his place, and he gestured for Marie to follow him. It was only a few steps away. She stepped round past the desk, leading Eric by the hand, and the man strode ahead of them to a closed door. Beside the door stood a policeman, also in shirtsleeves. The policeman was black, as black as Marie. He stared straight ahead of him. The customs officer knocked on the door and it opened straight away. He stood back again and gestured for Marie to enter. Marie looked at his face, he was still smiling. She led Eric through the door, and the interpreter followed.

It was a small office. A desk, with a telephone and a scatter of papers. A biro lay on a pad of notepaper, the top sheet was covered in doodles. There was another of the plain white tables, a few plastic chairs. The man put her case on the table and invited her to sit down. She sat, and the man pushed another chair across for Eric to sit beside her. The interpreter picked up the telephone and spoke briefly. A minute later another woman entered the office. She took a chair and sat behind the man, staring at Marie.

The man opened the suitcase and began to lift its contents

196

out, one by one, and lay them on the table. Eventually the case was empty. He checked it carefully. There was a pocket in the lining of the lid. He peered inside. When he was satisfied the case had nothing more to show him he closed it and set it on the floor.

Item by item he picked up the clothing and examined it. He held the fabric up to the light. He ran his fingers along the seams. He fingered her underwear, her blouses, her skirts; he rubbed the fabric between his fingers.

'Whereabouts in France do you live?' he asked.

'In Marseilles', she said. More whispering.

'It's warm', said the interpreter, 'in Marseilles, I mean. Your clothes; they're all very lightweight.'

They weren't inviting comment. Eric was fidgeting in his chair. Marie reached out her hand and patted his arm gently, hushing him. He sat still and stared at the customs officer. The man slid the clothes to one side of the table and turned his attention to the photographs. He laid them out as if he were dealing cards for a game of patience, then he stood and gazed at them. He chewed his lower lip for a moment. He sucked both his lips in between his teeth and the moustache met the skin below his lower lip. He shuffled the photographs together and dropped them back into the envelope.

'Could I see your handbag, please?'

She passed it across and the man opened it. He lifted out each item, piece by piece. Once again, with the bag empty, he checked its inner compartments before setting it aside. He poked about among the things he'd taken from her handbag, a comb, a pencil, a set of keys, her purse. There were paper clips, there was lip-salve, the French brand that she always bought. Perfume, tissues, a mirror, a couple of safety pins. Eric was fidgeting again. Marie reached towards him and he slipped out of the chair and stood beside her. She lifted him up and sat him on her knee. She glanced at the table and the man was putting everything back into her bag. She smiled at Eric.

'You're too big a boy, you know', she whispered to him, 'to be sitting on your mother's knee.' He grinned at her and

dabbed his finger onto the end of her nose. She nipped his nose between her finger and thumb and he laughed.

'Marie Yembe?'

She glanced up at the man. He was smiling at her. On the table in front of him, isolated in the middle of it, was Eric's birth certificate.

'It is my sister's certificate', she said. 'I am bringing it for her.'

'Yembe?'

'It is our family name. Before we were married. She had the child before she was married, when she lived in Kinshasa. It's just across the river. That's why it says Yembe on the certificate. She is my older sister.' The interpreter translated it, leaning to whisper into the officer's ear while he, expressionless, gazed at Marie. Then he turned and whispered to the woman.

'Monique Bosson?' asked the woman. 'Is she married?'

'Yes, I am Monique Bosson. You have seen my identity card.' Marie was staring at the interpreter. Once again, it was clear that he'd followed what she said.

Eric had picked up the change in his mother's mood. He was staring at her.

'I'm afraid', said the man, 'I'm going to have to detain you while I consult with other officers. I have reason to believe that you are not in fact Monique Bosson, but that your true identity is Marie Yembe, and that you are not a French citizen, but a citizen of Zaire. Have you any comment?' He said it all in English, with a formal, deadpan manner, then he sat back in his chair, while Marie, not comprehending, stared at him. The woman translated it.

'It is my sister! I told you! It is my sister!'

'And yet you answered to her name?' said the woman.

'It was my name, before I married! Yembe! It was my name.'

'And yet', said the man, and he held up the French identity card, 'it says here that you are Monique Bosson, and that you are not married.'

'But I am married', she said. 'I am married.'

'And you have a child named Eric, and your sister has a child named Eric? Both of you? And these children are the

198

same age?' The interpreter struggled to keep up with him, translating phrase by phrase. Marie lifted her hands to her face and began to cry.

'It's really so much better if you can be frank with us', he said, and his French was perfect. 'If only people could be honest in these matters. It would save so much distress.'

27

Bertrand had found digs in Crouch End, not far from Chris Davis' house, in another street of terraced brick. Watching Philippe were two juniors from the embassy in London. They were in an embassy van, a plain Ford Transit with its windows shaded. The two juniors, Jonas and Edouard, were in touch by radio with Bertrand and with a team of watchers, ready to follow Philippe if he should leave the house. But nothing happened. He was followed down to the shops near the clock tower. He was seen to buy a newspaper each day, sometimes an English paper, sometimes a French paper. One evening he came back to the house with a Chinese carry-out and a video from the rental shop. They were trying to get an intercept on the telephone but they hadn't managed it yet.

That morning they'd called Bertrand to tell him that Philippe had bought a newspaper. It was yesterday's *Le Soir*, said the watcher.

Bertrand told the man to buy a copy and bring it round to the digs. The man arrived twenty minutes later and handed the newspaper over with an ill grace. Bertrand watched the man turn away into the street, the collar of his leather jacket hunched up round his ears.

He took the paper up to his room and began, aimlessly, to leaf through it. There was nothing there. He went down to the kitchen and made himself a cup of coffee.

Back in his room he called the van.

'Anything?' he asked.

'*Elokko tey*', said Jonas. Nothing.

'Is there anything in the newspaper, patron?' asked Jonas.

'*Elokko tey*', said Bertrand.

That afternoon, bored, Bertrand picked up the newspaper again. He turned to the international pages and scanned the stories once more. Then, in a single column at the edge of the page, he saw the name Mobutu. He began to read the story.

There were few details. The incident had happened at

Kisangani, Stanleyville, to give it its colonial name. It was Tchisekedi again, another rally, but this time it had gone ahead. Kisangani was part of Tchisekedi's home territory, just as it was Lumumba's years before. So the rally had gone ahead and several hundred people had turned out. Bertrand tried to put himself in Antoine's shoes; the rally would have been too big to stop. He would have put people into the crowd, though. Then, afterwards, pick up half a dozen of the leaders, not too many, no-one too close to Tchisekedi.

They must have jumped them too soon, when the journalists were still around, some Belgian freelance probably, had stayed up-country for a few days afterwards, waiting for a steamer to go down-river. Shit; who'd be in Antoine's shoes, now the story was out.

Although, in truth, there were few details. The story said that there were eight people killed. It said they'd been beaten, and their bodies dumped in different locations around the town. And they were all known to be Tchisekedi supporters, members of the outlawed UDPS.

But sources close to President Mobutu, it said, had identified rogue elements in the Security service who were responsible for the killings. They had already been severely punished. And that was a change from the policy of comprehensive denial. The journalist had realised it too. Senior political figures, he wrote, had speculated that the president, under heavy pressure from the US to tackle human rights abuses, might finally give way and declare that opposition parties could be formed, might break the MPR's monopoly of political appointments with a view, perhaps, eventually, to allowing multi-party elections.

He wouldn't do it. But the speculation couldn't have appeared unless someone at the top had authorised it, and, if not the president himself, someone who enjoyed his confidence. Someone had calculated that, in the circumstances, a few Security officers could be sacrificed for the sake of appearances. Which meant that someone, perhaps a few people, would have been, in fact, severely punished.

Bertrand left the house and walked down to the shops. He

found a newsagent and bought copies of the *Independent*, the *Guardian* and the *Daily Telegraph*. Walking back towards his digs he found it hard to keep from breaking into a run. It was as if everyone he passed in the street, seeing the thick wad of newsprint under his arm, had guessed the secrets that he wanted to conceal.

Back in the house, Bertrand opened the papers, snatching impatiently at the pages in his eagerness to turn them. There was a piece in the *Independent* about the killings, just two sentences in the foreign briefs. Nothing in the *Telegraph*. In the *Guardian* the killings were 'alleged', but there was a reaction piece from Tchisekedi calling for multi-party elections and an end to the persecution of opposition groups. Then the article went on about changes in Africa since the Berlin wall came down; about the growing list of countries where long-established leaders were beginning to feel the bough shaking beneath them. Kaunda, it noted, in Zambia, had announced that there would be a presidential election. Siad Barré had fled Somalia, Habré had fled Chad, and in Liberia, Samuel Doe had actually been killed. In Kenya, Daniel arap Moi was thought to be about to make new concessions to his opponents.

Bertrand gathered up the newspapers, rolled them up and stuffed them into the wastepaper basket, but the basket, a small, conical thing woven of straw, toppled over and the newspapers spilled out. Bertrand jammed the papers back in and propped the basket against the wall beneath the wash-hand basin.

He picked up the radio. 'Anything', he demanded.

'*Elokko tey*', said Jonas.

'Cut the damn Lingala!' said Bertrand.

'Sorry, patron', said Jonas.

'Just keep your eyes on the house', ordered Bertrand.

'Yes, patron', said Jonas. Bertrand switched off the radio.

He'd grabbed the youth to stop him bolting past and out of the doorway. He held the youth by his shoulders and, as he held him, David struck him on the back of the head with

the baseball bat. The blood splashed out of him and into Bertrand's face. He couldn't believe how immediately the blood splashed out, from the boy's ears, from his mouth and nose. The boy stiffened, and began to jerk his arms and legs like a clumsy wooden puppet. His eyes had rolled back in the sockets. David hit him again, and more blood came gulping out of the boy's mouth. Bertrand still had hold of his shoulders but the boy was staying on his feet, the kicking of his legs keeping him upright. Then, in the random juddering, there was one moment when both legs kicked together and the boy simply jumped straight up, breaking loose from Bertrand's grip. The boy fell in an awkward heap, still kicking jerkily, a pool of blood spreading out from his mouth and over the kitchen floor.

Later, when Bertrand had fetched the kerosene, had brought it through the building and out to the waste ground at the back, he'd found the men standing beside the half-dug pit. They were looking into it with frightened expressions; when Bertrand looked into the pit he saw why, saw the bones and the ragged remains of clothes, saw the last fragments of soft matter falling away from the skull and, looking down at the excavated earth, he saw the bones of the hand, still together, neatly lifted out with a shovelful of the earth. He saw the hand, palm upwards as if it had laid in the ground all those years still pleading, Look, I have no weapon, I mean no harm, please, please don't.

Nobody would move the bones. Bertrand shouted at them but they simply stood and stared until he had no choice but to take a shovel and get down into the trench himself. He dug out the skeletal remains, laid them in a heap beside the trench, and then the men returned to digging.

When the pit was dug they threw the students' bodies in. Bertrand helped with the work. The bodies were still limp; they felt as if the bones themselves had gone soft; the muscles and tendons had all turned lax and rubbery. Arms and heads flopped loosely. The blood no longer ran, and where it had spilled it was drying into a sticky mess like dark red toffee. Bertrand shovelled the bones they'd found, the dislocated,

disarticulated bones of Pierre Chiluba, still tangled in the crumbling earth, back onto the newly dead.

They doused the corpses liberally with kerosene. They splashed on gallons of it, till the smell of it hung heavy in the air and drove off the smell of sweat and blood. Kerosene fumes shimmered. Bertrand dripped the last of the stuff onto a knotted rag then, standing well back, he put a match to the rag and threw it into the trench. There was that first great burst of billowing flame, then the bodies burned. Pierre Chiluba's bones cracked in the fire with the students' corpses. Bertrand and his men just stood and watched, and waited. An hour later, when the flames had died back and the pit contained nothing but a mass of ash and half-burned bones, they shovelled back the earth. But when they were done, when a long mound of earth marked the pit's position, they saw thin wisps of pale grey smoke boiling up from the broken ground.

Back at the base, Bertrand had sent out for crates of beer and they'd tried to drink the afternoon's work out of their memory, but it didn't work. After an hour or so the men began to drift off to their homes. Eventually Bertrand found himself alone.

It was early evening. In the poky room in Crouch End, Bertrand lay on the bed and stared at the ceiling, at paper painted grey and blotched with damp.

Mobutu wouldn't last for ever, but neither would Kawena. If Kawena went, suppose he went tomorrow, Bertrand would still have too many people above him in the organisation. And there were too many young people below him, ambitious, who'd sell him out without a second thought. But if Philippe did go over, and if Mobutu held off the challengers, as he'd been doing very skilfully for nearly thirty years, then there'd be a future for anyone who stuck with Mobutu and against Tchisekedi. If they could use Philippe to find out more about Tchisekedi's supporters inside the Security organisation, then there'd be a purge and perhaps a senior job for Bertrand after all. But suppose the story at Kisangani were repeated? Suppose

someone tried to deal with the killings at Mbuji-Mayi the same way?

Kasai was the problem. The reason that Mobutu was losing his grip on Kasai was Tchisekedi, a charismatic Luba with a national following. Tchisekedi wasn't MNC, even if he did want to keep the country in one piece, so he'd got no historical baggage, not like Lumumba had carried. Even Lumumba, safely dead, was a hero in Kasai these days. But if Mobutu went and Kasai broke away? Most of the students we killed in Mbuji-Mayi were Luba.

And Philippe is Luba.

28

Thomas Manza cleared his throat and looked up from his text to the crowd of journalists filling his room in *Le Royal*.

'If you will allow me, gentlemen, I'll read a prepared statement on behalf of the Prime Minister, Patrice Lumumba.'

The scuffling and jockeying for position quietened, and Manza began to read.

'First: There are rumours to the effect that the Prime Minister has left his official residence in Leopoldville. These rumours are completely without foundation.'

'Second: Monsieur Lumumba has indicated his intention to remain at his residence and await the arrival in Leopoldville of the Commission of Conciliation recently appointed by the General Assembly of the United Nations in New York. When the members of the Commission arrive, he expects to receive them and to press his case for the restoration of the legitimate, properly elected government, in accordance with the express wish of the parliament of the Republic of the Congo, before that body was illegally dissolved.'

'Third: Monsieur Lumumba requests that the United Nations immediately withdraw its support for the illegal government formed by Monsieur Ileo at the request of Monsieur Kasavubu, and with the support of Colonel Mobutu. Similarly, the so-called College of Commissioners has neither democratic legitimacy, nor the constitutional authority, nor the practical capacity to administer the affairs of the Republic of the Congo, and should be dissolved.'

The patient silence which had greeted the opening pronouncement was giving way to muttering and disappointment. They'd heard Lumumba's position often enough to need no new rehearsal of it. As the press men left Manza to his statement, new rumours were already in the air. The body of Lumumba's daughter, it was said, had actually been flown to Luluabourg in Kasai, not to Stanleyville. Lumumba was going

to attend the funeral and then travel on to Stanleyville from there. Lumumba himself had been seen in Kikwit, in Leopoldville province, and was heading either for Port Franqui or for Tshikapa. One of Mobutu's deputies was in the lobby; he claimed that during the night Lumumba had slipped out of the rear of his residence, down to the river bank. He'd been taken upriver by boat, clear of Leo (one of the correspondents had heard the boat's engine himself) and then he'd joined a convoy of his followers for the drive out through Equateur province. He was planning to enter Orientale province at its northernmost point, then move down to Stanleyville. There was another rumour that he'd already crossed into Orientale province at Boende.

Dayal spent the morning issuing denials. No: UN troops had not helped Lumumba to escape from the city, nor had they provided transport to enable him to reach Stanleyville. The UN could not confirm that Lumumba had actually left his residence, and troops stationed at the residence would resist by force any attempt by the *Armée Nationale Congolaise* to enter the residence. No: the UN would not under any circumstances provide either troops or transport to assist in any search for Lumumba, wherever he might be; neither would the UN provide any protection for Lumumba except in the immediate vicinity of his residence.

At about three in the afternoon there was a phone call from an irate Ian Scott.

'Do you realise that there are bloody tanks in my garden?'

'I'm sorry to hear that, Ian', said Dayal.

'Your men are *reinforcing* themselves', said Scott.

'If there is to be an attempt to storm the residence', said Dayal, 'then that would be entirely in order.'

'*Two* bloody great *tanks!*'

'Mr Scott . . .'

'Two bloody great tanks and the garden is running with Congolese. Do you realise we can't go outside our own door? I'm not prepared to be caught in the bloody crossfire, man!'

'What do you want me to do?'

'Tell them once and for all that Lumumba isn't in there. Or

else get your bloody people out of the way and let the Congolese go in to look for themselves!'

'And if Monsieur Lumumba should actually be in his residence? What do you imagine would happen if I let the ANC go in to look for him, if they actually found him?'

'Serve the damn fool right if they arrest him.'

'And if they arrest him, Mr Scott? And, just suppose, suppose they kill him? Do you think that would make for peace? For public order?'

'I warn you, Dayal', said Scott. 'Either you let them in to look, or else I'm going to telegraph my superiors in London. If there's a bloodbath, I'm going to make sure they know that you're responsible.'

By four, however, no-one still believed that Lumumba was in his house. Dayal ordered the UN's Moroccan troops in to look, and they found the building empty. The Moroccans withdrew, and the ANC flooded in like water through a breached dam wall. They vented their frustration on the furniture, but once the house had been smashed up and anything remaining of value had been stripped out of it, they drifted away. By six o' clock that evening Ian Scott was free once again to enjoy the pleasures of his garden.

Wednesday, November 30th

'For God's sake, Patrice, let's go!' Mulele took Lumumba by the arm and tried to steer him back towards the car. Lumumba turned and glared at him.

'Pierre, these are my people', he said.

'But this isn't an election. It's a manhunt. Do you think Mobutu will sit in Leo and . . . he'll throw everything he's got into tracking us . . . *you* down.'

'These are *my* people. They won't betray me!'

'Patrice, if this is anybody's part of the country it's mine, and I'm telling you, I'm terrified. If we go on like this . . .' Mulele waved his arm to point to the crowd gathering round them.

'Nine cars! There isn't a soul for miles around who won't know where you are.'

Lumumba shook his head.

'You say it's not an election, Pierre. But that's exactly what it *is*. It's not about diplomats in New York; it's who the people choose . . . these people have only heard Kasavubu's story, Mobutu's story. Shouldn't they hear what *I've* got to say?'

'Yes. From Stanleyville. From the radio at Stanleyville, where Mobutu can't get at you. Where you can set up a government. You've got the ministers, all of Orientale province, Kivu, North Katanga . . .'

'I know that', snapped Lumumba. 'Do you think I don't know I've got the people of the Congo behind me.'

'And if Mobutu's men come with guns and say, "Where is Patrice Lumumba?" what do you think the people of the Congo will say then?'

'My people won't betray me, Pierre. This isn't just your country. I was born in Sankuru, my people are from here . . .'

'Your people are waiting for you in *Stanleyville*, and it's a long way away. We've been on the road three days, Patrice, three days, and we're not even halfway there! Bulungu! Mangai! Are we going to stop in every village on the way?'

'They *wanted* me to speak', said Lumumba. 'In all those places; they wanted to hear me. All those weeks in Leo, in New York. These people haven't had a chance . . .'

'Patron!' Someone had shouted. Mulele turned to see Rémy Mwamba running towards them.

'Look!' said Mwamba, and pointed away to the west. The crowd had fallen silent and everyone was looking in the same direction. The aircraft was low down, almost on the horizon. It's engine was scarcely audible. They saw it turn, a flash of sunlight from a polished surface.

'We've got to go', said Mulele. Lumumba gave a sigh.

'Please, patron', said Mwamba, and began to lead Lumumba towards his car.

Five minutes later they were on the road, heading for Mweka. The roads were drying out. The convoy raised a cloud of dust into the air, a cloud of dust the colour of the soft red ground, dust that hung for ages in the air and could be seen for miles around.

★

When they reached the Sankuru there was only a simple wooden raft to ferry the cars across, pulled along a rope slung between the banks. They managed to get two cars at a time onto the raft, but even with men from the convoy helping the two ferrymen it was hard work hauling the whole lot across the river; and there was the ever-present danger that, if they lost hold of the rope, the raft would drift away downstream.

They forced Lumumba to go over on the first trip and almost lost him when, as the car tried to ease its way up from the raft and onto the jetty, the front wheels slipped to the side of the ramshackle ramp and the back end of the car, still on the ferry, shifted across with the river current. The car had to be lifted bodily back onto the ramp.

Pauline stayed back, with their youngest child, Roland, and waited for the second crossing. Lumumba could only stand at the riverside and watch as, with the ferry still in mid-river, the ANC closed in.

Mulele and Mwamba tried to pull him back from the bank.

'It's you they're after', said Mulele. 'Pauline's all right. They'll let her go. If we go now we can still get you to Stanleyville. They can't get their trucks onto the ferry. If we go now they can only follow on foot.'

Lumumba stood and stared back at the Congolese soldiers who had surrounded the remains of his convoy. The soldiers were pointing their rifles, with bayonets fixed, at Pauline and Roland.

'Leave them alone', he shouted. Mwamba was dragging him back towards his car.

'If it dawns on them to shoot, Patrice . . . it's not far away, please . . .' But Lumumba shook himself free and went to the edge of the jetty.

'Come here!' he shouted to the ferrymen.

The ferry had stopped. An African officer strode down to the bank and shouted to the ferrymen; if they didn't bring the raft across to him, he said, he'd open fire. The ferry began to move again, slowly closing the distance to the shore where the officer stood.

'Please, Patrice', said Mulele, 'Come on.'

Lumumba kept staring back across the river. He shook his head.

'If I can just talk to the soldiers', he said. 'Trust me. They won't harm me.'

On the far side the officer had climbed onto the raft. He held up his revolver and then threw it onto the bank. The two ferrymen bent to the rope and began to pull their passenger across. Lumumba stared at the officer as he drew closer. A few yards from the riverside the officer told the ferrymen to stop.

'I have a warrant for your arrest', he said to Lumumba.

Lumumba stared back.

'Also for the arrest of Maurice Mpolo and Joseph Okito.'

'They're not here.'

'If I can take the three of you back to Leopoldville', said the man. 'I promise that the rest of your people can proceed unharmed.'

'Don't you know I am the Prime Minister of the Congo?', demanded Lumumba.

'If you don't come with me', said the officer, 'your wife and child are dead.'

'Don't go, please, Patrice', said Mulele.

Lumumba kept staring at the officer. 'Do I have your word?' he asked.

'I don't want your wife', said the man. 'Are you coming or not?'

Lumumba took a pace forward. He was standing right at the edge of the jetty. He looked down at the water for a moment, then the ferrymen brought the raft close in, and Lumumba stepped aboard.

29

Philippe was sitting in the kitchen with Chris Davis. The clock seemed to have stopped.

'It only takes an hour and a quarter', said Philippe.

'There's always delays', said Chris. 'You don't know if it left on time. And then it gets to Dover and there are more delays, it's not as if . . .'

'I know', said Philippe.

'Catherine'll call, won't she? If there's a problem?'

'I don't know', said Philippe. 'It might take a time before she realised. She can't go and ask . . .'

'But if she's got through and Marie doesn't appear . . .?'

'I know. I know, I'm sorry . . .'

Chris opened the dishwasher and began to wander around the kitchen, picking up dishes and cutlery and loading them into the machine. Philippe stood and began to help him tidy up.

'You know', said Chris, 'as soon as Isobel gets home – she sees the place all clean, she's going to know there's something wrong.' He laughed, and Philippe smiled. He took a milk bottle over to the fridge and set it on its shelf inside the door. The champagne bottle was still there. He reached out to it and turned it so that the label was visible.

'Will it do?' asked Chris.

'It'll be just right', said Philippe.

'OK', said Chris. 'You get the chairs up on the table.' He was filling a bucket with hot water. Philippe laughed.

'Come on', said Chris. 'I'm going to Flash the floor. Ten minutes. No bother.' Philippe looked at the clock. It hadn't moved.

They stripped them both, Marie and the child, then they put them in separate rooms and searched them. Marie stood naked and shivering while the woman, the interpreter, went through her clothes, and then she heard Eric, screaming in the

212

next room, wordless, screeching. Marie rushed to the door but the woman pulled her roughly back and told her to stay where she was.

'You know we can hold you for days if we want', said the woman. 'Keep you in a bare concrete cell with just a bucket to shit in, and every time you shit we'll check it. It'll all come out eventually. Same with the boy. If you've hidden it on him, we're going to find it. If you've hidden it *in* him. If it's there, we're going to find it.'

Marie backed away from the woman and squatted on the floor of the interview room.

Later, when they'd allowed Eric and Marie to dress again, and reunited them, the questioning began once more. Her name, where was she from, what was the purpose of her visit? How did she have those documents? She stuck to her first story, she was here to visit her sister, her sister stayed in Birmingham. So how come she said the birth certificate was for her sister's child, when it said, place of birth, Kinshasa, when she said her sister had been in Britain for five years, when she said the family came from Congo-Brazzaville? Marie's voice became flat and dead, and the litany of answers settled down into a drip of 'No's, and 'I want to see my sister', and more 'No's'.

They asked her was there anyone in Congo-Brazzaville, or in Marseilles that they could telephone? Was there anyone in Britain they could inform? They asked her for her sister's address in Birmingham, but she couldn't give it.

'She said she would meet me in London', said Marie.

'And you don't have any letters from her? You don't even have her phone number?'

The customs officer tapped the interpreter on the shoulder, and they went over to the back of the room together, where they whispered to each other.

'She's scared of something', said the interpreter.

'They always bloody are', said the officer. 'She's scared of being caught.'

'No. I mean, she's running away from something. I don't know.'

'Well she's certainly hiding something, isn't she.'

The interpreter agreed.

'And . . . she hasn't actually said anything about . . . danger, persecution . . .?'

The interpreter shook her head.

'She hasn't used the word "refugee"? What's "refugee" in French?'

'Sounds more or less the same. You'd have noticed it.'

'She hasn't said "asylum"?'

'No.'

'So what do you think?'

The interpreter sighed. 'I think she's Marie Yembe.'

The customs officer nodded. He turned back towards Marie, took a step towards her. She cried out and huddled into the chair. Eric was clinging to her, but staring at the customs officer, terrified, The man stopped, and stepped back to the interpreter.

'OK', he said. 'You stay with her. I'm going upstairs and recommend she gets sent back to France. They can sort it out from there.'

Bertrand was lying on the bed in his digs. He heard the radio, and when he picked it up, there was Jonas.

'Patron?'

'What is it?'

'Someone just arrived. A white woman. We haven't seen her before. She talked to the Davis man, and then they called Lukoji.'

'And you haven't got the microphones in yet?'

'No.'

'Shit.'

'He's standing in the doorway talking to her. He looks worried.'

'Well, that's something. OK. Just watch. If he goes off with her, just make sure you don't lose him. If they go inside, call me back and I'll come round. Understand?'

'Patron.' The radio cut out, then a moment later Jonas was back on air to say that Philippe had invited the woman inside.

Bertrand stood up and stripped off his shirt. He went over to the sink and washed, then dried himself and put on a fresh shirt. He stood in front of the mirror, checking his appearance.

Philippe led Catherine through into the spotless kitchen. Chris Davis was filling the kettle.

'Would you like something to drink?' he asked. 'Tea, coffee . . . a glass of something . . .'

'Coffee', said Catherine.

Chris put the kettle on to boil and reached for the jar of instant. Then he thought better of it, put the jar back on the shelf, and began to root around in the cupboard for a percolator. Catherine put her overnight bag and her handbag on the kitchen table, and sat down. Philippe sat across the table from her.

'I waited for over an hour', said Catherine. 'Then I had to run to catch the train. I thought I'd better just come and tell you.'

'But you don't know anything for sure?'

'No.'

The woman reached out and opened her handbag. She took out Marie's passport. Inside it were the pages from her notebook with Philippe's London address and phone number. Catherine dug into her handbag again. There was Marie's chequebook, her bank card, an American Express card, a diary with phone numbers in Kinshasa. There was her marriage certificate.

Philippe picked up the passport, a small, dark-green covered booklet. He turned to the first page and saw Marie's face, under-exposed, sullen, staring back at him. He flipped to the back of the booklet and saw the stamp they'd put in at the British embassy. His expression didn't change, patient, non-committal; he gazed down at the passport for a few moments, then closed it and dropped it back onto the table. He reached out to the rest of Marie's things, as if he were pointing to them with his index finger; he steered them around on the table top, said nothing.

'What are you going to do?', asked Chris.

The phone rang. Chris went to answer it in the hallway, and then called back to the kitchen, 'Philippe, it's for you.'

While Philippe talked on the phone in French, Chris opened a packet of ground coffee and set up the percolator. Catherine watched him without a word. The first gurgling *choof* of water boiled up in the percolator, and a moment later the dark liquid began to drip down through the grounds and into the glass jug. They were both listening to Philippe. His voice was calm and businesslike.

He came back into the kitchen.

'It's André', he said. 'He's with the embassy in Paris. They've had a call from French immigration. They're sending her back to Calais.'

Catherine ran her hand through her hair.

'I'm sorry', she said.

Philippe shook his head.

'She forgot about the birth certificate', he said. 'It's not your fault.'

'I should have checked her luggage', said Catherine.

Philippe stood by the table, his finger tips grazing its surface, he was looking down at Marie's things. Then he shook his head as if he were trying to shake off sleep.

'André says the French will hand her over to someone from Security . . . Zaire Security . . . He's going to pick her up in Calais and take her back to Paris. He's got an apartment. I've got to get to Paris. I need to go straight away.' He looked at Chris. 'The last flight's just after nine.'

They looked at the clock. It was almost eight fifteen.

'You've had it', said Chris. 'It's an hour, minimum. You can't do it.' Philippe frowned.

'What about the ferry?' said Catherine.

'You can do Waterloo to Dover . . . couple of hours', said Chris, he was already in the hallway, and returned a moment later with the phone book.

'Stena Sealink', he said, 'Stainforth, Staunton, Staveley . . . Steel .. Stena!' He rushed back into the hallway and dialled the number.

'Half-eleven!' he shouted. 'I'll ring for the train times.'

He dialled again.

'It's engaged', he shouted.

Philippe went out into the hallway and set off up the stairs.
'I'll get my . . .'

'I'm through', shouted Chris. Philippe ran up to his room
and returned a couple of minutes later, pulling on his coat.

'I've called a mate', said Chris, 'He'll get you down to the
tube, Finsbury Park. He stays just down the road, he'll be here
in a minute. OK? Finsbury Park; get the Victoria line; change
at . . . Warren Street, OK? You get to Waterloo by nine, five
past nine, and you'll make it. You should do it.' He glanced at
the clock. 'No problem. You can hire a car at the other end,
get you into Paris . . .?' he glanced at Catherine.

'About three hours', she said.

'Get you into Paris, four in the morning?' Philippe
nodded.

'You OK for hiring the car?' asked Chris.

'I think so', said Philippe.

'Sure . . .?'

A car horn sounded in the street outside.

'OK', said Chris. 'His name's Ricky. Come on.' They were
in the hallway, heading for the front door.

'Good luck', shouted Catherine, but there was no answer.
Through the open door she heard the car door bang shut and
the car move away. Then the front door closed and Chris
reappeared in the kitchen. He smiled at Catherine and she
smiled back.

'Have you got somewhere to stay?' asked Chris.

'I booked a hotel. I'm going back in the morning. I . . . can
I stay here a while? See if there's any news?'

Chris went over to the percolator and picked up the jug of
coffee. He paused. The whole house was silent.

Bertrand watched Philippe leave. A while later a radio mes-
sage came in; they'd followed Philippe to the tube station, and
someone was trailing him through the Underground.

Bertrand acknowledged the call. Set into the console in
front of him was a row of tape machines. There were cassettes

in place, but they were motionless. Bertrand slipped the cassette out of the nearest machine and waved it at Jonas.

'When are the microphones going in?' he asked.

'They promised tomorrow', said Jonas.

'And the phone?'

'Tomorrow.'

'We should have had them in tonight.'

Jonas kept his mouth shut. Bertrand was tapping on the console with the blank cassette.

They heard a siren. It was on the main road, only a street away. Bertrand stopped tapping and Jonas saw his instinctive glance in the direction of the sound. Then Bertrand's gaze flicked across at Jonas. The first siren died away but was followed a moment later by another.

'It happens all the . . .'

'Quiet', hissed Bertrand. As the second siren faded into the distance, they heard music.

Jonas crept over to the rear window and looked out through the darkened glass. He could see nothing. The music grew louder, then he heard banging, like someone kicking a dustbin. Out of the streetlights' pattern of darkness and brightness, on the brow of the hill, Jonas saw a group of youths emerge, four of them, one with a stereo system on his shoulder. As they approached, the music rose in volume.

Jonas turned back towards Bertrand.

'It's just kids', he said.

Bertrand pursed his lips.

The youths were about fifty feet away when one of them climbed up onto the boot of a car and jumped up and down on it. He leapt up onto the car roof and down again onto the bonnet. The others yelled and cheered. The youth jumped forward onto the next car. The music was deafening. Then a deep male voice bellowed at the kids to kill the noise. They jeered, but the youth on the car jumped down onto the pavement. His nose pressed against the rear window, Jonas saw a large man emerge onto the pavement and take a step towards the youths. They shouted again, but this time they ran. Jonas ducked away from the window as they came level

with the van. He winced as, in passing, they beat on the side panels. Then the music faded as they ran on down the hill. The man who had chased them away shouted after them, 'Wankers!' then, a few moments later, a house door slammed shut, and once again the street was quiet.

Ten minutes later the message came in by radio. They'd lost Philippe at Warren Street.

Jonas watched as Bertrand sighed, then carefully set the blank cassette in place again in the recorder. Without saying a word, Bertrand got up out of his seat, squeezed past Jonas and opened the rear door of the van. Bertrand climbed out, and still Jonas said nothing. Then the door slammed shut and once again the van rang like the inside of a drum.

30

The streets of Paris were dark and wet when Philippe drove into the city. There was no traffic. The streetlamps cast their shaky streaks of light onto the glistening tarmac but the city, it seemed, was not at home. Only in shop windows did light, the flare of tungsten or white halogen, prevail; tungsten, halogen, neon, *cuirs, latex, lingerie, videos.*

Philippe found André's apartment building without difficulty. He pulled the hire-car in to the kerb. He climbed out and looked up from the pavement at the second floor where he knew André's apartment to be. There was no light, not on the second floor, not anywhere in the building. He went over to the doorway and pressed André's button on the entry panel. The harsh ring had an antique, handcranked quality. Philippe stood and waited but there was no answer. He rang again and waited. A car hushed slowly past on the wet road. He turned to look at it, and saw a woman's gaunt white face stare back at him. The car drove on. He rang the bell again.

As he stood and waited, he heard a siren in the distance, another moment and he realised the sound was coming closer. He looked along the street and saw the headlights of a car, it was racing towards him, there was a blue light flashing on the roof. As the first car came closer he heard another siren's wail approaching.

The first car shot past him and, at the next corner, slewed round to the left and disappeared. The second car took the same left turn.

It was intuition that made him get back into his car and drive after the two police cars. He made the left turn and found himself in yet another street lined by tall apartment buildings, but this one was blocked off at the far end. There were three police cars, all stopped near the end of the street, headlights full on, blue lights flashing, sirens silenced.

He pulled in to the side of the street some twenty yards short of the police cars. He got out and started to walk

towards them. Then he heard another siren and an ambulance appeared. He could see the railings clearly now, thick, cast iron bars about four feet high. The blue lights from the police cars turned like lighthouse signals; at every revolution their glare flickered on the railings' glossy, uneven surface like thin streaks of lightning.

He saw the ambulance crew climb out of their vehicles and confer with two policemen who pointed out beyond the railings. Philippe walked closer and saw a black Mercedes parked right at the end of the street. There was a CD plate on the rear of it.

He came closer to the railings. He was standing beside the Mercedes and he stooped to look inside it.

'Hey!' He looked up. One of the policemen was staring at him. The man started towards Philippe.

'Why don't you just fuck off out of it.'

'I thought it might be my friend's car', said Philippe.

The policeman laughed. He unclipped a torch from his belt and switched it on, shining the powerful white beam into Philippe's face. Philippe raised a hand to shield his eyes from the glare. He reached into his jacket pocket and produced his passport. He opened it so that the policeman could see the diplomatic accreditation.

'I'm Zairois', said Philippe. 'What's happening.'

'One of your niggers', said the policeman. 'She's gone fucking berserk.'

'Where?' asked Philippe.

'Look for your fucking self', said the policeman. He pointed out beyond the railings. Philippe walked over.

Beyond the railings the ground sloped steeply downwards, and at the bottom was a large expanse of level ground with, shining out from it, the gleam of railway lines. It was dimly lit, but Philippe could see a group of five, maybe six people, and a constant, shifting, clumsy movement.

'Go on down', said the policeman. 'The more the fucking merrier.'

The ambulance crew, two of them, had brought a stretcher out from their vehicle. One of them had climbed over the

railings, and between them they were trying to manoeuvre the stretcher across. Philippe went up to them and helped them get the stretcher over. The second man climbed over and Philippe watched them set off awkwardly down the slope. He climbed the railings himself and stumbled down the steep, hummocky ground towards the tracks. He quickly overtook the ambulance crew.

As he came closer he could see there were four policemen trying to deal with someone on the ground. There was a struggle. As Philippe approached he saw two of the policemen raise their batons and start to lash down with them at the figure on the ground. There was another man with them, trying to restrain them, trying to grab one of the batons, to stop them hitting out. One of the policemen turned on the man and cracked him over the head. The man staggered back. It was André.

Philippe broke into a run, but by the time he got there it was over. The figure on the ground lay still, and André was standing quietly, with blood glistening as it ran down his face from a wound over his eye. The policemen were standing round, embarrassed by this point, and waiting for the ambulance crew to arrive. Philippe looked down and saw Marie. She was wearing a thin cotton dress which was badly torn. She seemed to be asleep. He knelt beside her and reached out to touch her. Her face was dirty and bloody. He reached out, but before his hand reached her he pulled it back and held it at his side.

'She's all right.' It was one of the policemen. 'Just went crazy. It's all over now.'

The stretcher arrived. The policemen shoved Philippe aside and he watched while the stretcher was laid on the coarse, stony ballast and then Marie was dragged across onto it. Philippe started towards her again but André held him back. He watched while they buckled broad orange nylon straps round Marie to hold her onto the stretcher.

'Who's this, anyway?' asked a policeman. He was looking at André for an answer.

'He's with me', said André. The policeman shrugged and

turned away. André and Philippe started back up the slope, following the stretcher.

Back in the street, Marie was put into the ambulance. When the door was starting to close, Philippe tried to climb in to be with her. The ambulance man pushed him back, and one of the policeman grabbed his shoulder to steer him away from the ambulance.

'I want to go with her', said Philippe.

'No chance', said the policeman. Philippe shook himself free of the policeman's grip, and turned to glare at the man. The policeman started back a half-step.

'Philippe', said André. 'Wait'. André went over the ambulance driver and found out which hospital Marie would be taken to.

The door closed at the rear of the ambulance. Philippe watched as Marie was driven away. He felt André's hand on his shoulder, and turned towards him.

'Where's Eric?' asked Philippe.

'He's back at the apartment', said André. 'Come and see him. Irène's looking after him.' André led him towards the Mercedes, but Philippe pulled away again and walked towards his hire car. Then he stopped, and turned back towards André.

'What happened?'

André went up to him. His voice was gentle. 'Come back to the apartment, Philippe. You can see Eric, and I can give you the whole story.'

'I want to know what happened', said Philippe. André shook his head.

'All right', he said. 'I picked her up in Calais. I went in the Mercedes. I went into the room where they were keeping her, and they said to her, "This man is from the Zairean authorities, we are handing you over into his custody." What do you think she thought. She sat and shivered all the way from Calais to Paris. They sat in the back, clinging to each other. She wouldn't say a word.'

'How was Eric?'

'He wouldn't say anything, either. We get back to Paris all right. I stop outside the apartment. I say, "OK, here we are",

she sits and stares at me, and she's starting to dribble, making funny noises. Eric's scared stiff. I say "Come on, we'll get you something to eat, get you a bed", she won't move. I say, "OK, wait here a minute", and I go into the apartment. I think, maybe if Irène talks to her. Maybe she'll trust Irène. I go into the apartment and two minutes later I'm back down at the car with Irène. There's Eric in the back seat. No Marie. Ten minutes later the police appear, some railway worker's seen somebody on the line. I suppose . . . the police, sirens; it was just the last straw.'

Philippe was staring at the ground.

A car door slammed, then another, and another, and there was the sound of car engines starting up. With no sirens, no flashing lights, the three police cars drove away. Philippe stood and watched the tail lights moving off down the street, dragging their blurry reflections behind them. He watched the cars as they turned right, out of the street, and away.

31

On the second of December 1960, Patrice Lumumba was flown back to Leopoldville. At about the same time as he arrived at Ndjili airport, around 5pm, two more of his ministers were flown in. Maurice Okito and Joseph Mpolo had been captured in the north of Leopoldville province; like Lumumba, they'd been en route for Stanleyville.

The three men were loaded onto the back of a truck, where they sat for some time before being driven away to a house near Mobutu's Leopoldville residence. It was while they sat together in that truck at the airport that they were photographed. There's a series of photographs, and it's from this series that the best known images of Lumumba are taken. They appear again and again. They appear on the covers of books, the Panaf biography, the English translation of Lumumba's own book, *Congo, My Country*. The latter book uses three of the images as illustrations, 'At Leopoldville after capture'; 'In transit after capture'; 'In the hands of General Mobutu's men.' It's from this same series of photographs that the image of Lumumba appears, barely a moment on the screen in a montage of black and white shots, in Oliver Stone's film *JFK*. Lumumba from the side, a soldier in shorts and short-sleeved shirt, his hands holding the end of a rope. Another shot, from the other side; we can see that Lumumba's hands have been fastened behind his back, and this time it's another soldier who holds the rope. Some accounts say that Lumumba was handcuffed; the photographs don't show his hands; perhaps he was handcuffed and the coarse rope which we see in all the photographs was knotted round the handcuffs' chain, not biting into the skin at all.

The most widely-used of all the shots is from the front, with Okito and Mpolo in the foreground, and behind them Lumumba. He's wearing a simple, white shirt; open-collared, short-sleeved. Eye-witness accounts say that the shirt was soiled and torn; the photographs don't reveal it. The witnesses

say there was blood on his face; it doesn't show up in the photographs. And in all of these shots Lumumba wears much the same, patient expression. Patient? It's hard to tell. There's a trace of a frown, perhaps; a calm before the inevitable storm, the sure and certain expectation of a crown of thorns.

At seven that evening, somehow, Okito managed to get to a telephone. He called Thomas Manza.

'Patrice has been beaten like a dog', he said, 'he's had his clothes taken off – Thomas, I'm begging you, get the UN people to do something . . .'

Okito managed a 'Goodbye'. Manza held the telephone, listening, but there was no more. He left his suite in *Le Royal* and went up to the sixth floor. Dayal wasn't there, but Rikhye was; Rikhye was Dayal's Indian military adviser. He listened to Manza's account of the phone call.

'I'm sorry', he said. 'We protected Lumumba as long as he stayed in his residence. But from the moment he escaped, the UN could take no further responsibility for him.'

Manza left Rikhye and returned to his own suite of rooms. He stood for a while and looked out over the city lights. It was a pity he hadn't been able to talk to Dayal. It was Dayal who'd kept Manza safe throughout the wave of arrests that had broken over the capital, washing away Lumumba's crumbling support.

'I can put you under UN protection, Thomas', Dayal had said. 'But only so long as you stay in *Le Royal*.'

Saturday, January 14th, 1961
'So we send him to Bakwanga. If we send him down to Tshombe, Belgium gets the blame. Kalonji's less trouble. And if we use him as a Prime Minister and he brings Kasai back into the Congo . . .'

'Belgium gets the blame if Tshombe does it . . .'

'Tshombe doesn't *want* Lumumba.'

'Oh yes he does.'

Bomboko sat back in his chair and watched them bickering. If you stopped listening to the words, if you just watched their expressions, tried to concentrate less on what was being said and more on the tone of voice . . .

Well he'd been scared too. When they'd heard about the mutiny at Thysville, they'd all been shaken. Enough to offer Lumumba the job of deputy Prime Minister, under Kalonji. Nobody was surprised when he turned that down – Kalonji would never have gone for it, either – but they were all surprised when Lumumba simply went back to his cell.

Mobutu and Kasavubu had seen the writing on the wall at closer quarters. There was Mobutu's shock when the attack on Kivu failed and he was driven back into Ruanda-Urundi. And just a couple of days later, when Kasavubu got up on his hind legs in Luluabourg and tried to speak to the crowd, they chanted back 'Long live Lumumba', 'Where is Lumumba'. Kasavubu was distinctly rattled, chants of *uhuru* roaring in his ears; freedom. For Lumumba? Bomboko smiled.

The mutiny had scared them, all the same, and if Gizenga's government in Stanleyville was still getting weapons from Cairo, and with all the rumours of the last few days about a coup in Leo?

'Time's running out, Joseph', said Kasavubu. Bomboko tuned back into the conversation.

'Kennedy can't do anything', said Mobutu. 'He never even replied to Patrice's telegram. Come the 20th the Americans'll be too busy celebrating . . . there's no rush.'

'Joseph', said Kasavubu. '*We* can't hold on that long. Not with Patrice still alive. Anyway, all Kennedy has to do is stop the money. How long do you think your troops would stay loyal if you couldn't pay them?'

'We have to move him somewhere safe', said Mobutu.

'Safe for who?' asked Bomboko. Mobutu glared at him.

'Well away from Leo', said Mobutu. 'But I don't want him killed.'

'None of us want to see Patrice killed', said Bomboko. It was like talking to a child. 'But as long as he's alive, he's going to make trouble. The people at Thysville were as loyal as anyone you've got. He was there for less than a month and what happens? Christmas dinner. He's the guest of honour at their Christmas dinner! Joseph, there isn't anywhere in the Congo . . . there isn't anybody Patrice can't charm. There

isn't a prison in the Congo. The only people who won't listen to him are the Luba in Bakwanga, and Tshombe in Katanga. Get him down to Tshombe. Let Tshombe and Munongo take care of him.'

'We can't send him to Katanga', said Kasavubu. 'The Belgians won't like it.'

Mobutu turned towards Bomboko. 'You don't want to see him killed?' said Mobutu. 'You mean you don't want to be there when it happens, that's all.'

Bomboko smiled. 'Joseph', he said. 'Well done. Now, the only other thing you need to grasp is that every day we wait, arranging it grows more difficult.'

Tuesday, January 17th

Mukamba and Nendaka glanced at each other for reassurance as the officer led them to Lumumba's cell.

'You say it, then', said Nendaka. Mukamba scowled at him.

'Why does it have to be me?'

'Because he knows you . . .'

'Shh!', said Mukamba, and indicated the cell door.

When they walked into the cell they were smiling.

'Patron', said Mukamba.

Lumumba stood and greeted them. 'What's the news?' he asked.

'A coup', said Mukamba. 'We've got to get you back to Leo. They've got rid of Mobutu and Kasavubu. They've got rid of the Commissioners . . . they want you back.'

There was just the ghost of a smile on Lumumba's face.

'When do we leave?' he said.

'It's difficult', said Nendaka. 'The UN won't let . . .'

'We've got a small plane with us', said Mukamba. 'It'll take you to Leo.'

Ten minutes later the little Air-Brousse Rapid Dragon was bumping along the runway at Lukala airstrip. Then, with a last bump, they were climbing into the air. They swung out over the river, still gaining height, still turning, and when they levelled off they were flying down the river's course,

away from Leopoldville, towards the coast. The three men, Lumumba, Okito, Mpolo, looked at each other.

'Where are we going?' asked Lumumba, raising his voice above the sound of the engine.

Nendaka turned from his seat near the front of the plane. He saw the three enquiring faces. He threw back his head and laughed.

There was a small airstrip on the coast at Moanda. The UN hadn't bothered to mount a guard there. The Air-Brousse plane taxied up to an Air Congo DC4 and the three men were transferred in a matter of moments. Mukamba stayed in the smaller plane for the flight back to Ndjili, but Nendaka boarded the DC4 with his prisoners and their guard. The guard was made up mainly of Luba soldiers, under the leadership of Fernand Kazadi. Kazadi was a member of the College of Commissioners, in charge of Defence. He wasn't a soldier, but he'd brought an ANC officer with him.

Pierre van der Voersch, in the body of the aircraft, supervised the closing of the doors. As he made his way up to the cockpit he saw the three prisoners being shackled into their seats.

He left the cockpit door open. As he went through the take off routine with Tignée he could hear the guards shouting at their prisoners.

'Come on', he said to Tignée. 'The sooner we get this over with the better.'

The aircraft moved off down the runway and started to pick up speed. The clattering and shouting from the soldiers in the body of the plane lessened. Tignée took the plane up as steeply as he could, gaining as much height as possible before the flight path took them out over the ocean, yet still they were close enough to the water to see the texture of its surface, the choppy grey-blue water shining in the sunlight. As they climbed they saw the mouth of the river, the red earth in suspension in the river water staining the ocean. The Congo was a dull red slick in the salt water, stretching out to the horizon. Then they reached their cruising height and began a

long turn towards the south. Once they were on their heading, Tignée unbuckled his seat belt.

'You take it for the first stretch', he said. 'I'm going to have a look back there.'

Tignée opened the cockpit door and saw soldiers getting out of their seats. He went along the aisle and found Kazadi, with his ANC officer beside him.

'Everything all right?' asked Tignée.

The officer looked up at him. 'Fine', he said. 'How long will the flight take?'

'We should be there by about six in the evening', said Tignée. 'Have you something with you? To pass the time?'

The officer smiled. 'I don't think that will be a problem', he said.

Tignée smiled, and turned back towards the cockpit. Then he heard a crack, and as he turned, he saw one of the soldiers with his rifle raised, ready to hit Lumumba again with the butt. Blood was streaming down Lumumba's face. Tignée turned to look at Kazadi.

'Shouldn't you be taking care of the aircraft?' asked Kazadi.

Tignée went back to the cockpit and closed the cockpit door. He glanced at his co-pilot and saw the worried expression, but neither of them spoke. Tignée sat down and concentrated on the instrument panel, the sound of the engines. He put on his headphones and listened for radio traffic.

After about an hour, the aircraft seemed to hit a patch of turbulence, rocking a little from side to side. Pierre van der Voersch looked at his captain. Something seemed odd; the sky was clear. There was a banging sound from somewhere to the rear.

'I'll look', said Tignée.

They'd ripped out half the seats, and chained the three prisoners together in the middle of the plane. Blood ran across the steel floor; it had splashed the seats, windows, everything inside the cabin. As Tignée watched, the soldiers kicked at the three huddled figures. Mpolo screamed. His arm had been broken. One of the soldiers hefted the broken back of a seat and crashed it down onto Lumumba's head, then raised the

seat again for another blow but lost his balance and lurched back against the side of the cabin. A piece of metal, projecting from the remains of the seat, crashed into one of the windows, cracking the glass.

Tignée looked for Kazadi. He was sitting, with the officer, at the rear of the aircraft. As Tignée clambered past the prisoners, one of them looked up at him. The man said nothing, but the hopelessness of his expression made Tignée sick.

'Mr Kazadi', said Tignée.

'Yes?' said the officer. Kazadi was sitting tight-lipped.

'This has got to stop.'

'Why?' asked the officer. 'We're not going to kill them.'

'If you carry on like this', said Tignée, 'the fabric of the plane will be in danger.' Kazadi smiled.

'We'll try to bear that in mind', said the officer.

'You'd better do more than that', said Tignée, 'Or I won't be responsible.'

'I'll take the responsibility', said the officer.

'And just who would you be, in that case?' said Tignée. Kazadi had turned away from the conversation and was gazing out of the window.

'Kawena', said the officer. 'My name is Kawena.'

They flew on past Bakwanga, and in the later part of the afternoon they cleared the forest. Below, the ground climbed up towards them until they were flying over a broad, upland plateau. Ahead of them Katanga's dry savannah land, dusty yellow grass and scrub, stretched off into the distance towards Northern Rhodesia.

It was approaching six when they came in towards Elizabethville. The light was still fair, with the sun near the western horizon, but with cloud starting to close in.

Elizabethville, that most European of the Congo's cities, with a climate so much cooler and more temperate than the sweaty tropical warmth of the broad Congo basin. Like Bukavu, the air was clean and fresh, but there was none of the luxuriant, rampant forest that surrounded Lake Kivu. And Elizabethville was an orderly place, with its streets laid out in a

regular grid, with its modest villas and their neat, rectangular gardens. The blue jacarandas, planted in the 1920s to line Elizabethville's new avenues, had grown into tall, elegant trees that gave the town a suburban feel. And in the gardens flame trees grew, modest, rather like apple trees, so that when the scarlet flowers blossomed on the naked branches, you felt that you were in an orchard; a more strikingly-coloured orchard, naturally, than anything back in Belgium, but, nevertheless, with a tamed, rural feel, nothing out of scale.

The cockpit door was locked.

They began their descent. The gridded streets were flicking past beneath them and the cockpit door was locked. Ahead of them, on the south side of the town, was the smelter, the fiery glow of its huge furnace indicating that, whatever was happening in the rest of the Congo, here life was going on, steady, industrious life. Locked. Late sunlight winked on the smelter's towering copper-clad chimney and Tignée could see the spoil-heap rising like a mountain. Some people found it ugly. Tignée turned his mind to it, the dark, glassy clinker and its shining, bronzed surfaces, the way the light played on it, the iridescent sheen of it, like a beetle's back, like a sunbird's plumage, like the weird lustrous green of a mallard's head, he thought, and remembered childhood afternoons, watching duck on the lake back home, the cool, misty air.

They felt the comforting bump as the aircraft's wheels met the runway. The control tower directed them over to the far side of the airport, away from the section patrolled by the UN's Swedish contingent and towards the hanger that had been designated for Katanga's own military aircraft. Tignée brought the plane to a halt a short distance from the hangar.

They were barely at a standstill when a line of vehicles rushed out to meet them. The plane was surrounded by trucks and jeeps, all disgorging soldiers whose uniforms showed them to be Katanga's *gendarmes*.

'What the hell?' said Tignée.

Pierre van der Voersch simply pointed out of the window at his side of the cockpit.

'What?', asked Tignée.

'It's an armoured car', said van der Voersch. 'They've got a cannon on it. They're aiming at the plane.'

The soldiers had formed a cordon right around the aircraft. Tignée opened the cockpit door and went through to see Kazadi. The aircraft's door had already been opened and the steps thrown down. The prisoners were being jostled to the doorway. Kazadi, seeing Tignée approaching, stepped towards him.

'Thank you, Captain', said Kazadi. 'An excellent flight. But I think you can leave it to us now.'

The last of the Luba bodyguard were leaving the aircraft. Tignée looked out and saw them driving the prisoners forward. The three men had been blindfolded, and their hands were tied behind their backs. They were being pushed along a gauntlet that led from the aircraft to one of the jeeps, where a huge man in a dark suit and dark glasses was clearly in charge. As the prisoners moved towards the jeep they were kicked and clubbed by the soldiers. Tignée saw one of the men knocked to the ground, and a ring of soldiers closed round him, kicking and stamping.

'Is that Munongo?' asked Tignée, pointing to the figure in the jeep. Munongo was Tshombe's second-in-command and Katanga's Minister of the Interior.

'As I say, Captain', said Kazadi, 'I think you can leave things to us now.' The Commissioner held out his hand, but Tignée refused to shake it.

'As you wish', said Kazadi, and left the aircraft.

Lumumba, Okito and Mpolo were hoisted into the back of the jeep, which set off immediately across the airfield, away from the terminal building. The rest of the convoy set off after the jeep, and followed it out through a cut in the airport's perimeter fence. When they were gone, Tignée saw a group of soldiers about fifty yards from the aircraft, walking slowly towards it. In the failing light he could just make out the pale blue of their helmets.

32

Kawena's black Mercedes pulled off the highway and onto the slip-road that led towards Ndjili. As the main entrance came into view, Kawena glanced at the letters 'MPR', which were fixed to the concrete wall of the airport building. They were tall letters, made of stainless steel and arranged one above the other. As the car drew closer Kawena could see that there was graffiti on the wall beside the letters. He smiled; it was beautifully done, spray-painted letters in violent yellow with a blood red margin. 'MPR', said the steel characters, and the painted lettering completed the words, *'Mort Pour Rien'*, dead for nothing.

Kawena told the driver to stop. The car drew in to the kerb some twenty or thirty feet short of the graffiti. From this distance Kawena could see that there was a spidery swathe of lettering along the wall at about chest height. It was scrawled in chalks and charcoal; there was Tchisekedi's name. Someone had written up the letters 'UPDS', the initials of Tchisekedi's party, but in the wrong order, and the 'S' was back to front.

'How long has this stuff been here?' asked Kawena.

'I don't know.'

'Stéphane', said Kawena. 'How long have I known you? Tell me how long the stuff's been here.'

'Some of it appeared about a week ago, patron.'

'*Mort pour rien.* How long has that been there?'

Stéphane turned round to look at his boss.

'There. I said it', said Kawena. '*Mort pour rien.* I said it again. I'm still alive. It's the oldest joke in Kinshasa. You heard it when you were a child. How long has it been there?'

'A week, patron.'

'And you never thought to tell me about it.'

'I thought someone else would . . . I didn't think it was my place.'

'I don't suppose it was.'

Kawena looked out again at the graffiti and the people

passing. As he watched, a middle-aged woman emerged from the airport building with her daughter beside her, a girl of maybe fifteen or sixteen. The mother stopped and pointed out the graffiti to her daughter, and the two of them laughed.

Two men in abacosts came out of the building. Kawena saw the moment when they noticed the car. He watched as they buttoned up their jackets, struggling to fasten them over the grubby vests they both wore underneath. He saw them whisper to each other. You could hear the cogs turning; shall we try and slip back inside the building? Shall we acknowledge that we've seen the car?

Kawena opened the door and stepped out. The two men came to a ragged sort of attention. Kawena beckoned to them to come over.

'Have you seen this before?' asked Kawena, and pointed to the graffiti.

'We saw it just this morning, sir', came the answer.

'You're lying', said Kawena. He spoke softly.

'Yes, sir', said the man.

'It's been here for over a week, hasn't it?'

The spokesman was silent. His colleague, still standing stiffly, if untidily, to attention, continued to stare out into the distance.

'I want the two of you, right now, to go and get a mop and bucket and clean it off. Do you understand?'

'Sir?'

'You understand what I'm saying?'

'Sir, we tried. We told one of the cleaners to wash it off. He said it wouldn't come off, sir.'

'Go and get a bucket and a mop', said Kawena. The two men ran off, back into the terminal building, while Kawena stood and waited for them. Already the shock wave had spread out, circles of reaction. People walked past with their eyes down, avoiding Kawena, avoiding the graffiti. The chatter of voices had been cut to nothing.

The men returned, one with a bucket of soapy water, the other with a mop. Kawena strode over to the wall and they trailed after him.

'Give it here', said Kawena, and grabbed the mop. He thrust it into the bucket and then began to scrub at the web of chalky lettering. It rinsed away with barely any effort.

'So you tried to wash it off', said Kawena, and handed the mop back to the man who had brought it. There was no reply. Kawena took a handkerchief from the pocket of his abacost jacket, and dabbed carefully at a spot of foam that had landed on the man's collar.

'The two of you', he said, and he said it very gently, 'Wash off everything that will wash off, and then go and find someone to clean the spray paint off. Get a solvent, acid, whatever it needs. Do you understand?'

Kawena strode back to the car and climbed in. Stéphane sat quietly at the wheel, waiting for the word to move on.

'What do you think?' asked Kawena. 'A round-up in *la Cité*? Rake out a few Tchisekedi supporters? A place like that, must be crawling with them, eh? What do you think?'

Nothing from Stéphane.

'Come on, Stéphane. Tell me what you think.'

'I don't know.'

'No? Well what about this, then? What would you say the chances were . . . all this graffiti . . . what would you say the chances were that our President saw it?'

He stood in the airport manager's office on the top floor of the building and looked out over the broad expanse of tarmac. He glanced at his watch.

'Is the flight on time?' he asked, still surveying the scene outside.

'I'll check', said the manager. Kawena heard him make the call.

'It's on its final approach', said the manager. Kawena, immobile, continued to look out over the airport.

A few moments later the Air France 747 came gliding down. Kawena saw the puff of smoke as its wheels grounded on the rubber-striped runway. As the aircraft slowed, Kawena lifted a pair of binoculars to his eyes. He followed the plane as it turned off the runway and began to taxi in towards the terminal.

'How will they get the stretcher off?' he asked.

'They'll use a special . . . sort of lift thing. It goes to the rear door.'

Kawena waited. It was a quarter of an hour before they got the lift positioned at the rear of the aircraft, but he was watching through his binoculars as Marie was taken off. He watched her mother's anxious expression as the lift brought Marie down to the ground. He watched her bend down to speak to her daughter, but Marie, head bandaged, gave no response. She seemed to be asleep, or heavily sedated. There were two men waiting to take charge of the stretcher. They carried Marie across to a waiting ambulance and loaded her in. Her mother climbed in beside her, and the ambulance moved away.

A call came in on Kawena's radio. 'They're on their way, patron.'

'I know', said Kawena. 'Call me when they get there.'

The next morning, just after nine, Stéphane dropped him several houses away from the mother's place. He strolled along the street, weighing up property values. Marie's father had been a businessman, and he'd left the family comfortable. For the moment, at least; for the time being.

The gate swung open without a sound, and there was no sign of life from the house. He knocked on the door and waited.

When Marie's mother answered the door she was still in her dressing gown. She had a puzzled expression.

'Good morning', he said, while she hesitated. 'I'm a friend of Philippe's. I wonder if you'd mind if I came in for a moment. Could I have a word with Marie, perhaps?'

She opened the door and gestured to him to come in. He stepped into the living room, and Marie's mother disappeared into another room. There was no sign of Marie. He looked round the room, which was tidy and clean, if cramped. Then Marie's mother, dressed, reappeared.

'I'm sorry', she said. 'I didn't ask your name.'

'Kawena', he said, and looked to see if she recognised the name. There was no reaction.

'My daughter is upstairs. She hasn't been well. I'll go up and see if she's awake.' Kawena thanked her. Marie's mother left the room again.

When she returned a minute later she seemed more guarded.

'I don't think you'll get much from her', she said. 'She's not . . .'

'If I could just see her for a moment?' said Kawena. Marie's mother turned and led him into the hallway and up the stairs. At the door to Marie's room her mother knocked lightly, and then pushed the door open, gesturing for Kawena to go in. He stepped into the room and closed the door gently behind him.

Marie was sitting up in bed with a dressing gown round her shoulders. The bandage had been removed from her head, revealing that part of her scalp had been shaved and the skin was puckered by a row of stitches running along a thick, seamed wound. There was bruising and swelling around her eyes and mouth, and her lower lip had been split. As she stared blankly at him, Kawena's polite smile faltered.

'I just wanted to see how you were', he said, and moved closer towards the bed. Marie's eyes tracked him.

'I was trying to remember the last time we met', said Kawena. 'It must have been just last month, you remember? At the Intercontinental ..?' He noticed her pressing her swollen lips together. He went across to the window and looked down into the garden.

'Or was it . . .', he turned to look at her, smiling at her, '. . . didn't I come back with Philippe one evening . . . when was that? Was that after the Intercontinental ..?'

Marie turned stiffly towards her bedside table and reached for a jug of fresh orange juice. Kawena, seeing the backs of her hands cut and grazed, was at her side in a moment. He took the jug and poured juice into a glass. For a moment the only sounds in the room were the sound of the cool juice splashing into the tumbler and the chink of ice cubes against the jug's glass sides. He held out the tumbler for her. She took it carefully, drank a mouthful, and then put the glass down on her

bedside table. She looked up at him, angry, wary, and he backed away, her eyes following him.

'What do you want?' she asked.

'I just wanted to see how you were, see that you were all right. I heard about the trouble you had in . . .'

'That's what Kotosa said. Can't you do any better?'

Kawena gave a wry smile. 'You've got to understand my position . . .'

Marie, trying to shift herself, grimaced with pain. He took a step towards her and she pulled away from him, sucking her breath sharply in between clenched teeth.

'Are you all right?' he asked.

'I'm fine', she said. 'Just tell me what you came here to do.'

'Marie', he sat down carefully beside the bed, watching for her reaction. There was none.

'I've always . . .', he said. 'Philippe, Philippe has always had my . . . respect. Philippe and you . . .'

'How do you know what I'm like?'

'I've been in your home, Marie . . . I've met you at receptions . . . I've talked with Philippe, we've talked about our families. He's told me about Eric . . . You know I never had children . . .'

'I've seen *you*. I've seen you with your ministers and generals . . .' She broke off, and touched her fingers to her lower lip, pressing gently either side of the half-healed split.

There was silence. The two of them stared at each other until there was a sound just outside the bedroom door. Kawena looked towards the door. Marie picked up her glass of juice and took another drink, then sat the glass back on her bedside table again.

'I just wanted to tell you', said Kawena, his voice low, 'that it isn't too late for Philippe . . . he hasn't burnt his boats. I wanted you to tell him that if he just calls me . . .'

She glared at him. 'What if he doesn't call you?'

Kawena was looking down at his hands. He glanced up at her face and then away again.

'I wasn't trying to threaten you.'

She gave a dismissive hiss.

There was a creak from a floorboard just outside the bedroom door. Marie turned and raised her voice a little. 'Mother, it's all right. Please, just leave us. We're fine.' It was only when she raised her voice that her speech seemed marred by the swelling around her mouth. They heard footsteps go along the hallway and down the stairs. Kawena smiled and looked at Marie again.

'No woman in her right mind', said Marie, 'would want you for the father of her child.'

He raised his hand, then checked it.

'See?' said Marie.

Kawena looked away towards the window. Marie stared at his profile. He turned his head to meet her gaze again. Marie looked down at her battered fists and remembered Madame Manza's tight grip. She unclenched her fists and spread out her hands. She took a deep breath and looked back into Kawena's face.

'There's nothing left for you to do is there?' she said.

Kawena looked away and she laughed, then winced and, frowning, touched her fingers to her lip. She glanced at her fingertips to see if there was blood, but there wasn't.

She called out, 'Mother! Mother, can you come up?' and her mother came running. Her anxious face appeared round the edge of the door.

'Mr Kawena's leaving, mother. Can you show him out?' she said, and gave her mother a smile. Kawena stood and looked down at Marie. He shook his head sadly from side to side.

'Goodbye', she said, and held out her hand to him. He shook hands with her, just a light touch of palm on palm, then went over to the door. He looked back at her and said goodbye, so quietly it was almost as if he were speaking to himself.

Stéphane said nothing when Kawena got into the car, simply pulled away and headed back towards the *deuxième Cité* where Kawena's technicians had already slipped the cassette into its plastic case and were labelling the recording with the date and place and time.

33

Chris Davis opened his front door and went into the house. The kitchen beckoned, a cup of tea, five minutes to sit down in peace and quiet. He slipped off his coat and hung it in the hallway, dropped his briefcase to the floor, and went through.

The kitchen was unusually tidy, but that wasn't the first thing that caught his eye. There was a young black boy sitting at the kitchen table, eating a bowl of breakfast cereal. He must be about five, thought Chris, maybe six . . . The boy looked up at him and gave a broad smile.

'*Je m'apelle Eric*', said the boy.

'*Er .. jerm apelle . . . Christophe*', said Chris.

Eric answered in French, and Chris caught something about '*maison*'. He could remember the classroom, one of the classrooms . . . one of the French teachers. '*Je . . .*'.

Eric spoke again; something like *abeet* half-caught in Chris' memory, and he recognised *ici* at the end of the sentence.

'*Oui*', he said. '*Je habit ici.*' Eric smiled. He seemed happy to carry on eating the cereal, so Chris turned to the kettle while he tried to gather his thoughts. He filled the kettle, plugged it in, and flicked the switch. Eric climbed down from his chair and brought the empty cereal dish over to the sink. He reached up and held the dish under the tap, then rinsed it and put it into the washing up bowl. Chris looked down at him and smiled. He rummaged around for a way to say 'dishwasher'.

Eric spoke. Not only did Chris fail to recognise a single word, he failed to recognise what the words actually were, where one stopped and another started. '*Pardonnez?* he said.

Eric said it again, but this time he pointed up at a shelf. Chris looked up and saw a collection of jars and tins. He reached up and pointed to a large jar. Eric shook his head. Chris tried again. Eric spoke again; from his tone of voice, thought Chris, he's being very patient. Chris pointed to the next tin along the shelf. Eric clapped and grinned. Chris lifted

the tin down. It was a shortbread tin. He opened it and there were biscuits.

He caught the '*s'il vous plait*', and held the open tin out to the boy. Eric took a single biscuit.

'*Merci*', he said. He went back over to his chair, sat down, and began to nibble at the biscuit. Chris put the tin back on the shelf.

He went across to the table and sat down opposite the boy.

'*Ou est Papa?*', he tried. Eric seemed to understand, but Chris caught nothing of the reply.

'I'm here', said Philippe, coming into the kitchen. Chris gave a sigh of relief. Eric looked up at his father and beamed with pleasure.

'*Il est mon copain*', said Eric, and pointed to Chris.

Chris looked at Philippe.

'Where ..?'

'She's in Zaire', said Philippe. They flew her back to Zaire. She'll go to her mother's.'

Later that evening, when the meal had been cleared away and Eric was settled down for the night, Philippe came back down into the kitchen where he found Chris and Isobel still exchanging their days' news.

'Come on in', said Chris, and, with his foot, pushed out a chair towards Philippe. Philippe took the chair and, almost shyly, he sat down.

'He seems a bright kid', said Isobel. Philippe smiled again.

'How was your day?' asked Philippe. They both answered. It was fine, no problems. Tiring, but fine.

'Better than yours, I guess', said Chris. They smiled.

'Actually, today was fine', said Philippe. 'The journey went well. It was calm, the crossing. Eric enjoyed it, I think.'

Nods from Chris and Isobel, 'Ah-ha, Uh-huh', the intonations of agreement.

They sat for a while without saying anything, then Isobel excused herself and went up to the office, leaving Chris and Philippe alone together.

'Fancy a beer?' asked Chris. He went over to the fridge.

'It's Mexican', said Chris. He opened a couple of bottles and passed one over to Philippe, who looked at the bottle sitting on the bare wood. A little cluster of bubbles of foam slid slowly down the neck of the bottle, down over the paper label, to settle into the crevice between glass and wood. The bubbles burst, and the drop of beer was pulled under the curve of the bottle's base, pulled out along the curve of the bottle's circumference.

'What's going to happen to Marie?' asked Chris. Philippe continued to stare at the bottle, then, looking away from Chris, he raised the bottle to his lips and took a drink.

'I don't know.' He was staring away at the kitchen wall. Chris took a sip of beer.

From upstairs the sound of Matt's heavy metal music crashed out into the house, then, almost immediately, the music was turned down, a door closed, and the sound was gone.

'She has epilepsy'.

He was still staring at the wall.

'So you've got to get her out . . . to get treatment for her?'

'Her parents knew', said Philippe. 'They knew before we got married.'

'Can they look after her? Until you get her out?'

'Her mother can look after her.'

'She'll be safe?' asked Chris. Philippe turned towards him and gave him a blank, dead stare. Chris turned away.

'They should have told me.'

'If you want Eric to stay here,' said Chris, 'until you can get something worked out. There's plenty of room in the house. Allie's good with kids. If you have to go away for a few days . . .'

Philippe turned to Chris and smiled. 'Thank you', he said.

Chris reached for the paper. 'Will you go back?' he asked, and riffled through the pages, looking for something. From the corner of his eye he saw Philippe slowly nodding his head.

'Here', said Chris. 'I saw it this morning'. He began to read out the brief report; there was to be a Constitutional Conference in Kinshasa, it said. Opposition parties had been declared

legal, and the Conference was thought likely to support Tchisekedi Wa Mulumba, demanding that he be asked to form a government.

'Can I see?' asked Philippe. Chris passed the paper across and watched as Philippe studied it briefly. Philippe's face was expressionless.

'You knew about it?' asked Chris.

'Yes', said Philippe. Chris took another sip at his beer.

'I'm probably going to go back to my country', said Philippe. 'The president wants to talk with me . . . to discuss what role I might play, if I go back to Zaire. To live, I mean.'

He turned to look at Chris, who was trying hard not to show any reaction. It was the first time Philippe had said 'the president' instead of just 'Mobutu'.

'It will give me chance to talk to Etienne', said Philippe. 'I may be able to go to the Constitutional Conference. I gave your number to the ambassador in Brussels. He's acting as a go-between.'

He didn't say between who.

'You never said "the president" before', said Chris. Philippe gave a wry smile.

'I've been thinking things over', said Philippe. 'I remember something my father once said, it was a verse from the Bible. "Even the archangel Michael, when he was disputing with the devil about the body of Moses, did not dare to bring a slanderous accusation against him". Did I ever tell you about my father?'

'No', said Chris.

'He was a priest', said Philippe. 'He was with the president . . . Did I ever tell you my father was there when they defeated the Simbas in Bukavu?'

Chris shook his head.

'There was one of them. He'd been shot in the stomach. It was after the battle. My father and the president were visiting the place where the fighting had been, and the Simba was lying on the ground . . . when the president came up to him he began to curse him. "I will kill you", he said. My father said, "How will you do this, lying there with your intestines

244

hanging out of you. You are dead. How will you kill anyone?"
But they were brave men, all the same.'

Chris stared at him. Philippe looked back at him, smiled,
and took another drink of beer.

'You know what Simba means?'

Chris shook his head.

'It means lion.'

Chris raised his eyebrows for a moment.

'As in "the devil goes around like a roaring lion".'

Philippe laughed.

'Lumumba sold beer, you know?' said Philippe. 'Before
independence. He worked for one of the breweries.'

'I read that', said Chris.

'Eric looks very like you', said Chris. Like father, like son.
There was Lumumba's patient expression again, as he waited
in the back of the truck at Ndjili.

'I know', said Philippe.

'You never said anything about your own father before',
said Chris. He paused, but there was no reply from Philippe.
He hesitated, then continued.

'I thought, when I saw the pictures, it struck me that you
look very like Lumumba.'

Philippe smiled.

'That used to happen all the time', he said. 'When I was
working for Security. I met a lot of people who had known
Lumumba. Not just in Zaire. I remember a conference in
Germany, a man came up to me, he was a General, he asked
me right out if I was Lumumba's son.'

Chris raised his bottle and took a sip, looking over the
bottle at Philippe.

'When were you born?' asked Chris.

Philippe smiled.

'I was born in 1961.'

Chris tried to remember the dates. When was Lumumba
arrested? When was the last time he saw Pauline?

'I was born in November 1961', said Philippe, and he smiled.

'So it's almost possible, then', said Chris. 'You could be
his son? There must be just a matter of a few weeks in it,

from when he was arrested . . . the last time he was with Pauline . . .?'

'You have to remember', said Philippe, 'when Lumumba was arrested, they held him for several weeks at Thysville, which is not very far from Kinshasa.'

'And Pauline? After he was arrested, she went back to Kinshasa?'

'For a while', said Philippe. 'But Lumumba had children by another woman, too. And when he was at Thysville, the man who was responsible for guarding him . . . actually I knew the man . . . he was one of Lumumba's supporters. He could have arranged almost anything. That was right up to January 1961.'

Chris did the sums. 'So it's not possible', he said.

'And if I were to tell you', said Philippe, and gave a sly smile, 'that before I was born, I was in my mother's womb for eleven months?'

Chris laughed. 'I'd have to think about that', he said. He drained his bottle of beer and stood up.

'Some things about Africa are hard for Europeans to believe', said Philippe. He finished his beer and passed the empty bottle to Chris.

'What's going to happen to Eric?' asked Chris. He dropped the empties into the waste bin, heard the thud of them hitting the bottom of the bin, and the clink as they bumped against each other.

'There's the family in Bukavu', said Philippe. 'It looks as if I might have to send him back. But I wanted to be with him for a few days . . .'

Chris smiled at him. 'As long as you want, mate', he said. 'As long as you want.'

In the van, parked in the street outside Chris Davis' house, Bertrand took off the headphones and passed them to Jonas.

'That's it for tonight', he said. 'Get that lot transcribed.'

Jonas leaned across and stopped the tape.

'You're going to send Kawena the whole lot?' asked Jonas.

'All the stuff about the Belgian embassy. About going back to the Conference, going to see Tchisekedi.'

'About Lumumba?'

Bertrand laughed.

'You mean "If I tell you I was in my mother's womb for eleven months"? To Kawena? He'd never believe it.'

34

Kawena picked up the telephone and heard the president's voice. He listened for a moment.

'I'll come out straight away', he said, and heard the line go dead.

He called his secretary. 'Get Stéphane, will you. Have him ready for me downstairs in five minutes. For Nsele.'

Kawena left his office and went down the stairs to the situation room. He called through to London and, when Jonas answered, asked to be patched through to Bertrand.

'He's in his digs', said Jonas. 'I'm trying to get him . . .' There was a moment's pause.

'Where is he?' demanded Kawena.

'I'm sorry', said Jonas. 'I can't get an answer.'

'Never mind', said Kawena. 'You can tell me what's happening. Is Philippe still inside the house?'

'He is', said Jonas. 'But we haven't heard anything in the last few hours.'

'When did you last see Bertrand?'

'He came in mid-morning.'

'Did he say what he'd be doing the rest of the day?'

'I don't think so.'

'You don't *think* so?'

'No. I mean, I'm sure he didn't . . .'

'Never mind', said Kawena. 'You've been sending in regular logs . . . phone calls, any callers?'

'Yes'.

'Well, get hold of Bertrand. Tell him I want him to call me, as soon as you see him, do you understand?'

'Patron'.

Kawena cut the line.

Stéphane said nothing when Kawena ordered him to turn off the highway and take the car past the airport buildings. The graffiti was gone, the concrete beside the MPR sign was

scrubbed clean, standing out against the weathered surface of the rest of the building.

'OK, Stéphane', said Kawena. 'Let's just hope he didn't see it.'

As they drove back towards the highway, Kawena gazed out of the windows at the bare landscape around the airport. Clear of the city, the ground was covered with thin scrub, tall clumps of grass stalks dried to silvery yellows and dusty greys; stunted trees bare of leaves. There was a termite mound, its jagged pinnacles rising above the scrubland. As the airport sliproad curved into the main highway, all the way round the curve, Kawena stared at the termite mound.

Thirty years ago Kawena had driven out into another scrubland landscape, a thousand miles from Kinshasa, out into the barren waste beside Luano.

They called it '*l'Ancienne Plaine*', a patch of scrubland that stretched for several miles between the airport and Elizabethville itself. The town's first airstrip had been there, before Luano was built, but that was long-abandoned. The road was tarmac for the first couple of miles, but then it came to a crossroads and after that the surface was just dirt. The convoy rolled on another couple of hundred yards from the crossroads, then turned off into a small plot of ground where some European had made a start on a small, one-storey house. There was a roof of sheet metal which had barely started to rust and the walls were newly whitewashed. Sacks of cement and heaps of timber still lay all around the building, but there was only a dark space where the door should have been.

Munongo was in charge, but with him were four Europeans. Kawena hadn't recognised them, but Kazadi seemed to know them. Kawena was standing in the back of the truck, beside an African Gendarme.

'Who are the Europeans?' he asked.

The Gendarme gave him a fierce look. 'Keep your voice down', he whispered.

'Who are they?' Kawena's voice was quiet, but insistent.

'There's Gat, the Captain; there's Huyghe, Colonel Huyghe. I don't know the other two ..'

'Belgians?' The Gendarme nodded.

'*Force Publique*. But there are mercenaries too.'

A group of gendarmes had been sent back on foot towards the crossroads. They strung themselves out across the road, closing it to any further traffic. Another group went further down the road in the direction of Elizabethville. When they were in place they signalled back to the convoy, and Munongo climbed down from the jeep with Kazadi following close behind. Kawena watched while Lumumba, Okito and Mpolo were hauled out of the jeep. Lumumba stood, but Okito and Mpolo collapsed to the ground and had to be dragged bodily into the house. Kazadi walked back to Kawena's truck and gestured to him to come down. They walked together towards the house. As they came closer to it, Munongo passed them on his way back to the jeep. Kawena turned to watch him go. The jeep, the armoured car, the two trucks, all drove off together towards the town and, as they disappeared into the distance, silence fell. It was barely ten minutes since the DC-4 had come to a halt at the airport.

'Come on', said Kazadi. 'Let's see what we've got.'

There was one large room inside the house, and someone had lit a couple of paraffin lamps. The three prisoners were on the floor. Lumumba sat with his back to the wall. As Kawena and Kazadi entered, he glared at them. Kawena looked away. Okito and Mpolo were either side of Lumumba, and neither of them seemed conscious.

Gat spoke first. 'We're just going to wait', he said. 'But if they try to escape . . . we stop them.'

Ignoring Lumumba's angry stare, Kawena went across to look at Okito. There was a dark, wet patch in his hair. Kawena took one of the lamps and held it closer. There was an open wound in Okito's scalp, as if a strip of the skin had been torn off, and in the lamplight Kawena could see the pearly white gleam of bone. Okito's breathing, however, still seemed quite steady.

'He'll live', said Gat. 'I don't know about the other one.'

Kawena moved across to look at Mpolo. Like the others, he

250

was blood-spattered, his face swollen, bruised and cut. There was nothing so obvious as Okito's injury, but Mpolo's breathing seemed less regular. As Kawena watched, a sort of shiver, a shudder, shook Mpolo's body.

'He was doing that in the jeep', said Gat. 'He'll not see out the night.'

'Did Munongo say how long he'd be?' It was Kazadi's voice.

'Our job's just to wait'. Kawena turned to see who had spoken.

'Colonel?'

'I said wait.'

It was after midnight when they heard the sound of a car on the road outside the house. A few moments later Munongo reeled in to the house, reeking of drink.

'So', he said, and lurched across towards Lumumba. 'You still think you're invincible?'

Lumumba stared up at him. Munongo turned towards Kazadi.

'Lift this man to his feet!' Kazadi took Lumumba by the arm, but he raised himself and stood, still defiant, in front of Munongo.

'You still think you can spit bullets?' asked Munongo. 'Here!'

Munongo turned back towards Kawena. 'You!' he said, 'Give me that!' He pointed to the bayonet which hung at Kawena's belt. Kawena slipped the bayonet from its sheath and passed it, handle first, to Munongo. As Munongo grabbed it, the blade cut Kawena's palm. He looked down at the blood welling from the wound. When he looked up again, Munongo had the point of the bayonet pressing at Lumumba's chest.

'What do you have to say to that?' asked Munongo. Lumumba's expression seemed to have softened.

'You have sold your soul', said Lumumba. Munongo drove the point of the bayonet into Lumumba, pressing him back against the wall. There was a run of blood down his shirt,

but Munongo paused with the blade barely an inch into Lumumba's body.

'You will apologise for that', said Munongo. Lumumba, his face locked into a defiant grimace, began to slide down the wall. Munongo, keeping his grip on the bayonet, followed him, so that eventually Lumumba was lying on the floor, the point of the bayonet still fixed in his chest. Munongo began, very slowly, to press the bayonet deeper into the wound. Lumumba's eyes widened, and his face twisted with pain, but his mouth stayed tightly closed.

There was a sudden, deafening metallic bang. Kawena's ears rang with the shock of it. He turned and saw that one of the Belgians had fired. When he looked back at Lumumba, he saw a hole in the side of his head, just in front of the ear, and a mess of blood and bone. Munongo stepped back from the body and the room filled with the sound of gunshots. Kawena and Kazadi covered their ears with their hands as the sound hammered at them. The bodies by the wall juddered, broken again and again by the pistol rounds.

It was over when the four men had each emptied a whole clip into the three bodies. A tide of blood was seeping out towards the centre of the room. Gat stepped forward and, kneeling beside Lumumba's body, placed his hand, palm downwards, in the blood. The other three Belgians followed his example and, as Kawena watched, they shook each other's hands. Gat turned and held out his hand for Kawena to shake it. Kawena hesitated, but Gat's furious expression made him change his mind. He reached out and shook Gat's hand, feeling the slippery blood between them, his own blood and Lumumba's smeared together. He looked down at his hand and, instinctively, wiped the blood away on his uniform.

There was a click. He looked up. Gat had slipped a fresh clip into his automatic. He offered the gun, butt first, to Kawena.

'Do you want to?' he asked. Kawena shook his head. Gat grinned, and returned his gun to its holster.

★

'What exactly is happening with Philippe', asked Mobutu.

Kawena took another sip of his coffee, and returned the cup carefully to its saucer.

'We're watching him very carefully', said Kawena. 'There's no sign of him meeting with any . . .'

'With any of our people?'

'That's right. He applied for asylum. He used a false name.'
Mobutu was nodding slowly. Kawena watched as the thick swell of fat under the president's jaw was squashed between chin and chest.

'Of course, we can't be sure he isn't just establishing a cover for himself . . .?'

'But you don't think he is?'

'That's right.'

'He hasn't been in touch with Etienne?'

'Not as far as I'm aware', said Kawena.

'But he hasn't done anything about the . . . other matter?'
Kawena shook his head. 'It could be early days, though.'

'When did you last talk to Etienne?'
Mobutu's voice was quite calm. Kawena took a deep breath.

'I haven't actually spoken with him since . . .'

'Since he paid a visit to your . . . office?'

'That's right.'

'That's a long time ago', said Mobutu.

There was a pause before the president spoke again.

'You're happy, I take it, with the state of your kingdom?'
Kawena looked at him. He'd seen the president deny all knowledge of *la deuxième Cité*, deny its existence even to his own ministers just as smoothly and as effortlessly as he'd denied its existence to ministers in virtually every European government. And nobody believed him for a moment, but it was expedient to appear to believe him.

'I think we've got everything under control', said Kawena.

'I want you to do something for me', said the president. 'I want you to go to London. I want you to look after things personally. I've arranged for you to become our ambassador. You can go there . . . as soon as you can, really. We'll

arrange everything ... Is that all right? Will you do that for me?'

'Of course, sir', said Kawena. 'I'd be happy to do it.'

Mobutu smiled at him. 'Excellent', he said. 'That's excellent.'

35

It was eight in the morning and Kawena was at his desk on the upper floor of the *deuxième Cité*, trying to clear the backlog of paperwork before leaving for London. He was interrupted by a knock on the door.

'Come in', he called. A face appeared, looking round the half-open door.

'Patron, it's started', said the man.

'Right', said Kawena, and waved the man away.

He tried again to reach Bertrand in London, but, as before, Jonas said he couldn't get through to him.

'Tell him', said Kawena, 'that if he doesn't get through to me by the end of the night, he's on his own.'

In the van, Jonas looked up anxiously. Bertrand shook his head.

'I'll make sure he understands', said Jonas.

'You'd better', said Kawena, and ended the call.

The riots had started at Ndjili. The soldiers had run wild, flooding out of the nearby army base and descending on the airport buildings. Some had run out onto the tarmac where a flight for Brussels was boarding. About half the passengers were already in their seats when the first soldiers appeared in the cabin and began demanding valuables. A fat woman in a blue dress like a tea-cosy held out her handbag; the soldier snatched it from her and began to search through it. He found money, and gave a grunt of satisfaction, but it seemed he wanted more. He put the handbag's strap over his head, then reached out for the woman's neck, for her pearl necklace. She pressed herself back into the seat.

'*Sale flamande*', said the soldier. His hand closed on the necklace.

'No!' said the woman. She leaned forward and quickly unfastened the clasp at the back of her neck. 'Here', she said, letting the ends of the necklace fall free. The soldier smiled and tucked the necklace away in his battledress pocket. Beside

the woman, her husband was holding out his wallet. When the soldier took the wallet, the man began to slip his watch off his wrist.

The soldiers left the aircraft, taking with them the passengers' valuables and the contents of the drinks cabinets. They took the headphones for the in-flight video. They took the complimentary slippers, the eyeshades, the packets of cleansing wipes. But nobody was hurt. The captain's voice, a shade more mechanical than usual, took them through the flight's preliminaries. The control tower was still operating and, to the passengers' infinite relief, the aircraft was soon airborne.

The shopping mall at the airport was awash with broken glass; watches, clothes, drink, cameras and stereos, the stuff went out by the boxful. The light fittings in the display cabinets were gone, the tills were smashed and empty. All through the departure lounge, the boarding gates, the lobby, soldiers stood while people opened up their luggage. The monitors that announced arrivals and departures were ripped down and carried off, the loudspeakers from the airport's PA system. Furniture went, the paraphernalia from the airport's administration offices, from computers to the stapler. Already there was a stream of cars, taxis, car-hire vehicles, minibuses, heading back towards the army base, piled high with loot.

In the city, things were less peaceful. By nine o' clock the sound of gunfire could be heard across Kinshasa and the sky was thick with plumes of dark, oily smoke from burning cars. Barricades had sprung up across the streets; some were manned by hostile crowds of people waving placards that, for the most part, vilified Mobutu. Some were manned by soldiers, regular soldiers from Kokolo base and from the base beside Ndjili. In spite of the turmoil, there were still people driving furiously around the city, soldiers in hijacked cars, people rushing out to loot, and others rushing to protect their homes or businesses. Most of the gunfire was sheer celebration, soldiers enjoying the freedom to shoot at anything they liked. And where they were hindered by a shop's protective metal shuttering, they ripped through it with heavy machine gun fire that tore the thin metal apart as if it were cardboard.

As soon as the soldiers opened the place up, it seemed, a hundred people would descend and in a matter of minutes the shop would be stripped, people running away with whatever they could carry.

But the telephones were still working, and already the European media were on the move. Film archives and photograph libraries were being searched and camera crews were on their way. A British crew, who'd already been at Lusaka airport after doing a piece on the run-up to Zambia's presidential elections, were in the air and heading for Ndjili where, it was rumoured, French troops from Congo Brazzaville were shooting it out with the mutineers.

Philippe missed the midday news. There was nothing in the morning papers and, anyway, the midday bulletins carried only short pieces, a hastily-prepared graphic showing the position of Zaire in Africa, then a close up on the shape of the country and a circle marking Kinshasa. There were a couple of telephone interviews, voices played over photographs of Kinshasa that had been taken in happier days.

It was Chris, switching on the six o' clock news that evening, who first saw the coverage. He shouted through to the kitchen for Philippe to come and look.

The first piece of video showed a barricade, a line of rolled and burned-out cars, a section of metal railing, and behind the barricade were people three or four deep, right across the road. There were placards calling for Mobutu to go, for the Constitutional Conference to start. There were placards for something called the 'Sacred Union', and in support of Tchisekedi, but his wasn't the only name. One placard called for the return of Antoine Gizenga, another for Mungul-Diaka, another for Nguza Karl-i-Bond. They watched as a soldier, standing some fifty yards from the protesters, levelled his gun and fired, one pull of the trigger, three rapid shots, then he moved towards the barricade. Two more soldiers came into view. The people at the barricade panicked and began to rush back away from it.

A soldier jumped out of the way as a truck swerved into the

road from a side-street. In the back of the truck lay a middle-aged woman, her clothes blood-soaked, her limbs flopping from side to side with the truck's movement. The cameraman followed the truck as it moved away, and there was the soldier again, casually aiming two three-round bursts at the rear of the truck as it departed. Then the picture lurched, the camera pitched into the ground and the signal broke up into sparkling grey streaks. A moment later it cleared and, from the camera lying sideways-on, there was a close up of a pair of feet and the lower part of a soldier's legs, clad in plain green khaki. The soldier aimed a kick, and then the camera was picked up. The picture leapt and swung about as the camera crew ran away down the street.

Chris looked across at Philippe. Philippe was staring coldly at the TV. Chris turned back to the news broadcast.

The camera was showing what had evidently been a large department store. The front of the building had been torn off, and, inside, the debris lay in tangled, charred heaps. The upper floors, smashed open, sagged downwards, and the place was festooned with wiring and strips of metal. Water, spraying from a burst pipe, was gently dousing the whole thing. Ruined as the place seemed, there were people rooting about in the rubble for anything of value, dropping bits and pieces into cardboard boxes that they carted around with them, like scavengers after the battle. Eric stood beside his father, open-mouthed.

'You recognise any of it?' asked Chris.

'It's the centre of town. Place de la Victoire. But it looks as though the whole city's gone up.'

'Can Mobutu survive this kind of thing?'

There was a long pause.

'Doesn't it mean he's losing his grip?' asked Chris.

'It might mean the opposite', said Philippe. 'If he's told the army to go out and loot. It's a way of paying them. It keeps them happy.'

'He's *told* them to do this?'

'It's possible. You saw the placards?'

'I saw one for Tchisekedi.'

'There was one there supporting Mungul-Diaka. He's just Mobutu's front man. Half the opposition parties are Mobutu's. He's set them up to pack the Constitutional Conference with his own supporters. And you saw the soldier shooting at the barricade. That wasn't regular army; it was the DPS, the Special Presidential Division. See the uniform? No insignia. And the rifle – a late model M16. Only the DPS have those at the moment. It's a show.'

'So what does it show?'

'It shows Mobutu's in control. That there's agitation, opposition, but only Mobutu can keep the whole lot together. You watch. This'll die down as quickly as it's started. The French will help him out, and the Belgians will cover Shaba. There'll be a lot of noise about foreigners leaving. It's not the first time.'

'But in the meantime a lot of people get hurt?'

'It's perfect . . . accidents can happen very easily . . . people can simply be found . . .' Philippe took a deep breath before continuing.

'Then Mobutu asks for more investment to rebuild the country. Meanwhile, he tells America he'd like the Constitutional Conference to go ahead, but, look, the country's just too unstable, we're not ready for that kind of thing yet, the opposition isn't ready.'

In the van outside, Bertrand was listening to the conversation, and trying to decipher the sound-track from the television.

'You stay here', he said to Jonas. 'I'm going to find a TV.'

There was a television set in the lounge at Bertrand's digs. He sat and watched the nine o' clock news on it.

'Are you from there?' asked the landlady. Bertrand just kept staring at the screen.

'Isn't it terrible', said the landlady.

'Yes', said Bertrand.

'You must be very worried, then', said the landlady. 'For your family, I mean.'

'My family are not in Kinshasa', said Bertrand.

'Oh.'

'Please', said Bertrand. 'I want to watch it'.

'All right, love', said the woman. 'I'll go and make a cup of coffee. Would you like that?'

'Thank you', said Bertrand.

Back at Chris Davis' house, the family sat and watched the television. Philippe had been right about the speed with which the worst of the rioting had come under control, but across much of the city there were still fires burning, and there were still bursts of gunfire to be heard. They showed the airport; there was video of the wrecked shopping mall, of the ruined lounges; there was a scatter of baggage, clothing, papers, strewn across the lobby, but there were flights taking off and landing, and crowds of European faces, anxious, tight-lipped men and women queuing for the first flight they could get. A young French soldier, interviewed, swore at the Europeans; 'They just wanted to get rich', he said. 'They knew the risks. I don't see why we should risk our necks to save that bunch of pricks.'

Cut to a crew at Mama-Yemo hospital. The cameraman walked to the doorway. Littering the entrance, littering the concrete path that led up to the hospital's main entrance, was a spill of broken syringes and needles.

'This is the operating theatre', said the reporter, and pulled aside a plastic curtain; the curtain was the only thing that divided the theatre off from the corridor. The room was bare. No lights, no equipment, only the operating table itself, standing in the middle of the room. On the table lay a young black man, wearing only a pair of underpants. As the camera tracked across him he jerked and twitched incessantly. Then they showed his head, his forehead laid open to the bone. There was nobody with him.

'That's the best hospital in Kinshasa', said Philippe. Isobel turned to look at him. Eric, sitting on Isobel's knee, was staring at his father, not used to the bitterness in his voice.

'There's plenty of money', said Philippe, his eyes still on the TV images. 'If you're in the government, there's money to fly to the best Swiss . . .'

'And you're going to leave her there?' Isobel was staring. 'With epilepsy, in the middle of that ..?'

The television news moved on. In London, Prime Minister John Major emerged from 10 Downing Street and walked towards his car. He looked towards the cameras and he smiled and waved. Chris hit the button on the remote and the screen went dark. He looked across to Philippe's seat, but Philippe was in the hallway, at the telephone.

It was Marie's mother who answered.

'Philippe, thank God. Where are you? Where's Eric?'

'I'm in London. Eric's with me. He's fine. What about you? Has there been anything close to you?'

'It's been quiet here. We can hear the shooting. But there's nothing on TV, the station's dead. How's Eric?'

'Eric's fine', said Philippe. 'Look. Stay put. Stay in the house. But if anybody comes, just let them have what they want. Do you understand? I can't get back there. If you don't try to stop them, they won't hurt you. How's Marie?'

'She's OK. She's better, but she says she wants to go to the house. To Binza. She wants to get her things before the looters get there.'

'Binza's the first place they'll go. You're safer where you are. Do you understand? I'll try and keep in touch . . . All right? Just sit tight.'

'All right.'

'OK. I'm going to put the phone down, but you're going to be all right. Understand?'

'Yes'.

In the living room, Chris heard the end of the call. Then there was a pause, and he heard Philippe dialling again, and a short conversation, just the whispery sound of quiet speech beyond the door.

The next morning the city was quiet. From half a dozen places in the centre, black smoke rose in thick, twisting columns, black, dark grey, grey-brown, but there was very little gunfire. The looting continued, but the soldiers had it under control by now; that is, they were more organised. Some were

removing goods from the shops and houses, while others ran a shuttle service with trucks to take the stuff away.

At Kokolo barracks there were long queues stretching along the road. People paid a fee to enter the compound and, once inside, they began to search through the market that had, like a chemical precipitate, appeared overnight. There were rows and rows of electrical goods laid out across the parade ground. In some of the huts there were impromptu stores selling jewellery and perfume. There were clothes for sale, there was furniture, whole bathroom suites hacked out of European houses. Civilians wandered up and down the vast bazaar, looking for their own property, and if they found it, they tried to bargain for it, but however much they paid, they had to pay. They had to pay and they had to get a receipt. The few who tried to leave the camp without a receipt found their goods taken from them again and returned to the bazaar, and if they found their property for sale again, they had to pay again.

Marie was up and about, insisting that they go and collect her things from Binza.

'There'll be nothing left', said her mother. She looked at the angry wound on Marie's scalp. 'And anyway. How will we get there?'

'We can get a taxi', said Marie. 'And we don't know that there's nothing left. What about my clothes. They cost a fortune . . . please . . . come with me?'

By mid-morning her mother had grown weary of her pleading, and finally consented to call a taxi.

'He's charging ten times what it costs', said Marie's mother, her hand covering the mouthpiece.

'Mother, if we get just a fraction of the clothes, it's worth it. Please.'

Her mother told the taxi to come for them. An hour later they stood in the gutted shell of Philippe's and Marie's home. There was nothing — not a piece of clothing in the house, not Marie's, not Philippe's, not Eric's. All that was left in Eric's room was a litter of torn-up books and comics. Every room was stripped bare; even the window frames had been torn out.

The whole street was the same, every house deserted. Gates and railings had been torn up. Even trees from the gardens had been hacked down and carted off for firewood. Marie stood and looked at the destruction all around her, her bruised and swollen face just dumb and staring.

'Come on', said her mother, and took Marie by the arm. She led her across to the taxi.

On the way back they passed through Gombé where the Europeans were still holed up in the Intercontinental. There was a ring of French paratroopers around the building, but within sight of them the Zairean soldiers carried on their looting.

As they crossed the Place de la Victoire they saw that there were shops which still hadn't been torn open. The taxi driver eased out into the square, looking anxiously around him. An army truck roared past, but the soldiers in the back of it paid the taxi no attention. The taxi moved further across the square, then stopped, the driver frozen into stillness behind the wheel.

Ahead of them stood a soldier with a rocket launcher. He was glaring at the taxi, and he seemed to be aiming directly at them. Then he shouted, but they couldn't make out what he was saying. The taxi driver threw his door open and ran from the car. Marie and her mother watched him go, and turned to see that the soldier had come closer towards them. As they watched, he squeezed the trigger.

The explosion, when it came, was colossal. They felt the car shaken by the shock wave, and heard debris raining down around them. Behind them a building was hidden by a boiling cloud of dust and smoke, and the soldier was running towards it.

Then there was someone climbing in to the driver's seat. A big man. They shrank back from him, still terrified, silent. He frowned at them and turned his attention to the car's controls. The engine was still running. The man put the car into gear and drove off, fast, across the square. Ten minutes later, still without having spoken, he stopped the car outside Marie's mother's house.

'Get out', he said, and they obeyed him. They stood and stared at him.

'Go on!' he said, and shooed them away. They turned and ran into the house.

Philippe, Eric and Chris sat in the living room, watching the lunchtime news. The situation in Kinshasa, it said, was stabilising. Europeans continued to crowd the airport, and Belgian military transports were flying them out. All civilian traffic had been stopped, the French and Belgian troops were in control. By now the newsreel footage was ready, and grainy black and white photographs showed the fighting that had followed independence in 1960. This time, the newsreader said, there is no talk of sovereignty, no talk about appealing to the UN.

They cut to a report from Lubumbashi. Belgian paratroopers were guarding the airport and there were more of the frightened European faces, more military transports; there was talk of exodus, destruction, talk of bankruptcy. The copper mines, the reporter said, are closed, which they never were in 1960 but, as there had been after independence, there was talk about secession. The 'Baltic' option, so they said, was being floated, for Kasai, for Kivu, and for Shaba or, they pointed out repeatedly, for Katanga, as it always used to be known.

They cut to a camera crew in Mbuji-Mayi. There was a pile of paper in the street, then a close-up of the reporter's hand, holding a 10,000 Zaire note. A tight shot on the note itself, Mobutu's portrait, the horned head, a leopard leaping. They pulled out again, and the pile of banknotes in the street was being doused with petrol. The reporter stepped back and someone threw a match. The paper went up with a thumping *hwhooff*, a ball of flame rising up into the air.

'In Kasai', said the reporter, 'Zaires are worthless. The only currency people will accept is American dollars. Everything else is barter. But for the people to publicly *burn* Mobutu's currency is as clear an indicator as there could be that, at least here in the southern provinces, the president's writ no longer runs.'

'Now *that*', said Philippe, 'is new'. And as he spoke, the wheels of cassette recorders turned.

In the poky little lounge in his digs, Bertrand was watching the same broadcast. He'd been trying all day to get through to Kinshasa, but it seemed the lines were down, and there was no-one in the embassy in London that he trusted.

The reporter's final piece was done, not to camera, but over the shot of burning money. Bertrand watched the pile of burning banknotes, watched the ashy fragments lifting on the updraught from the fire, watched the scraps of blackened paper fluttering in the air, their edges glowing like the tips of cigarettes, then flickering out.

36

There was a band playing jazz. It was smooth and precise. Philippe paid for his coffee at the self-service restaurant and wandered towards the band. He found a seat at one of the low tables near the bar. When he checked his watch it was eight minutes to twelve.

High overhead, forming the ceiling of the wide expanse of lobby, was the underside of the tiered concert hall. It rose in concrete steps, as if they were there to be walked upside down, out from the heart of the building, up and out through the high windows, out towards the river. Around him was a gentle stir of people having early lunch; the place was barely a third full.

Mr Thomas had chosen the meeting place. 'Do you know the Royal Festival Hall?' he'd asked, and sounded surprised when Philippe said yes. 'I'll meet you on the ground floor, then', he'd said. 'Near the bar, there'll be a band playing. It's not too noisy. Do you like jazz?'

The band was playing and it was still only five to twelve. Philippe glanced at the coffee and saw that he'd almost finished it.

'I'm afraid I can't spare you very long, though', Thomas had said. 'I hope you understand.'

Philippe stood up and walked towards the entrance. There were two big doorways and, bridging the space between them, a shop within plate glass walls. It was a bookshop; Philippe wandered through it, between shelves and tables which offered books on art, on opera, on ballet; thick, richly coloured books. He emerged from the far side of the book-shop, beside the other set of doors.

He went outside for a moment. It was a fine day, although the bleak expanse of paving offered little comfort and the air, though fresher than inside, still had the scent of the city on it. He checked his watch. Twelve, right on the nail.

Philippe went back into the building and began to scan the place for Mr Thomas. He went across to the bar and looked

266

over the seating area where he'd been a few minutes earlier; he saw his own empty cup and saucer sitting on the table and the seats around the table empty. He walked across to the self-service restaurant and checked the tables close beside it. There was the bookshop, a record shop, a salad bar on the far side of the hall, another glass-walled shop that stocked fine bric-a-brac, everywhere the shining sheets of thick plate glass. All around there were people in twos and threes, chatting over drinks or pastries. Here and there a lone figure sat and scribbled at a notebook, or passed the time with a newspaper. Everybody, it seemed, was relaxed, had time, had nowhere special that they needed urgently to be. There was no Mr Thomas.

He bought another coffee. There was barely a queue, but he turned as he waited and scanned the wide lobby, watched the people who came in through the plate glass doors. He took his drink over, just like before, to a table by the bar, near the band, and sat down to listen and watch.

He'd tried, on the telephone, not to sound urgent, but surely, you must realise, the situation has changed; I've got to get my wife — she's still my wife — out of that shambles. A phone call would do it. A phone call, Mr Thomas, to the Home Office, to the Immigration people, to speed up the application for asylum, review Marie's case, just lose the file from Dover. It would be the easiest thing in the world, all Mr Thomas had to do was want it to happen.

But Thomas had cut the conversation short, had arranged the meeting and told Philippe to save his case till then; he would listen, he promised, to whatever it was that Philippe had to say, but he had to understand, there were priorities. There could be no promises. I'm afraid. But I'll see you at twelve tomorrow and then we can talk.

The band swung into a version of 'Chatanooga Choo-choo'. It was beautifully light, a sweet clarinet tone, and a bright, dancing rhythm from the bass. Bloodless. Philippe glanced across at the band. The bass player was a huge man, a tall, broad black man with his eyes closed and a smile on his face that reminded Philippe of Tshombe.

Philippe glanced at his watch. It was a quarter past twelve. The coffee was cold. He stood and patrolled the lobby once more. He went outside again, in case, perhaps, I heard him wrong. He knew he hadn't heard him wrong, but perhaps, maybe, he's misremembered exactly where we said we'd meet.

At half past twelve he found a phone booth and called Mr Thomas. A voice he didn't recognise informed him, with that warm, polite, transparently dismissive manner that English women do so well, that Mr Thomas wasn't in the office at the moment, and no, I don't know when he'll be back, and I'm afraid I can't say where he is; can I tell him who called? Philippe put the phone down.

At one o' clock the band stopped playing and there was a change over. A new band appeared on the little stage and, in the background, Philippe saw the first group of musicians putting their instruments away. The message, he thought, couldn't really be more clear. He finished the last of his last cup of coffee and left.

Twice, when Philippe had gone out through the doors, Jonas had called to Bertrand on his mobile phone; both times he'd had to send him back, and Bertrand had retreated to the snack bar in the basement of the building.

'He's going for the foot-bridge', said Jonas. He saw Philippe begin to climb the steps; saw him pause to drop a coin in the beggar's hat then set out across the river. A moment later Jonas saw Bertrand go after him.

Hungerford Bridge is almost a quarter of a mile long, and the footbridge is only a thin strip of steel with railings, bolted onto the side of the railway bridge that leads into Charing Cross. When trains go past the sound is thunderous, even a sudden cry of pain would be drowned in the noise. But as you get out towards the midpoint, if you look downstream, there's one of the best views in central London. The river curves away to the right and you look out over a broad pool with, across it in the middle distance, the dome of St Pauls. The view from Hungerford Bridge is open and unencumbered, and on a fine day the river shines with a pale blue-grey light,

blue–grey–green, clear and open to the sky, shining up from a bowl of creamy stone. As the sunlight bounces up from the water it feels as if somehow the sky has got underneath you, as if you're stepping out over almost nothing.

Philippe paused half-way across and stood for a moment to look out over the river. The bridge was busy with lunchtime crowds, but there are bays, passing places let out from the side of the walkway so that you can take your time over the view without obstructing the people crossing the bridge. Philippe glanced up to his left, to the back of the Savoy, and saw the clock showing five past one. Bertrand hung back, waiting for Philippe to move on. He held the knife, a sharp, short-bladed kitchen knife, in his right hand, hidden in the pocket of his fawn trenchcoat. He had only to thump the blade hard into the middle of Philippe's back. Just once, hard, and Philippe would stumble with the shock of the blow. By the time he sank to the ground he'd be too weak to struggle. By then the knife would be deep in the Thames and Bertrand would have hurried ahead through the crowd. By the time the bystanders realised what had happened, he'd be at the tube station and away.

Philippe started walking again, and Bertrand began to make up the distance. He wanted to hit him just before the north bank. He closed until Philippe was only a couple of steps ahead. He brought his hand out of the trenchcoat pocket, the knife held close to him, pointing downwards, no-one would notice it.

Except that close to the north bank there's another passing place where people stop to see the view. A party of middle-aged Americans, overweight, wearing flamboyant checks, their necks and shoulders hung around with bags and cameras, were standing there while someone's husband, father, uncle with a camcorder took in the view. He swung the camera round to catch the people crossing on the bridge. A moment prematurely Bertrand raised the blade to strike and the silver flash of light on metal caught the tourist's eye. He shouted. Philippe turned as Bertrand lunged, one instinctive move-ment that took him inside the blow and, as he struck out,

knocked the knife aside. Bertrand's hand banged into the railings and he dropped the knife which fell, just as he had planned, into the river, except that Bertrand was face to face with Philippe and Philippe was quite unhurt. They stared at each other for a moment then Bertrand turned and started back the way he'd come, back towards the south bank. Philippe called to him to stop, but Bertrand was running into the crowd like a man trying to charge down the waves. The noise in his ears was the roar of big surf, and Philippe was after him.

Like a wave, the turmoil ran ahead of them; people who could see them coming tried to step aside, but then they tangled with the rest of the crowd, who turned to see what the commotion was and in their turn stepped back to open up a space, to pull themselves out of the path of whatever it was that was happening. When Bertrand turned to run he opened up a gap of six or seven yards but, taking the brunt of the crowd's resistance, Bertrand was hindered and could hear that Philippe had almost reached him. He felt Philippe's hand catch at his shoulder, heard Philippe's voice shouting, 'Wait, Bertrand, Wait!' and the voice wasn't angry but calling as you'd call to a friend, and all this struck him in the space of half a stride as he shrugged the hand free of his shoulder then heard Philippe stumble behind him, turned, and saw that Philippe had fallen.

Bertrand tried to charge on ahead. Philippe was on his feet again and starting to make up the ten or fifteen yards that Bertrand had gained. Bertrand, staring ahead of him, saw the crowd thicken. He saw a young woman trying to jump aside and he saw her jostled back into his path. There was a black man, tall and heavily built, who couldn't seem to make room for Bertrand and Philippe to pass. The black man had something with him, a large black case. He was pushing the case in front of him, trying to manoeuvre it into a space in the crowd but the case was right in Bertrand's path. Bertrand jumped at it, trying somehow to vault past it, to get clear, but as he leapt, trying to get over the case, the big man pushed outward and Bertrand felt himself pitched

up into the air, his balance completely thrown, momentum carrying him forward and up and out over the railing. He grabbed at the steel bar, felt it torn from his grasp, saw the shocked faces in the crowd as he fell away from the bridge. And as he hit the water, in the last split-second, there was Philippe's face, looking down at him, more puzzled than angry. Then the water closed over him and he sank down into it, thrashing his arms and legs, can't swim, can't swim, can't swim.

Bertrand fought his way up to the surface and tried to orient himself towards the near bank, but the river kept turning him round and round and his own lashing out at the water was uncoordinated.

On the bridge the crowd had pulled back from Philippe, looking at him as if they expected him to act. Someone on the riverside had thrown a lifebelt into the water, but it had gone only a short distance out from the bank and Bertrand hadn't seen it. Philippe looked down as Bertrand beat helplessly at the water, and saw him sink again beneath the choppy surface. Looking down at it, the water seemed dark and opaque, and Bertrand was completely hidden.

A moment later Bertrand came thrashing back up to the surface. Philippe saw him struggle once again to get his face up into the air, heard him shout for help, '*Aidez!*' heard the next cry choked, a strangled, spluttered cough. Philippe slipped off his jacket and his shoes and began to climb over the railing. As he was balanced on the handrail he felt someone grab him from behind, a huge pair of arms pulled him back onto the walkway and when he struggled round to see who it was he saw the black musician's face. The man was holding Philippe in a bear hug, and as they stared at each other, Philippe saw a look of amusement on the musician's face as if he'd just stolen a kiss.

'Make life a whole lot easier', said the musician, 'if you let him go.'

'Thank you, Arthur. I think you can release Mr Nkanda now.'

The musician relaxed his grip, and Philippe turned to see Mr Thomas standing beside him.

'Perhaps', said Mr Thomas, 'if you'd care to put your jacket and shoes back on, we could go somewhere a little less . . . conspicuous?'

Before Philippe could reply, Bertrand screamed for help again. The three men turned. They leaned on the railing and looked down at Bertrand's helpless splashing.

'It's up to you', said Mr Thomas.

'Let him go', said the musician.

Bertrand was drifting downstream, still thrashing and flailing ineffectually.

'Get him out', said Philippe. The musician shook his head.

'I'll get you a taxi', said Mr Thomas. He dipped his head and spoke briefly into his lapel. A moment later, from just upstream of the bridge, a small launch appeared and churned its way over to Bertrand. He was hauled aboard with rough efficiency, and the launch turned back upstream. From all around, the crowd sent up a clapping and cheering which died away as the launch passed under the bridge and was lost from view. Immediately the crowd began to thin. The normal traffic across the bridge got underway again. The musician picked up his double bass and, with a nod to Mr Thomas, set off across the bridge towards the Embankment. As the musician reached the far end of the bridge, the American tourist's camcorder was being handed back to him, minus the tape.

'So what about Marie?' asked Philippe.

Mr Thomas shook his head. He was adjusting the cuffs of his shirt. The shirt was beautifully cut, in a close-woven cotton fabric with narrow stripes of coral and white. The cufflinks were stylised roses, gilt metal, an inner circle of white-enamelled petals, an outer circle of red.

'Tell me', said Philippe. Mr Thomas looked up at him, mildly curious.

'If Bertrand had managed to do what he tried to do. What would you have done?'

The Englishman smiled. 'Come on', he said. 'Let's see what we've caught.'

37

The taxi stopped in Mayfair, outside the building where Kawena had his London residence. Philippe reached into his jacket, but the driver grinned.

'It's on the house, sir', he said.

'Which house?' said Philippe. The driver laughed. He released the lock on the rear doors and Philippe climbed out, hauling the half-conscious bulk of Bertrand after him. Philippe paused on the pavement, looking back at the cab. The driver was sitting and watching, a broad smile still on his face. Philippe shrugged his shoulders and started to half-lead and half-carry the soaking Bertrand over to the doorway.

He slipped Kawena's key-card into the lock. To his relief, the door gave a clunk as the bolt slid across, and he pushed it open. It was relatively easy to bundle Bertrand into the elevator. There was another card-lock for the apartment itself and then they were in, the sound of their breathing echoing from marble walls and floor.

A large reception room opened off the hallway. It was furnished in pale, creamy yellows, with gilded furniture in a repro, Louis Quinze style, but there was also a fine collection of African art. There were masks on the walls, Luba masks with huge, bulbous staring eyes, and there was a tall wooden figure on a plinth, surrounded by a glass case. Philippe switched on the lights and the gilded furniture gleamed. He dragged a chair over to the display case and dumped Bertrand into it. Then, with Bertrand lolling groggily in the chair, Philippe began to search the apartment. He found Kawena's office and came across a tape dispenser with a roll of sellotape. Philippe took the sellotape through into the reception room. Bertrand still seemed half-doped, and made no resistance as Philippe wound the tape round and round, fastening his arms to the chair arms, his ankles to the chair legs, layer upon layer of tape until the roll was finished. Bertrand could wriggle, could shake his head, but not much more. Dirty water from

his sodden clothes dripped slowly into the thick, cream carpet. Philippe went across to the tall windows. He glanced down into the street and saw the cab still waiting at the kerb. He drew the curtains across to block out the light. Though it was still early in the afternoon, the room was darkened, only a faint glow of daylight showing round the sides of the curtains. He breathed in, and wrinkled his nose in disgust; the stink of the river was on his own clothes too.

Philippe left Bertrand for a while to recover, and in the meantime he explored the kitchen. Kawena had a maid who came in regularly and, besides keeping the place dusted, she made sure that there was always a selection of basic provisions in stock. There was milk in the refrigerator, there was bread, and a rather dull selection of fruit — apples, oranges, bananas — together with some vegetables.

Philippe found coffee and set the percolator going. While the coffee was dripping into the glass jug, he changed out of his damp clothes and showered. He found a track suit in Kawena's wardrobe.

Back in the kitchen he poured himself a cup of the coffee. He found pâté, and spread it generously on a thick slice of the bread, then, taking an apple and a paring knife, he carried the food through into the reception room. Bertrand had started to take in his surroundings. Philippe pulled up a chair and a low table and sat just in front of Bertrand, eating the pâté and drinking the rich, strong coffee.

'Would you like something?' asked Philippe. He saw the confusion on Bertrand's face, the struggle between hostility and acquiescence.

'I'll get you something', said Philippe. He left his own food on the table and went through into the kitchen for more.

Back in the reception room, Philippe carefully tore off a piece of the bread, spread pâté on it and offered it up to Bertrand's mouth. Bertrand glowered up at him. Eventually Bertrand opened his mouth and Philippe pushed the food in. The coffee was more difficult; Bertrand sucked at the tilted cup but still some of it spilled down his front. Nevertheless,

they managed, between them, to get a reasonable amount of the food and drink safely into Bertrand's mouth.

When Philippe had finished his own bread and pâté and drunk the last of his coffee, he picked up the apple and the paring knife. Bertrand's eyes were on the knife, but he said nothing. Philippe reached out his hand and checked Bertrand's pulse.

'You've had a nasty shock, Bertrand', said Philippe. 'Stress. I'd tell you to relax, but I don't suppose you'd find that very easy.'

Bertrand glared at him. 'What are you going to do?'

Philippe took the knife again and began, very carefully, to peel the apple, working the blade down the fruit in a long, unbroken spiral. He glanced at Bertrand and smiled to see his eyes on the blade of the knife.

'Would you like some?' asked Philippe. Bertrand's teeth were clenched.

Philippe finished peeling the apple. He put down the knife and held up the fruit. He put the apple down on the table and picked up the long spiral of skin. 'There', he said. 'All in one.'

Bertrand shook himself in the chair, rocking it slightly back and forth, but his mouth stayed clamped shut. Philippe began to break off small sections of the peel, popping them into his mouth like sweets.

'Are you sure you wouldn't like a piece?' asked Philippe. He dropped the last of the skin onto the table and picked up the knife again. He cut a thick slice of the flesh from the fruit and ate it from the knife blade. While he chewed it, he cut another piece of the fruit and offered it to Bertrand. Reluctantly, Bertrand opened his mouth. He grimaced as Philippe put the fruit into his mouth, but began to chew it and seemed surprised at its sweetness. Bertrand swallowed, and Philippe cut himself another slice.

'Why did you try to kill me?' asked Philippe. There was no answer.

Philippe stood and went across to the door where a panel of switches controlled the lighting. He switched off the main room lights and switched on the small, halogen lights in the

display case. The case was to Bertrand's left. The strong light shed on the wooden figure illuminated the room immediately around it. Bertrand's eyes were drawn to the figure.

It was male, about five feet tall, with the stoop of an old man, but sturdy, head hunched down, the whole thing rough-hewn as if it had been made with an axe, the wood hacked out in blocks from heavy timbers something like railway sleepers; the head, neck, limbs, torso, all sub-angular. The face was cut in flat planes where the wood had split along the grain, a forbidding brow chopped in, cheekbones and jaw squared and massive.

It was heavy with iron and steel; hundreds of nails and spikes had been hammered into it, all with an inch or so left protruding. Brown iron bristled from the figure, from every part of it, rough-cut angular nails with square heads, European wire nails, the blades of knives, driven in and broken off, the tang of a file or a chisel, curved, shattered shards from an iron pot. Harsh, halogen light caught the edges and angles; points of brightness shone from the mass of rusted metal. Philippe walked across and stood by the figure, looking down at Bertrand, at the light gleaming on Bertrand's face, catching the gilt of the chair, the shiny surface of the tape that bound him.

'Why did you try to kill me, Bertrand?' asked Philippe.

'It was Kawena. He told me to do it.'

Philippe sat down again, facing Bertrand. He leaned close to him and smelt the filthy river. There was a smell coming from Bertrand like the smell of a wet dog. Bertrand tried to pull back into his chair.

'Tell me why you tried to kill me, Bertrand.' He sat back and watched Bertrand sag.

'If I wanted you dead, all I had to do was let you drown.'

Bertrand shook his head, his mouth tight closed. He was breathing in short, shallow gasps. Philippe left him for a few moments. He took the cups and plate back to the kitchen and stacked them in the sink. He poured himself a fresh cup of coffee and took his time drinking it, walking around the apartment, a casual inspection this time.

He went back into the reception room. He stood for a while behind Bertrand, looking down at him and sipping at the coffee. Then he sat down opposite him again and, saying nothing, stared intently at him for several minutes. Eventually Bertrand stirred himself.

'You always looked down your nose at me, didn't you,' said Bertrand, 'because I got my hands dirty. Me and all the other people who did what you told them to do. And then you tell me that what I'm doing's disgusting.'

Bertrand had made a huge effort to get this accusation out, and now he'd thrust himself back in his chair. His head was turned away from Philippe but he kept glancing at him, watching him from the corner of his eye.

'But you enjoyed it, didn't you?' said Philippe.

Bertrand tried to spit but nothing came out.

'When you finally took a knife, or a gun, and there was no-one to stop you, they looked up at you, didn't they. How did they look, Bertrand?'

Bertrand suddenly jerked at the tape that was binding him, trying to break free of it, straining his arms and legs against it, his face contorted with the effort.

'How did they look, Bertrand?'

Bertrand flopped back in the chair again.

'Take your time, Bertrand. We've got all the time in the world.' Bertrand lifted his head and glared at Philippe again.

'Kawena will kill you', said Bertrand. 'You know that? He knows where you've been staying. He knows where Marie is, where Eric is. He knows where your family are. He knows about André, he knows about Ndeko. You think he'll just let go? You think he'll just say, "All right, never mind, let him go, let them all go"? You're dead. Whatever you do to me, you're dead!'

Philippe shook his head gently from side to side.

'How do you think we got into this apartment?'

There was a long silence.

'You think he'll do a deal?' said Bertrand. 'You think he'll do some kind of a deal with *you*?'

Philippe leaned back in his chair. He folded his arms,

crossed his legs, and for several minutes he sat, saying nothing, just looking at Bertrand. Finally he spoke.

'Why did you try to kill me, Bertrand?'

Bertrand tried to spit at him again. This time a gobbet of spittle dragged on a thread of saliva and dribbled down his chin. Philippe went through to the kitchen and came back with a roll of tissue. He wiped Bertrand's face for him and dropped the crumpled tissue onto the table.

'It was the trial, wasn't it? You thought I'd try and get back at you.'

Bertrand struggled against the tape again, then subsided.

'We're both from Kasai, aren't we?'

Bertrand glared at Philippe, but said nothing.

'How did you feel about that, Bertrand? You used to curse Lumumba, didn't you? And he was dead before you were born.'

'He was dead before *you* were born. You think I don't know that. I've listened to you. "I was eleven months inside my mother's womb". Do you think anyone believes you? You think Kawena believes it? You think he'll treat you any different? Nobody believes it. Nobody believes it. You're from Kasai, you're the same as me and you should hate Lumumba too.'

'My mother was from Kasai, Bertrand. Is from Kasai. And the students you killed. Where were they from?'

'Bastard!' Bertrand shouted.

'Kasai', said Philippe.

'I had no choice!'

'There's always a choice.'

'No. There isn't. There might be for you . . . not for me.'

Bertrand's head was turned away from Philippe again. He was glaring at the figure in the case. Philippe reached out and took hold of Bertrand, hands either side of his head, turning his head, Bertrand trying to resist but Philippe winning out, turning him so that they were face to face again. Bertrand tried to throw himself forward from his chair, as if he were trying to butt Philippe in the face. Philippe held him securely. Bertrand shut his eyes tight.

'Bertrand, look at me.' Bertrand screwed up his face as if he'd tasted something vile.

'Look!' Bertrand's eyes stayed shut.

Philippe released him and Bertrand sagged back in the chair again. Philippe watched him closely, and a few moments later Bertrand opened his eyes, glancing briefly at Philippe, then looking down.

'Shall I tell you something?' asked Philippe. There was no reaction.

'About Kawena?' Still no reaction.

'Well, I'll tell you, Bertrand. You know when they flew Lumumba down to Katanga?' Bertrand gave a slight nod.

'Did you know that Kawena was with him? Kawena was part of the guard.' Bertrand's eyes opened.

'And shall I tell you something else?' Bertrand glanced at him, his face expressionless. Philippe smiled.

'Before Lumumba escaped? You know about that? You know the UN were guarding him?' Bertrand nodded.

'And there was an ANC guard all round the house, trying to get in at him, all set to arrest him if he came out of the house?' Bertrand nodded again.

'Do you know whose idea it was to put an ANC guard round the house? You think it was Mobutu, don't you?' Bertrand lifted his eyes for a moment to hold Philippe's gaze.

'It wasn't Mobutu', said Philippe. 'It was one of the Commissioners. There was a Commissioner for Justice. Do you know who it was?'

There was no reaction.

'It was Etienne Tchisekedi', said Philippe, and he saw Bertrand's eyebrows lift a fraction. Just for a moment, then the mask was back.

'Why did you try to kill me, Bertrand?' Bertrand shook his head.

'Why did you try to kill me?' Bertrand stared down at the floor.

Philippe reached out and lifted Bertrand's face. This time there was no resistance. He looked into Bertrand's face.

'You did it on your own account, didn't you?' Bertrand turned his head aside again. Philippe let him go, and sat back in his chair.

They sat like that for an hour. The light around the edges of the curtains faded. Philippe stood and went over to one of the windows. He drew the curtains aside and looked out. There were lights showing in the street, streetlights, car lights passing below. The cab was gone from the kerb. He let the curtain fall closed again and looked back towards Bertrand. He went across to him, sat down, and saw Bertrand look up momentarily.

'Does it really matter that you're from Kasai?' asked Philippe. 'What about the students you killed? What about the people you tortured and killed? You think it's worse to kill someone from Kasai than to kill someone from Equateur? You think we're really any different? Luba people, Lulua, Kongo? Here . . .' Philippe stood up and went over to the wall where one of the masks was mounted. He lifted down the mask and took it over to Bertrand.

'Look', said Philippe. 'Luba, yes?' Bertrand stared dumbly back at him.

'Big eyes', said Philippe, 'and little mouth. You understand?'

'And when you put it on, you cease to be yourself. The spirits come, the ancestors . . .' Bertrand said nothing.

'It's not true, Bertrand. Some things you have to say. Some things, you have to let them come out of your mouth. You have to stop pretending you have no mouth. You have to say it, let people hear it. Do you understand?'

Bertrand snorted.

'Mickey Mouse. It's a lie. You can make yourself like that. You can make yourself all eyes and ears, you can learn not to speak, just to look, observe, keep your distance. Don't get involved. You have to learn it, though, don't you, because it's not natural. It's not natural and it's not true. You can *act* as if you're different, you can look for a man's fear, and you can pretend you're different. And the only reason you're different is because you're the one with the power. *You* aren't going to get hurt. But it can all change round, and you've seen it

280

change round, already. And if it can change like that, one day you might be on the wrong end of it all. And if that happens, you'll hurt, and you'll be frightened. So when you sit there, when you put on the mask and you stare at some poor, naked, terrified man, you know, don't you. You know it could be you. And here you are, and everything you've done, someone else could just as easily do to you. And everything you do, somebody, somewhere remembers, and if you kill him, if you burn the body, if you cut it into little pieces and you burn them, bury them, whatever, you know that somewhere, there's somebody who remembers, and some day, some day it could all come out.'

Bertrand's eyes were closed.

'Bertrand, snap out of it. Be human. Don't believe the lie. Don't be so *stupid*. Because it is a lie.'

Bertrand kept his eyes closed, his mouth shut tight.

'If you kill him, Bertrand — whoever he is. If you kill every member of his family. If you wipe his people off the face of the earth. If you burn down his village and plough the ashes under, there's somebody who remembers. Even if it's only you. Because you remember. The smell of burning, the smell of blood. You remember every detail of his face and you try to forget and you can't. So you try to avoid certain words, don't you, because every time you hear them you panic.'

Philippe stood up, and Bertrand winced. Philippe went over to the doorway and flicked the switch for the lights in the display case. The room was in darkness.

'It comes back in the darkness, doesn't it?' said Philippe. No answer, but he heard Bertrand shift in his chair.

'It all comes back in the dark, doesn't it?'

Nothing.

'Doesn't it, Bertrand.'

He flicked the room lights back on and went over to Bertrand, who was slumped in the chair, weeping.

Philippe sat down opposite him. He lifted Bertrand's face, gently, and there was no resistance, just as there comes a stage with most, an understanding that the work is long past

the simple business of pain, that damage has been done that can never be undone. From that point on, you always knew, they always knew, there could be only more wreckage, then death.

38

Philippe was still holding the mask. He glanced down at its blackened, shining surface. The mask felt too light for the substance that, to the eye, it seemed to have. He set it down on the table.

'Are you going to cut me loose?' asked Bertrand.

'What we do, Bertrand,' said Philippe, 'makes us what we are. What we do and what we say. That's all there is. You can justify it inside your head. You can say it's only on the outside and you're still yourself on the inside. That doesn't change anything. What you do and what you say changes things, that's all. And what we do, you, me, Kawena; it destroys things. The only thing to do is stop.' He looked down at Bertrand. Bertrand held his gaze.

'The problem is,' said Bertrand, 'the stuff that's already done.'

'That's right. It's done. Nothing changes that.'

'And there are relatives . . .'

Bertrand was trying to pull his hand free of the tape.

'I know', said Philippe.

'What's to stop them . . .'

'Nothing.'

'So,' said Bertrand, 'we just hope for the best?'

'Maybe that's it. We just have to try and find a way to live with what's out there. And if you're watching your back for the rest of your life, it goes with the job. You knew that when you started. But if you carry on, it's just more people to look out for.'

Bertrand had stopped struggling. He was staring at the floor.

'So what do I do?' he asked.

Philippe sat back in the chair. 'You have to make up your mind', he said. 'Which horse you're going to back.'

'And if it's Tchisekedi? What do I do about that?'

'Suppose you carry on the way you've been going; suppose you carry on and *then* it's Tchisekedi?'

'What about Kawena?'

'Kawena will do the politics. Bertrand, what I'm telling you, you still think it's some kind of idealism? It's mathematics, Bertrand, it's objective. Kawena's not a fool. He'll do everything he can to keep his options open. He's not going to risk everything on Mobutu; why should you? He's not going to rely on some *tribal* connection; "between a brother and a friend, the choice is always easy"; rubbish. Do the mathematics, Bertrand. If you're worried about Tchisekedi, talk to him. If you're worried about Kawena, talk to him.'

'Let me go', said Bertrand, and tried again to twist himself free of the tape.

'The question is, Bertrand, what are you going to do? If I let you go, for instance?'

Bertrand sagged back into the chair. He was staring at his right arm, at the wrist, the shiny sellotape that held him to the chair.

'It wasn't Kawena who told you to kill me.' Bertrand was still staring at his arm.

'Come on, Bertrand. One tap for yes, two taps for no. It wasn't Kawena, was it?'

'Are you worried about that?'

Philippe exhaled, like a sigh.

'Are *you* worried about that? I don't need to tell him. But he'll talk to the people who fished you out.'

'That was the river police.'

'Bertrand. Don't be stupid. If you were listening to me . . . do you honestly think there was no-one listening to you?'

Bertrand stared down at the floor.

'If he does find out. When he finds out. If you tell him it was a mistake, if you step back in line, he'll let it go. As far as he's concerned, this has all worked fine. He's *learned* from it, Bertrand. Which is all he ever wanted to do. If you show him you've done the same; it can't do you any harm.'

Bertrand looked up at him for a moment, then looked away again. Philippe let him sit there for a while, sat and watched him. Eventually he spoke again.

'You haven't told me why you did it.'

Bertrand was still staring at the wooden figure.

'What are you scared of, Bertrand?'

Philippe saw Bertrand's gaze still on the wooden figure.

'Just hammer something into it, eh?'

Bertrand turned to look at Philippe.

'What if it's not Tchisekedi? What if it's Gizenga?'

'What difference does it make? Come on. You're not going to stake everything on Mobutu?'

'He's only in his sixties', said Bertrand.

'And you're only in your twenties. Who's the best bet?'

Bertrand was still staring at the figure.

'Don't be so pessimistic.'

Bertrand said nothing.

'I don't need anything from you, Bertrand. The trial, what you tried this afternoon, it's in the past. If I can leave it, why can't you? If I wanted to hurt you . . . don't you think I'd have done it by now?'

Bertrand looked back towards Philippe. There was just the slightest nod of his head.

'So we understand each other?' asked Philippe.

'Yes.'

'So I can cut you loose?'

'Yes.'

Philippe picked the knife up from the table. He drew the silvery blade across the sellotape and the plastic film parted like water. He put down the knife and peeled off the tape, bundling it up into a ball.

'I'll put some more coffee on', he said.

As he turned away, Bertrand stooped towards the knife. He was watching Philippe's back, just a few paces away, and trying to pick up the knife without making a sound, but Philippe heard a movement and he turned. Bertrand was caught with the knife in his hand and a look on his face like a guilty child. He straightened and took a step towards Philippe, who set himself for the attack.

The shot, when it came, had a hard, flat metallic sound, like somebody crashing a hammer onto steel, a jarring, clanging

sound that left discordant ringing in the ear. They both turned, and saw Kawena standing in the doorway, the gun in his hand still pointing at the ceiling.

Philippe was the first to react. He leapt forward to grab Bertrand's right hand. They wrestled for a moment, grappling for the knife, but Philippe had both hands round Bertrand's wrist and Bertrand's struggling was ineffective.

'Kill him', shouted Bertrand, his face turned towards Kawena. 'Or let me kill him.' Kawena's gun was pointing at the two men, covering them both.

Philippe spoke quietly: 'Use your intelligence! Drop it!'

Bertrand threw his weight against Philippe and struggled for the knife.

'Philippe, stand back.' It was Kawena, the gun still levelled at their heads.

'No', said Philippe. 'There's no need.'

'He isn't listening', said Kawena, 'Look.'

Bertrand's face was twisted, furious, his lips pulled back, the teeth grinding at each other.

'Some people just don't listen, Philippe', said Kawena. 'If we don't settle this quickly . . . if Mobutu gets wind of all this . . . there are realities here, Philippe.'

Bertrand turned to look at Kawena. Philippe made one last effort and succeeded in shaking the knife from Bertrand's hand. The two men parted, both of them now looking at Kawena, at the gun, at the dark circle of the barrel.

'Bertrand', said Philippe, 'I'm trying to give you a chance. Listen.'

'He's not listening.'

Philippe looked at Bertrand, then at Kawena.

'Let me do it, Philippe', said Kawena. Philippe looked at Bertrand again, and Bertrand stared back.

Philippe nodded. A second shot hammered out.

Philippe dropped to his knees beside Bertrand's body. Bertrand was lying on his back, staring up at the ceiling. Philippe reached out a hand and touched Bertrand's shoulder, felt the last twitching, quivering movement. He touched with his fingertip the dribble of blood that ran from the wound at the

side of Bertrand's head. He drew the eyelids gently down to extinguish Bertrand's terrified stare.

'It wouldn't have made any difference how long you gave him', said Kawena.

Philippe stood up. He turned towards Kawena. They held each other's gaze for a moment, then both of them looked away.

'I'll call Jonas', said Kawena. 'He can take care of it'.

'Has he done that kind of thing before?'

'He can handle it.'

Philippe sighed. 'We need to talk', he said. Kawena looked worn out.

'Go and make that coffee', said Kawena.

Jonas had driven away with Bertrand's body, bagged, in the back of the van. Philippe and Kawena sat in the kitchen, on bar stools, with the last of the coffee cold in their cups.

'I want them both', said Philippe. 'Both of them.'

'Not possible', said Kawena. 'If the boss finds out . . . I can't.'

'Eric, then. Let me keep him here.' Kawena shook his head.

'I'll look after them', said Kawena. 'If anybody tries to . . . I won't let it happen. Your family, Marie's family.'

'But you can't guarantee it.'

'You know I can't. But why should anybody . . . people actually *like* you, you know? I mean, within the business; Bertrand was . . . I don't know what made him so bitter. I don't think anyone else would hurt your family. But I can't guarantee it.'

'Then we don't have a deal.'

'Who said anything about a deal?'

'You wouldn't be here if you didn't want one.'

Kawena smiled.

'Suppose Marie stays in Kinshasa', said Philippe. 'If she stays with her mother . . . you'd look out for them?'

'I'll look out for them. But he wants me here, as the ambassador. I can't be everywhere at once. And I can't exactly go to our great leader and *resign*. And I can't just ring up Etienne and say, "Etienne, old friend . . ."'

'You're taking the ambassador's job?'

'It's the best place for me, here, or Brussels.'

Philippe waited.

'I can't guarantee anything', said Kawena. 'Any more than you can. Less, probably. I'll look out for you. But I need you to promise that you'll do what you can. If.'

'If?'

'If Tchisekedi . . . or Lambert, or Gizenga . . . Whoever. If Mobutu goes you're going to get an offer. We both know that. Whoever. And if that happens I want a guarantee that I'll be safe . . .'

'You said no guarantees.'

'You'll do what you can.'

'You've been around a long time. Somebody might go freelance.'

'You could get me somewhere safe . . . in exile . . .'

'Exile! Exile's for martyrs. Exile has dignity.'

Kawena held out his hand. 'In return for Eric', he said.

Philippe looked at Kawena's hand, at the tired, dry skin.

'I want Manza's wife looked after, too,' said Philippe. Kawena nodded.

'And leave André and Ndeko out of it, all of them.'

'Just give me a list.'

'Not funny. All of them.'

'OK.'

'And the Lumumba boy. I want him left alone.'

'All right.' Kawena's hand was still stretched out towards Philippe.

Philippe looked at Kawena for a moment, then took his hand and gripped it.

39

In late July the Home Secretary found himself in the dock, charged with contempt of court. He'd given an undertaking to a judge, they said, not to deport a Zairean man, a teacher whose asylum case was to be reviewed. The undertaking was given at 5.55pm. At 6.47pm the man was on the flight for Paris, and from Paris, to Zaire. And in Zaire, as Philippe had discovered, he disappeared.

'In a constitutionally unprecedented case', it said in the newspapers, the Home Secretary was found to have no case to answer. 'Ministers', said the headlines, 'are above the law.' The headlines said it on Saturday July 27th, the day after the judge gave his ruling. There was some discussion, over the next couple of days, in the broadsheet press, on democracy, the rule of law, and where the judge's decision left the citizen. But what was most interesting, the following week, was news of the Home Office drive to wipe out 'widespread dole fraud', by 'immigrant refugees'. On Friday August 2nd the *Daily Mail* ran a banner headline about the big police operation the previous day; 'More than 100 people were held in swoops across London and in the Midlands', said the copy, 'One couple from Zaire, who are awaiting the result of an application for political asylum . . .' And on the inside pages, under the headline, 'Time to close the floodgates', the paper's lead columnist wrote at length. 'The problem of refugees not so much seeking asylum in Britain as grabbing it has now reached a crisis.'

Ask me the news from home and I'll tell you. The news from Zaire that summer was bad. The Constitutional Conference was 'faltering'; in a tiny foreign brief was a note about seven people killed in clashes between opposition supporters and 'security forces'; on the day of the Home Office swoops, the Constitutional Conference was suspended; a week later an article detailed the training that South Africa, on the brink of relinquishing apartheid, had been giving to Zaire's crack

army unit, the *hiboux*, 'which has been accused of supporting a campaign of intimidation against opponents of President Mobutu Sese Seko.' Inflation, moving too fast for accurate measurement, was estimated at between 5,000 and 10,000 per cent.

Chris Davis folded the newspaper and tossed it onto the kitchen table. He glanced across at Philippe, who was still reading one of the tabloids. Philippe looked up.

'Who is like the beast? And who can war against him?' said Chris.

Philippe shook his head and carried on reading.

'More need you the divine than the physician', said Chris, and, grinning, got out of his chair and went across to the refrigerator. 'All we've got's this Mexican beer.' He took two bottles and put them on the table. He pulled open a drawer and began rattling its contents around.

'Potato peeler', he said. 'Corkscrew'. The rattling grew more indignant. 'I can't find the bloody bottle opener.'

Philippe put down his paper. He reached out and picked up the bottle opener from where it lay on the table top. He waved it at Chris, then stretched across and picked up a bottle. As he eased the cap off, a thin, spidery web of bubbles crept up a half inch from the rim, then broke, and the beer dribbled down. Philippe opened the second bottle, and passed it to Chris.

'Cheers', said Chris. They clinked their bottles together.

Chris sat down again. Philippe went back to his paper, and Chris picked up another of the tabloids, but threw it back again impatiently a moment later. 'Is there ever any good news?' he asked.

'There's no news from Bukavu', said Philippe. 'That's good news.'

'Did you ring last night?'

'Yes.'

'And they're fine?'

Philippe's face was blank. 'They're going to be OK.'

'You think Kawena's going to keep his word.'

'I think he'll try.'

'What about you?' asked Chris. He saw Philippe's lips pressed together for a moment, just a flicker of a frown, no more.

'*La patience est amère*', he said.

Chris grinned. 'But the fruits of patience, they're very sweet?'

Philippe smiled. 'Your French is coming on.'

Chris took another drink.

'What are you going to do?'

'Oh', said Philippe, and he paused. 'There are things that I can do to keep myself busy. There are people I can work with, I think . . .'

Chris laughed. 'If I didn't know you better', he said, 'I'd think you were being evasive. As it is . . .'

'You know', said Philippe.

'What about Tchisekedi?' asked Chris.

'Everybody has a past. You have to try and stop it turning into a cage. Did you ever do any anthropology?' Chris shook his head.

'You get it in a lot of African religion, coming of age ceremonies . . . a person reaches a certain age, and they don't go straight from childhood into adulthood, they have to go through a period of being . . . neither, almost not a person at all . . . anthropologists call it a 'liminal' phase, a threshold.'

'It's not supposed to last the whole of your life, surely?'

Philippe sighed, then smiled again, a faint smile.

'It's a time when things change, grow. It's a magical time. It's almost like going back into the womb.'

'And it lasts eleven months', said Chris.

'I've got to ask you', said Chris.

Philippe looked at him, patient, just a flicker of a frown.

'Are you actually his son?'

Philippe shook his head. 'Not really', he said.

'You mean it sort of *depends!*' said Chris, and Philippe smiled.

One day that October, when Madame Manza went to collect her mail, she found a large envelope waiting for her, post-

marked Kinshasa. Her hand hardly trembled as she picked it up, but as she carried it through into the study, she found herself beginning to shiver. She dropped the envelope onto the desk and turned away from it. Looking out through the window she saw that it was a bright, clear day. There was a hard blue sky, and new snow shining in the distance. She turned back to the envelope and opened it. Inside was the monthly cheque, in her name, as she'd grown accustomed to it. But there were legal documents as well. She took them out and tried to make sense of them. It was, she realised after a few moments, the freehold of her property, made over to her.

The same day, in a London newspaper, there was a story about an inquiry to be carried out into the death of an asylum-seeker in custody. It seemed to be an accident, the story said; apparently he'd suffered a heart attack while he was being restrained. It was, the story said, a routine inquiry; but there was added interest on account of the man's name, Lumumba.

At the end of the year, when the appeal was heard, the Home Secretary was convicted of contempt of court. The Solicitor General, however, was planning to represent his colleague in the government's appeal against the Appeal Court's decision, which it seemed likely would not be heard until after the next General Election. And the Constitutional Conference had broken down.